BIRDS OF THE PHOTO ARK

Western Rosella *(Platycercus icterotis)* LC

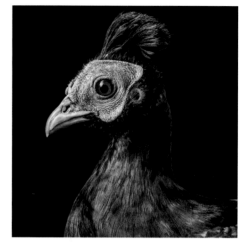

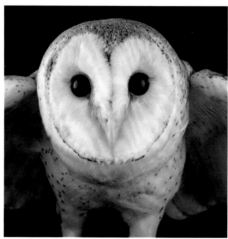
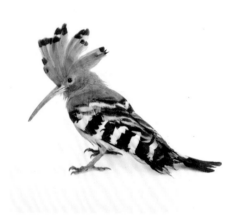
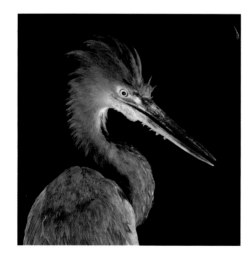
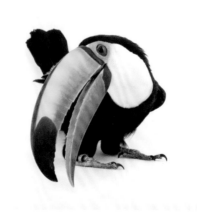
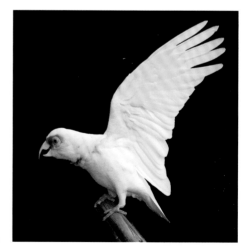

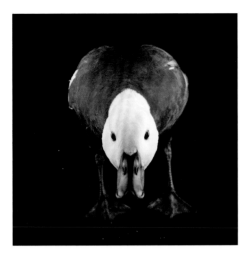
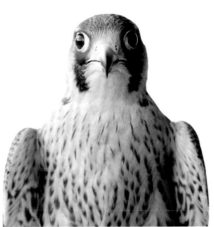

BIRDS OF THE PHOTO ARK

PHOTOGRAPHS / JOEL SARTORE
TEXT / NOAH STRYCKER

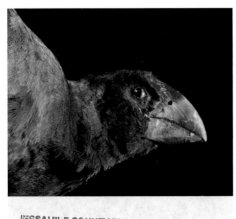

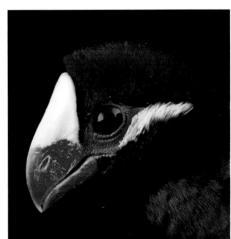

NATIONAL GEOGRAPHIC

WASHINGTON, D.C.

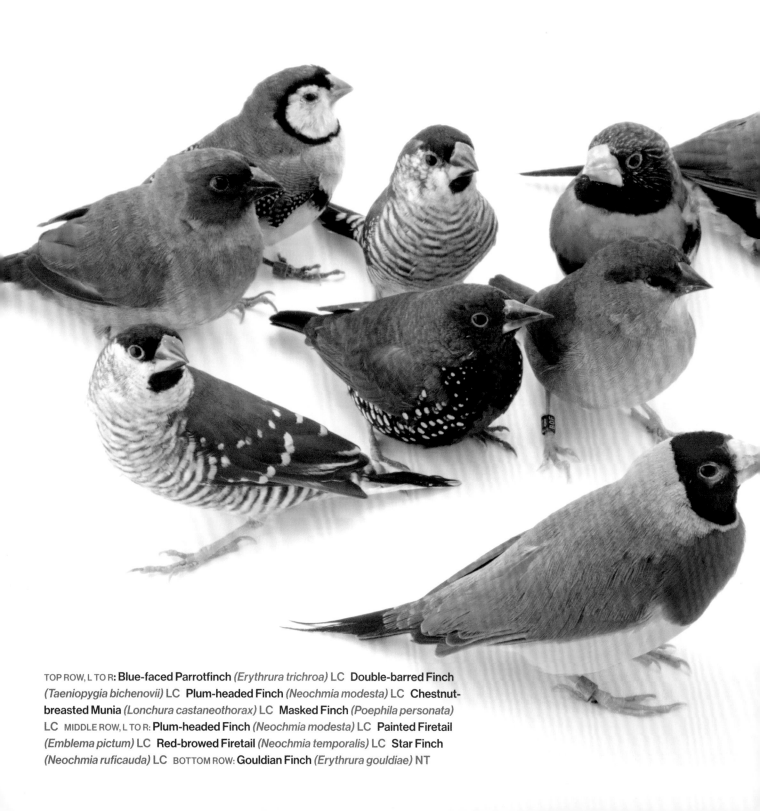

TOP ROW, L TO R: **Blue-faced Parrotfinch** *(Erythrura trichroa)* LC **Double-barred Finch**
(Taeniopygia bichenovii) LC **Plum-headed Finch** *(Neochmia modesta)* LC **Chestnut-
breasted Munia** *(Lonchura castaneothorax)* LC **Masked Finch** *(Poephila personata)*
LC MIDDLE ROW, L TO R: **Plum-headed Finch** *(Neochmia modesta)* LC **Painted Firetail**
(Emblema pictum) LC **Red-browed Firetail** *(Neochmia temporalis)* LC **Star Finch**
(Neochmia ruficauda) LC BOTTOM ROW: **Gouldian Finch** *(Erythrura gouldiae)* NT

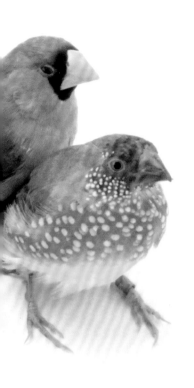

CONTENTS

White-bellied Kingfisher
(Corythornis leucogaster leucogaster) LC

TO AN EXTRAORDINARY TEAM OF
DEDICATED SOULS: REBECCA WRIGHT,
JESSIE GRAY, KERI HESS, KRISTA SMITH,
AND ALANNA JOHNSON.

FROM A SMALL OFFICE ON THE PLAINS
OF NEBRASKA, THEY HAVE
INSPIRED THE WORLD.

—J.S.

FOREWORD / JOEL SARTORE

The birds in this book are some of the most amazing creatures I've ever seen. Photographed on black and white backgrounds, their true colors and body shapes quickly become apparent. All are so complex, and honed to perfection over time. There is not one feather too many on the wing of this honeyeater, or too few on the tail of the pheasant when you turn the page.

And yet after marveling for years at the cassowary, the cockatoo, and the crowned pigeon, it's the birds I see in my own backyard that mean the most to me.

Each March at my Nebraska home on the Central flyway, I stand outside, hoping for a strong south wind to bring them. I've been waiting all winter for this. Downward they plunge, comets of color, splash landing in Nebraska's woodlots, pastures, and suburbs. Our feeders are loaded and ready, fuel for the work to be done; nest building, egg laying, incubation, fledging, offense, defense, and then gone again, all in just a few weeks' time.

Thankfully, some stay all summer. Goldfinches, robins, and Red-headed Woodpeckers. Nuthatches, flickers, and robins. And it's likely those arriving in your favorite forest aren't newcomers. They're the same old friends who arrived last year, and the year before.

Most amazing of all, many have just flown in from another continent.

Ever wonder how they do it?

We haven't got a clue.

Oh sure, we understand that long-lived birds like cranes learn land-marks along their migratory routes from their parents, and that other species find their way using the angle of the sun, or the stars, or Earth's

magnetic field. But that's about it. Though we've studied them for decades, the astounding precision of bird movement across our planet is still fundamentally mysterious and unknown.

Take many warblers, for example. Biologists think they may have a celestial chart in their heads to navigate by—and it must be a double map because the stars are different in spring than in fall. And don't forget that directions for a bird headed to a specific point in Arkansas are different from those for one headed to Nebraska.

Then there's the Cliff Swallow. At the end of the nesting season, at just eight weeks old, it picks up and flies, on tits own, to an exact spot in Argentina, *thousands* of miles away.

Those little rocket ships dashing about our backyards know more than we can possibly fathom.

For the last decade I've been on a mission to photograph all the world's animals under human care—rare and common species cared for in zoos, troubled species supported in wildlife centers, lost species kept going thanks to private collectors. At the time of this writing, I've photographed about 6,500 of the 13,000 species I estimate I'll need to bring aboard the Photo Ark before I'm done with the job. Of those, there are nearly 2,000 birds. Obviously, I'm partial to them.

Birds have played a major role in how I've viewed the natural world since I was a child. Calling melodically from

Blue-faced Honeyeater *(Entomyzon cyanotis)* LC

some high, hidden branch in the forest canopy, then gone again before I ever got a good look, they were a complete mystery to me, and unattainable.

My mother and father taught me to appreciate the birds that swirled around me as I rode my bike and played ball, but it was books like the one in your hands right now that gave me my first real perception of these winged wonders. In glorious full color, and with every name and migration route explained, the pages in my beginner's field guide soon became completely dog-eared.

And then there was the Time Life book called *The Birds* that my mother bought me in the 1960s. Toward the back, in a grainy black-and-white photo, perched Martha, the very last Passenger Pigeon. Once numbering in the billions, her kind had been market-hunted down to this single bird, all alone in a cage at the Cincinnati Zoo.

I returned to that photograph over and over again, and to the pages that followed showing black-and-white drawings of other birds that are now gone: the Heath Hen, the Labrador Duck, the Great Auk, and the Carolina Parakeet. How could humans actually doom birds to extinction on purpose? Even as a child, I couldn't get over it. Still can't.

And so anytime I get a chance to photograph a new species of bird, I'm all in. I want to be its voice, and let the world know the glories of each and every one, so that extinction never happens again.

Shooting for the Photo Ark has been the biggest honor of my life, and a great responsibility. For many bird species, this will be the one and only time they're documented well—their only chance to have their story told to the world. This book only begins to reveal the amazing variety of birds the world contains.

Whether these species survive into the future is really up to all of us, and that all starts with a simple introduction like the Photo Ark, showing these thousands of amazing species to many people who might never see them any other way. We won't save them if we don't know they exist.

So when birds serenade us at sunrise, their ancient calls resonate far beyond attracting mates and defending territories. That's actually the voice of Wilderness you're hearing. They sing from the heart, resilient and determined. And the best part is they'll be around for generations to come . . . but only if given proper stewardship.

How can you become a steward of the birds? Supporting your local nature center is a fine start, but so is speaking out. Make sure others know that you *don't* support putting any chemicals on lawns, but that you *do* want forests, prairies, marshes, and streams kept intact.

Good stewardship takes effort, but it's so worth it. The future of birds, and us, are intertwined more than we know. We soar, or plummet, together. ■

ABOUT IUCN LISTING CODES

The International Union for Conservation of Nature and Natural Resources (IUCN) is a global group dedicated to sustainability. The IUCN Red List of Threatened Species is a comprehensive collection of animals and plants that have been analyzed according to their risk of extinction. Once evaluated, a species is placed into one of several categories. Throughout the book, each species' current IUCN status is listed alongside its name.

EX: Extinct
EW: Extinct in the Wild
CR: Critically Endangered
EN: Endangered

VU: Vulnerable
NT: Near Threatened
LC: Least Concern
NE: Not Evaluated

INTRODUCTION / NOAH STRYCKER

Birds are as universal as air, as widespread as laughter. They live everywhere—from oceans to mountains, deserts to forests, Equator to poles—and unlike people, they don't need passports to travel. Spreading their wings, they can cross borders and defy gravity. No wonder birds have come to symbolize freedom, love, and peace around the world.

Birds appear among the first human expressions of art: Cave paintings in France, India, and Tennessee show a myriad of winged creatures alongside large animals, hunters, and other scenes. Nobody knows exactly what motivated those early illustrators, but their images remind us that the allure of birds is nothing new.

Visual art has played a crucial role in documenting our feathered friends throughout history. A recently discovered rock painting in northern Australia, for instance, seems to depict a giant, flightless species of "thunder bird," three times bigger than an Emu, that is thought to have gone extinct 40,000 years ago. If true, that painting would represent the only existing life portrait of the species, and it would also be the oldest dated artwork in Australia. A simple sketch of a bird manages to immortalize an ancient animal while redefining human history.

Such is the power of image that, for a while, a bird book held the record for the most expensive printed book ever sold: An original copy of John James Audubon's *Birds of America* was auctioned in 2010 for $11.5 million. Audubon himself probably never imagined such riches. Sent to America at age 18 to escape conscription in Napoleon's army, Audubon tried business, went bankrupt, and set out in the 1820s with paints and a shotgun to document the wild birds of the North American frontier. The resulting

folio of 435 life-size portraits, painstakingly illustrated from bird specimens propped up with wire, so charmed Europe's high society that Audubon—the "American Woodsman"—became an international celebrity. His images have endured for nearly 200 years, inspiring generations of bird lovers.

It's significant that the largest bird conservation group in the United States now bears Audubon's name, because Audubon was foremost a painter. He studied birds in other ways, including the first bird-banding experiment in North America, and noted some of the threats facing bird populations later in his career, but he is best known for his portraits.

Birds of America, like early cave paintings, also served a purpose that its artist might not have fully envisioned. Some of the birds in Audubon's folio—the Carolina Parakeet, Passenger Pigeon, Labrador Duck, Great Auk, Eskimo Curlew, and Heath Hen—have gone extinct since he painted them. The artwork celebrates a landscape that no longer exists.

Today, when people think about environmental conservation, they often focus on dollars and cents, politics, laws, and regulations. But that leaves out most of the story: The wonder of birds and nature is for all of us—all we need, as Audubon showed, is a proper introduction.

Few wild animals are as easy to observe as birds. No matter who you are or where you live, birds abound. Like people, birds are mostly audiovisual creatures, as opposed to many mammals, reptiles, amphibians, insects, and marine species that rely on other senses. Birds operate in ways that we can understand and enjoy, and they are accessible to everyone.

Jackass Penguin *(Spheniscus demersus)* EN

We've come a long way since Audubon's day, when millions of birds were killed for food, feathers, and sport. An outcry over waterbird hunting led to the first federal laws protecting wildlife in the early 1900s, along with the creation of the U.S. National Wildlife Refuge System and the U.K. Royal Society for the Protection of Birds. The book *Silent Spring*, about the impact of pesticides on birds and other wildlife, fostered a sweeping movement in the 1960s and the establishment of the U.S. Environmental Protection Agency in 1970. Birds have ignited global discussions about endangered species, biodiversity, and climate change in recent decades.

All it takes is a little magic—that initial spark when someone looks at a bird and becomes mesmerized. The tiniest flame of inspiration can change the world.

Bird-watchers may be a raffish crowd of academics, hunters, gamblers, poets, athletes, and seekers, but above all they are collectors—of sightings, of knowledge, of experience.

That's how I got started, anyway. When I was little, I collected stamps, coins, rocks, business cards, and Zane Grey paperbacks. Then my fifth-grade teacher suction-cupped a plastic bird feeder to our classroom window, and I started collecting bird sightings, too.

Something about birds appeals to an obsessive vein of human nature. Birds sort themselves neatly into species (most of the time), each with its distinctive habits and appearance. One of the first lessons any birder learns is that finding birds is often a matter of visiting the right locations. Birding becomes a treasure hunt, using clues to track down an elusive quarry.

Those who study birds have devised different

House Finch (*Haemorhous mexicanus*) LC

methods of cataloging them, from Carl Linnaeus' binomial nomenclature—the Latin classification system now used to describe all living things—to today's smorgasbord of field guides depicting virtually every species on Earth. Each attempts to quantify the bird world, breaking it down into manageable snippets. Nature is so overwhelming that we tend to approach it in fragments, ordering and assembling the pieces into meaningful stories.

My childhood obsession eventually grew into a career as a full-time bird nerd. I worked on field research projects for years, living for months at a time on windswept islands and in sweltering rain forests. But I never lost the thrill of spotting a new bird species, and gradually began to realize that there were just too many birds and too little time. So, in 2015, at 28 years old, I decided to create my own kind of catalog by tackling a worldwide Big Year: To record as many bird species as possible during one Earth orbit around the sun.

The logistics of this enterprise were formidable. Taking no days off, I visited 41 countries on all seven continents. On a shoestring budget, I slept on couches, on planes, and in jungles, when I could sleep at all. To maximize daylight, I got up each morning before dawn and traveled at night. In the end, with the help of hundreds of enthusiastic bird lovers around the world, I recorded 6,042 bird species—averaging a new species every waking hour, more than half of all birds on the planet—for a new world record.

After returning home, I discovered that my outlook had changed. Numbers and records mattered less than the adventure, which mirrored Audubon's quest to document America's birds in the early 1800s. By exhaustively pursuing birds, I had traversed more of the planet than most people do in a lifetime; and by compressing that

journey into one year, I gained a unique perspective of the state of birdlife in the modern world.

It's easy to get depressed about environmental issues, especially when traveling through the tropics where slash-and-burn agriculture, palm oil plantations, and wholesale logging are rapidly swallowing forests. During my Big Year, I saw firsthand how the human population explosion, especially in Africa and Asia, is churning through habitats. I also experienced how climate change affects the global environment: Local people told me over and over how the conditions in their regions had suddenly become unpredictable in recent years, disrupting human and bird populations alike.

But I also found an unexpectedly vibrant community of bird enthusiasts in places like China, Borneo, Kenya, Brazil, and Guatemala— where birding has not traditionally been a hot pursuit. Just in the past decade, thanks to the Internet, digital photography, and other technology, birds have inspired a new generation to head outdoors. People in far-flung places are finding new ways to enjoy and protect their feathered friends while connecting with like-minded souls. What was once a niche pursuit has quietly fledged into an international pastime.

Oddly enough, the digital age seems to have spurred a return to nature. Whether it's a backlash against screen time or a movement enabled by new technology, many people are now discovering birds on their own terms. Poignantly, just as birds themselves have never faced a more uncertain future, never have more people cared about them. I came away from my Big Year with an optimistic view: Beyond the grim news, I found a lot of people who care deeply about our natural world.

With those thoughts in mind, fresh after my long journey, the book you are holding began to take shape.

The genius of Joel Sartore's photographs of captive birds around the world lies in their intimacy. In the wild, birds are flighty subjects—"the great film wasters," as a friend once told me. We hardly ever have the chance to get near them.

Close up, birds reveal a host of traits we usually reserve for ourselves. They show expressions, moods, and personalities. Some are shy, others are curious, and a few just look hungry. An African Penguin seems to ask politely if you have any fish, while a House Finch and a Greater Yellowlegs strike jaunty poses.

Some of these interpretations are anthropomorphic, transferring our thoughts onto animals that can't possibly know that their photographs will be published. But birds definitely display feelings, perhaps similar to people's, and to suggest otherwise assumes that animals can't just because we can. Don't be afraid to read emotion into the birds presented here.

As you turn the pages, let Joel's images inspire your sense of wonder. Some of these birds are rare and seldom seen in the wild, and a few critically endangered species—like the Socorro Dove—survive only in captivity. Their portraits commemorate a tenuous existence. Most, however, can be found in their natural habitats, spread around every corner of the globe. It's reassuring to know that these creatures are real and still share our world.

I admire Joel's ambitious project to document every species of animal in captivity. He is a modern-day Audubon, bringing us face-to-face with the precious wonders of nature.

Take a closer look at birds. In *Birds of the Photo Ark,* they are inches away, gazing right back. ∎

Greater Yellowlegs *(Tringa melanoleuca)* LC

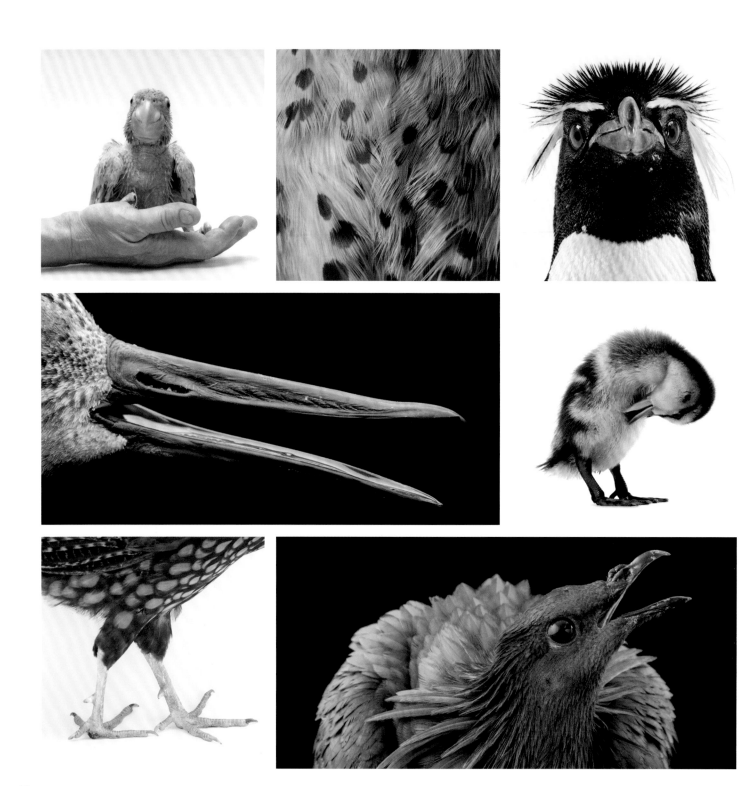

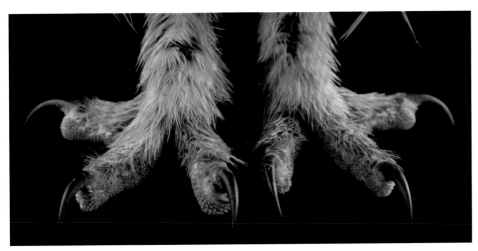

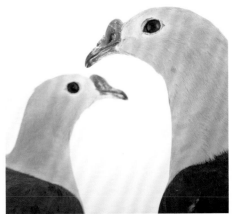

1 / WHAT'S IN A BIRD?

EVOLUTION / IDENTITY / DIVERSITY

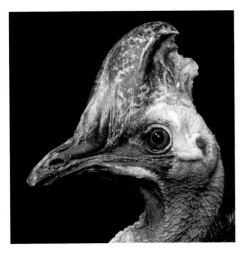

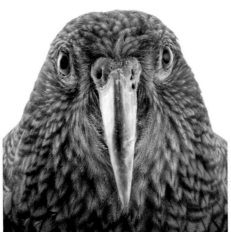

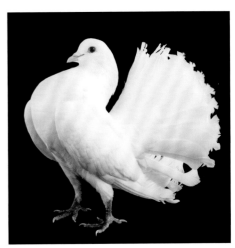

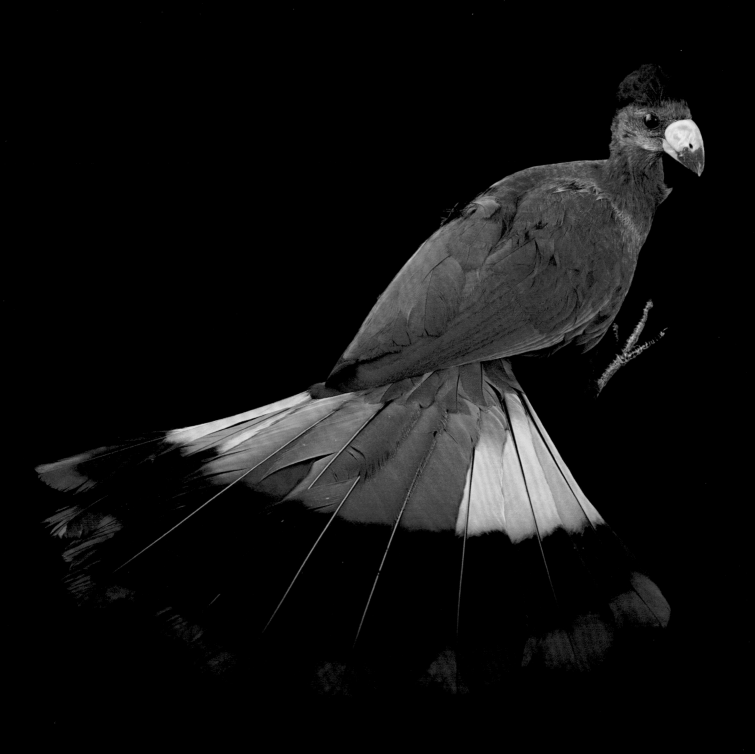

BUILDING THE PERFECT BIRD

Endowed with gorgeous colors, beautiful songs, the gift of flight, and the physical stamina to migrate thousands of miles, birds are nature's showstoppers. Though the thought that humans have much in common with birds stretches the imagination, about 60 percent of all birds' DNA overlaps with our own. As humans, we share so much of the avian genome that studying birds can literally help us learn about ourselves, from immunity from disease to cellular mechanics.

The 40 percent of the genome that we don't share accounts for all our dazzling differences. Many birds have adapted to be light and fast, highly specialized for flight and agility. Millions of years of evolution have given them some brilliant advantages, like an ultralight skeleton that, in many species, weighs less than their feathers. A bird's lungs are vastly more efficient than ours, and the digestive system is streamlined to the point of totally eliminating a bladder. Birds have sharp vision, good hearing, and quick reflexes for life on the wing. By comparison, we are downright sluggish.

The study of birds begins with their physical features—their development, characteristics, and diversity. To really understand our feathered friends, it helps to go from the inside out.

Great Blue Turaco *(Corythaeola cristata)* LC

The spectacular Great Blue Turaco, native to west-central Africa,
is nearly three feet long yet weighs just two pounds.

Rio Grande Wild Turkey *(Meleagris gallopavo intermedia)* LC

Like most birds, turkeys have superefficient digestion.
A meal may pass entirely through this bird's body in less
than four hours.

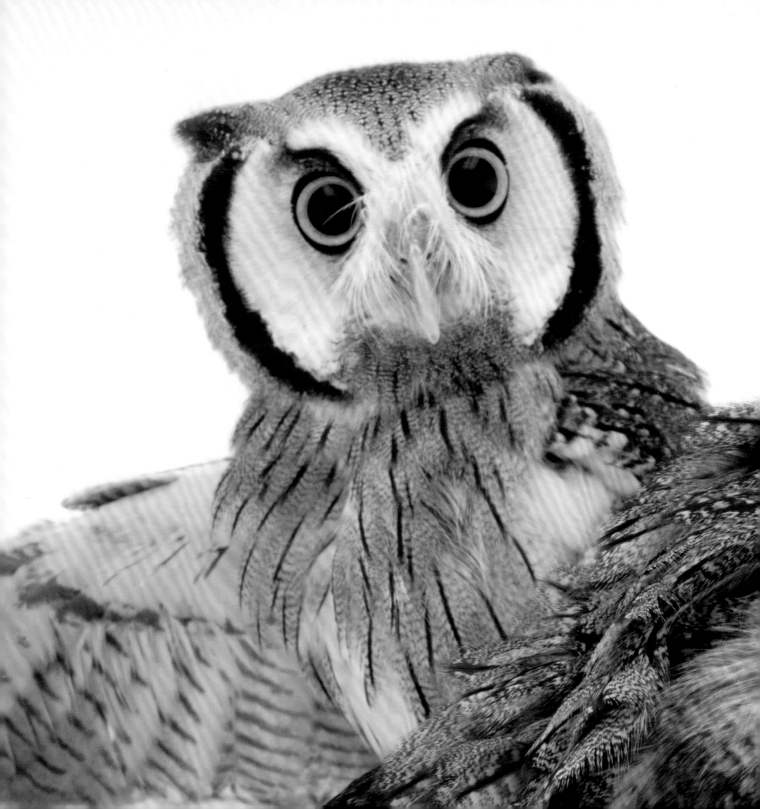

A concave facial disc acts like a parabolic dish for pinpoint hearing for this owl, native to central Africa.

LIVING DINOSAURS

About 66 million years ago, around the time a large asteroid collided with Earth, all dinosaurs went extinct—except one lineage, which had feathers and wings. Today we call them birds, and they are the last surviving dinosaurs.

Birds descended from theropods, a diverse group that once included *Tyrannosaurus rex* and *Velociraptor.* A 150-million-year-old fossil discovered in Germany shows that *Archaeopteryx,* a transitional genus in between the ancient dinosaurs and modern birds, was about the size of a raven with claws, teeth, a bony tail, and flight feathers. Recently, a piece of amber from Myanmar was found with a 99-million-year-old feathered dinosaur tail preserved inside.

The most primitive living bird may be the Common Ostrich, followed by a few other mostly flightless species: rheas, tinamous, kiwis, Emus, and cassowaries. Big, sturdy, and iconic, these creatures are truly modern-day dinosaurs.

Southern Cassowary *(Casuarius casuarius)* VU

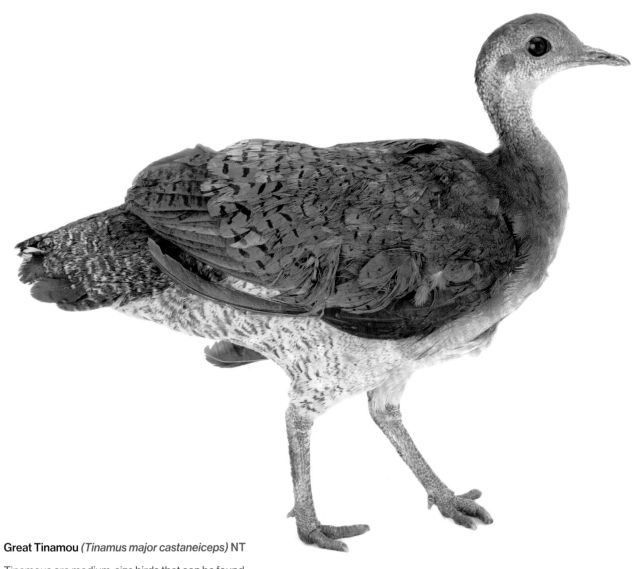

Great Tinamou *(Tinamus major castaneiceps)* NT

Tinamous are medium-size birds that can be found across the South American continent. They are among the most primitive living birds still roaming Earth today.

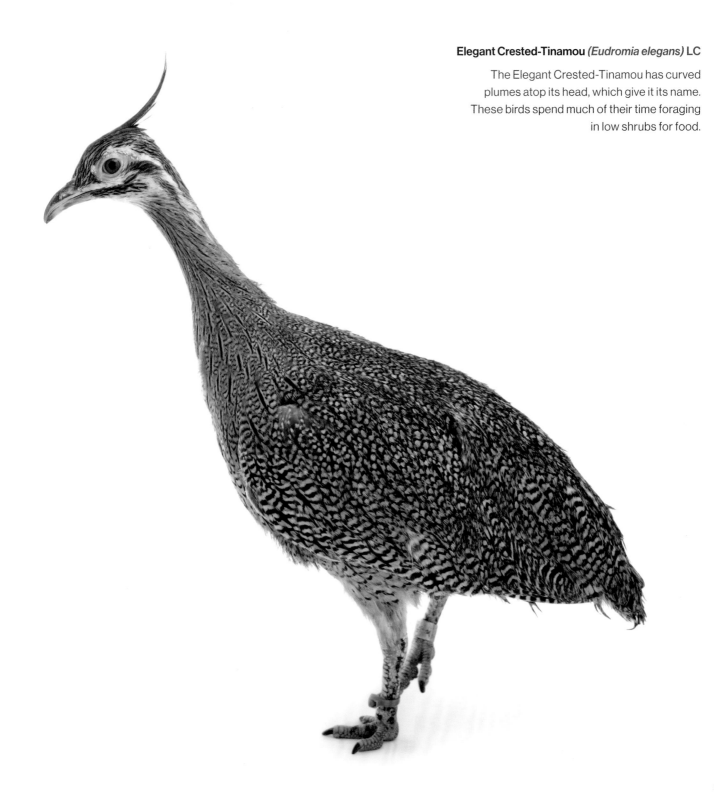

Elegant Crested-Tinamou *(Eudromia elegans)* LC

The Elegant Crested-Tinamou has curved plumes atop its head, which give it its name. These birds spend much of their time foraging in low shrubs for food.

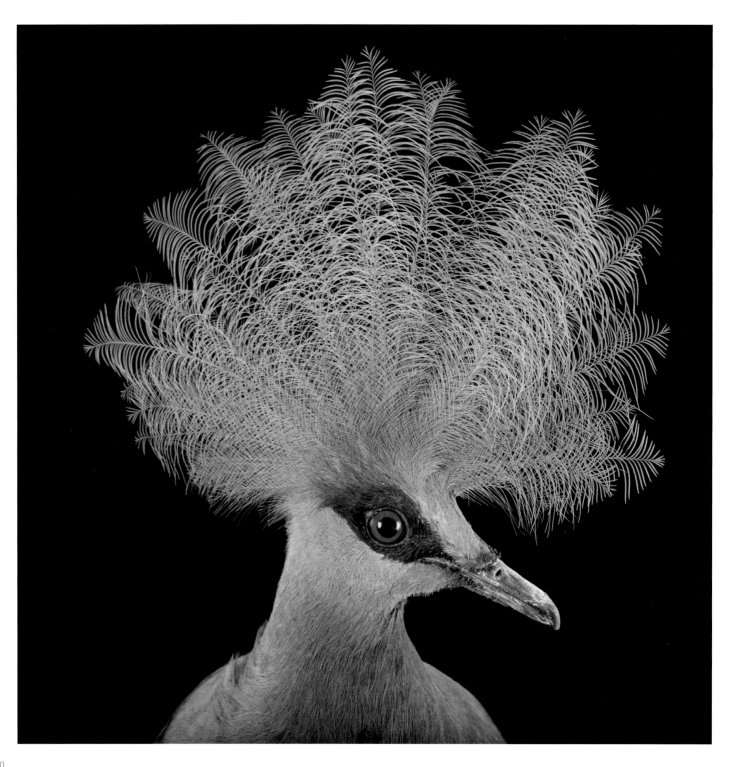

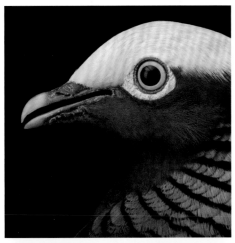

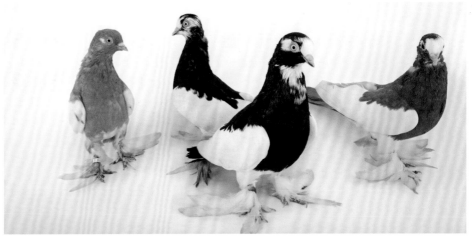

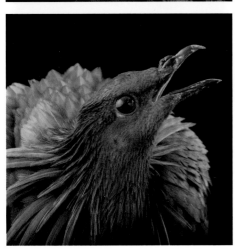

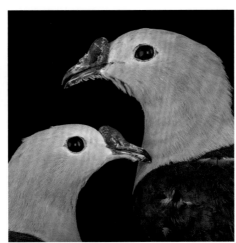

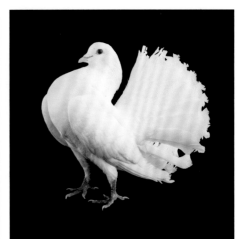

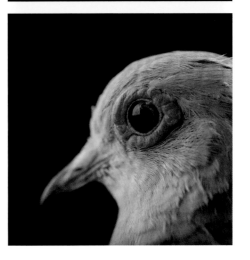

TO BE A PIGEON

Pigeons and doves are very prosperous, representing 351 species worldwide. They're more diverse than the average city pigeon — some are quite beautiful with bright colors, head plumes, and knobbed beaks.

OPPOSITE: **Western Crowned-Pigeon** *(Goura cristata)* VU THIS PAGE, CLOCKWISE FROM TOP LEFT: **White-crowned Pigeon** *(Patagioenas leucocephala)* NT **Tumbler Pigeon** *(Columba livia)* (domestic) LC **Fantail Pigeon** *(Columba livia)* (domestic) LC **Diamond Dove** *(Geopelia cuneata)* LC **Red-knobbed Imperial-Pigeon** *(Ducula rubricera)* NT **Nicobar Pigeon** *(Caloenas nicobarica)* NT

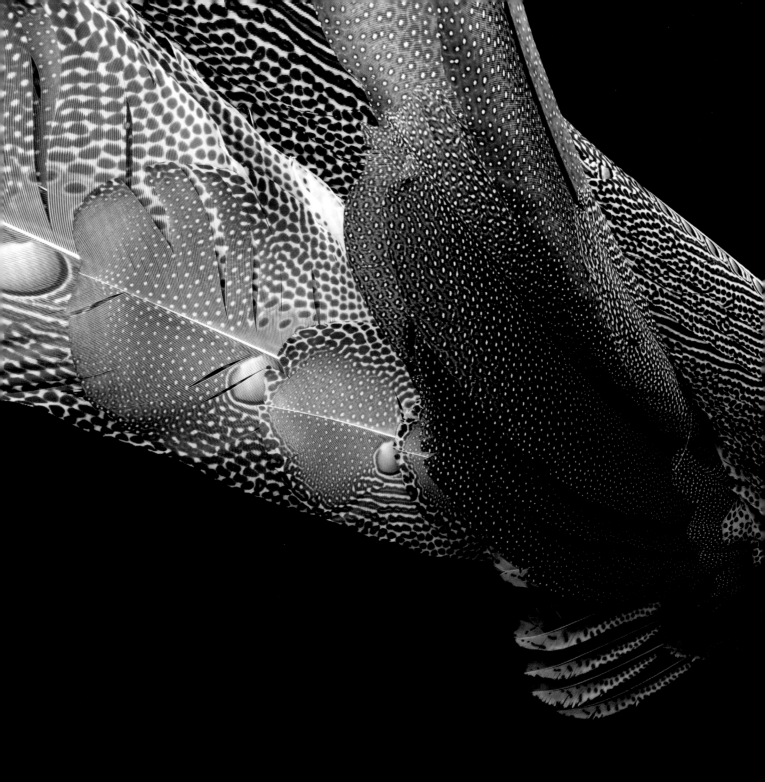

WHAT MAKES A BIRD?

A set of shared physical traits brings birds of all kinds together into a league of their own. They belong to a biological class called Aves, which is nested under the phylum Chordata alongside other animals with skeletons.

Feathers are the most obvious trait separating birds from all other living species. Every bird also has a toothless beak, a wishbone, a keeled breastbone, a four-chambered heart, two legs with scaly feet, and forelimbs modified into wings. Birds have warm blood and a high metabolic rate. And they lay hard-shelled eggs.

Inside the egg, bird embryos look curiously similar to a mammal or even a fish in the earliest stages. After developing essential organs, the embryo begins to resemble what we might recognize as a bird, and by the time it hatches—even if, as in some species, it's essentially naked—the young chick is unmistakably avian. A bird enters the world already distinct from all other forms of life.

Great Argus (*Argusianus argus argus*) NT

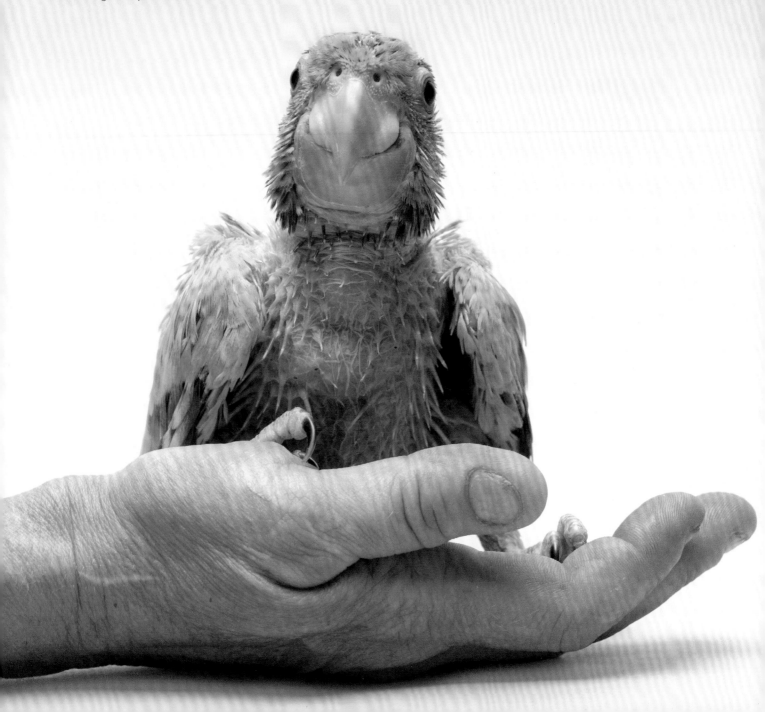

Golden Parakeet *(Guaruba guarouba)* VU

As a nestling Golden Parakeet develops,
its feathers grow in pin-like sheaths.

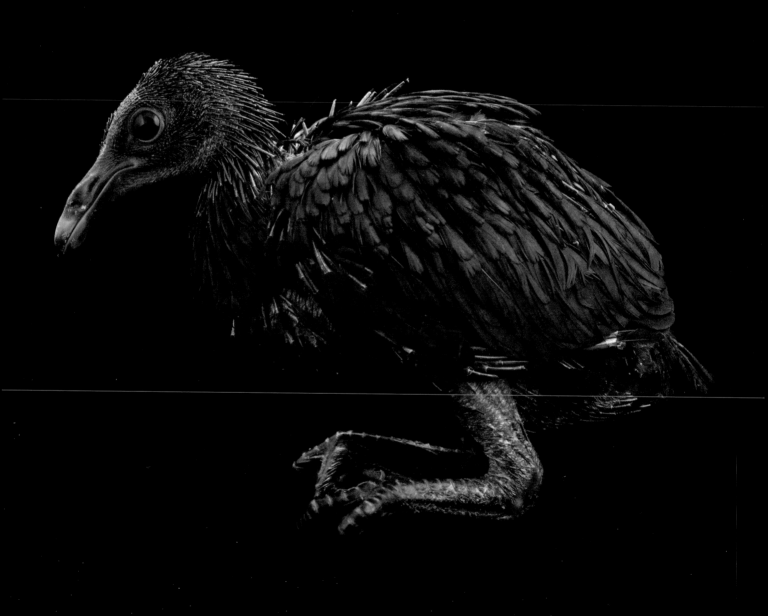

Nicobar Pigeon *(Caloenas nicobarica)* **NT**

During the beginning of their lives, many birds,
like this young Nicobar Pigeon, look
decidedly prehistoric.

Golden Pheasant *(Chrysolophus pictus)* LC

The mature plumage of a male Golden
Pheasant is distinctive—red and yellow
with iridescent accents.

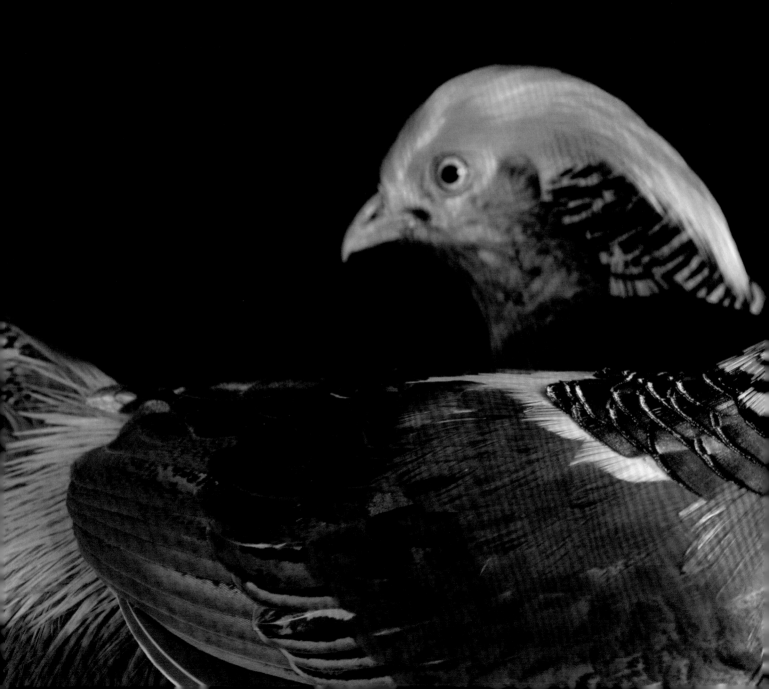

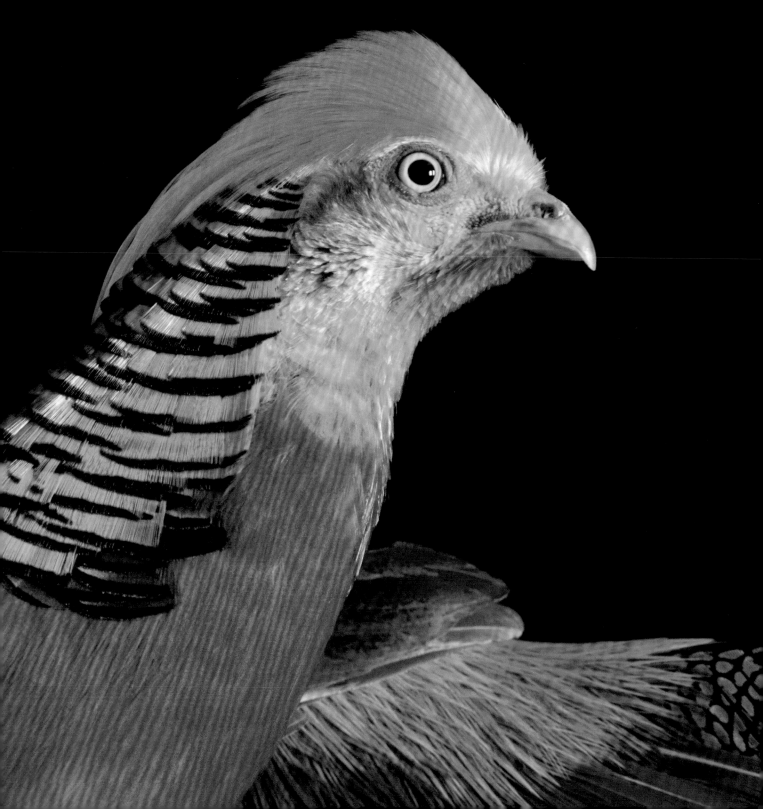

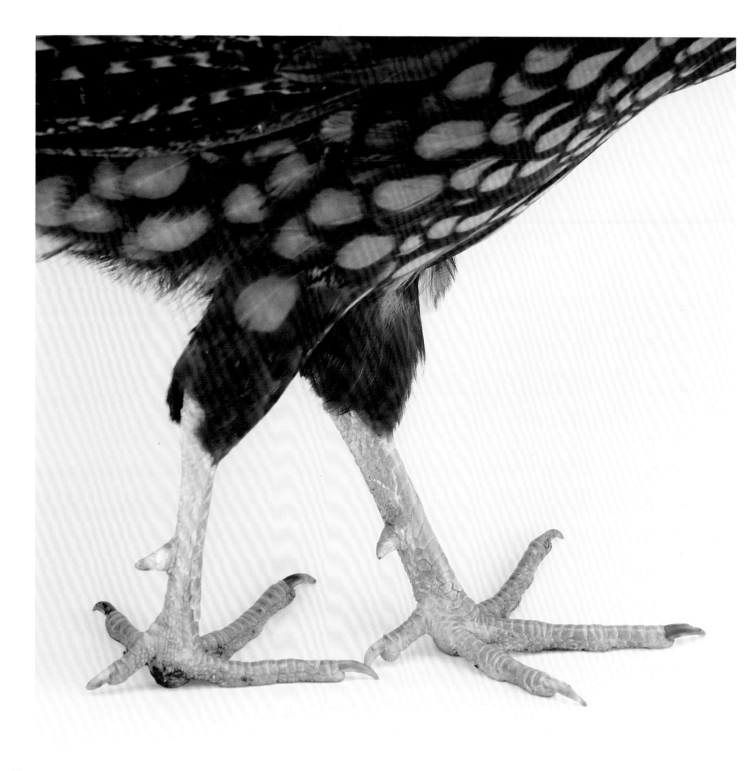

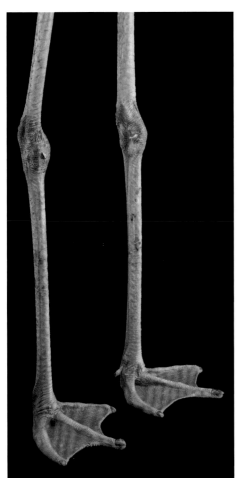

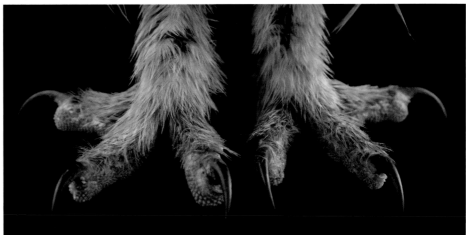

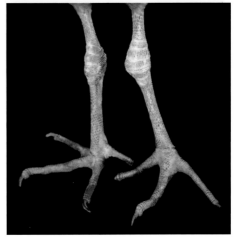

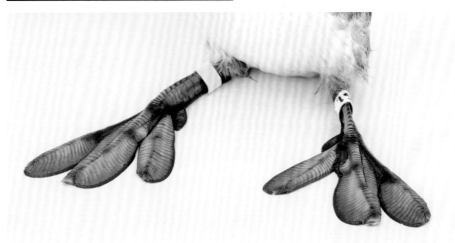

ON YOUR FEET

Birds technically walk on their toes, with the ankle joint located roughly where a human's knee would be. Avian feet come in all shapes and sizes.

OPPOSITE: **Temminck's Tragopan** (*Tragopan temminckii*) LC THIS PAGE, CLOCKWISE FROM TOP LEFT: **Chilean Flamingo** (*Phoenicopterus chilensis*) NT **Striped Owl** (*Asio clamator*) LC **Southern Screamer** (*Chauna torquata*) LC **Black-necked Grebe** (*Podiceps nigricollis*) LC **American Chicken** (*Gallus gallus*) NE

DIVERSITY AND ABUNDANCE

At last count, about 10,500 species of birds inhabited Earth—more than mammals, reptiles, or amphibians. And they're found in nearly every corner of the planet, from the tropics to the icy cold of the poles.

Birds are organized into 36 orders, and then further divided into 242 families. The richest families are the tyrant flycatchers (450 species), tanagers (409), and hummingbirds (369). There are 34 families that have only a single species, some of which are fairly bizarre: the Shoebill, with a murderous beak; the Secretarybird of Africa, with an eagle-like body atop crane-like legs that can stomp on venomous snakes; and the peculiar Oilbird of South America, which lives in caves and navigates by echolocation like a bat.

Some 200 to 400 billion individual birds live on the planet. Perhaps the most numerous wild species is the small Red-billed Quelea of Africa, which numbers in the low billions. These numbers, though impressive, only begin to convey the great, glorious diversity of the bird world.

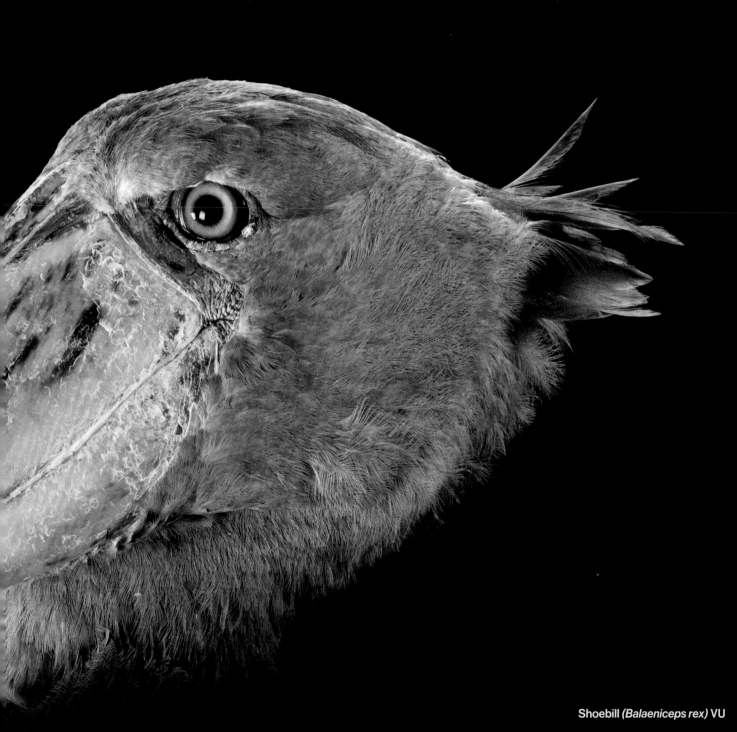

Shoebill *(Balaeniceps rex)* VU

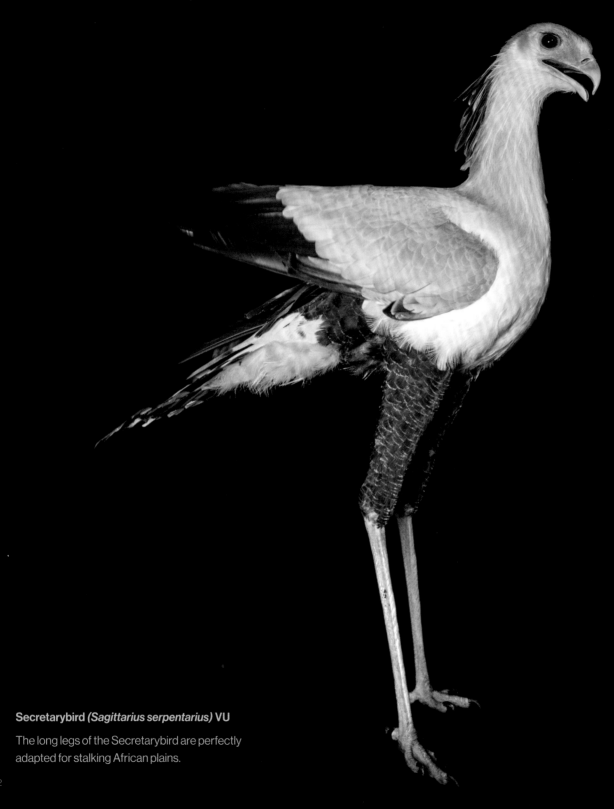

Secretarybird *(Sagittarius serpentarius)* **VU**

The long legs of the Secretarybird are perfectly
adapted for stalking African plains.

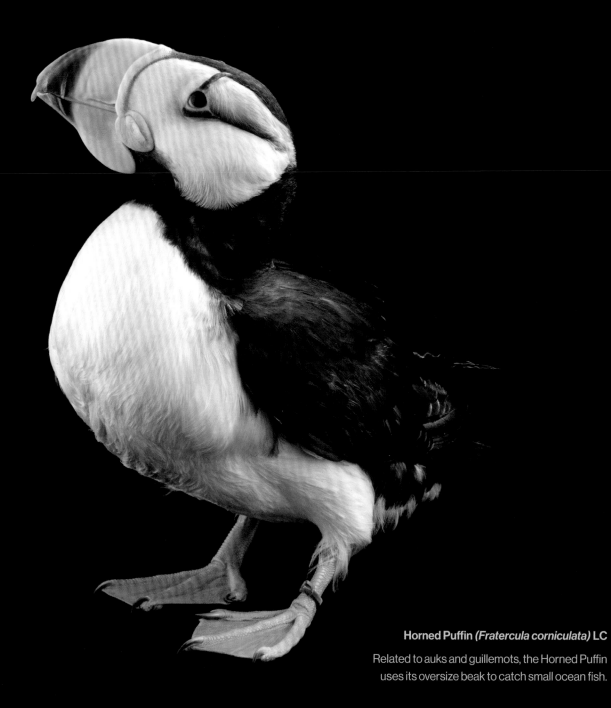

Horned Puffin (*Fratercula corniculata*) LC

Related to auks and guillemots, the Horned Puffin
uses its oversize beak to catch small ocean fish.

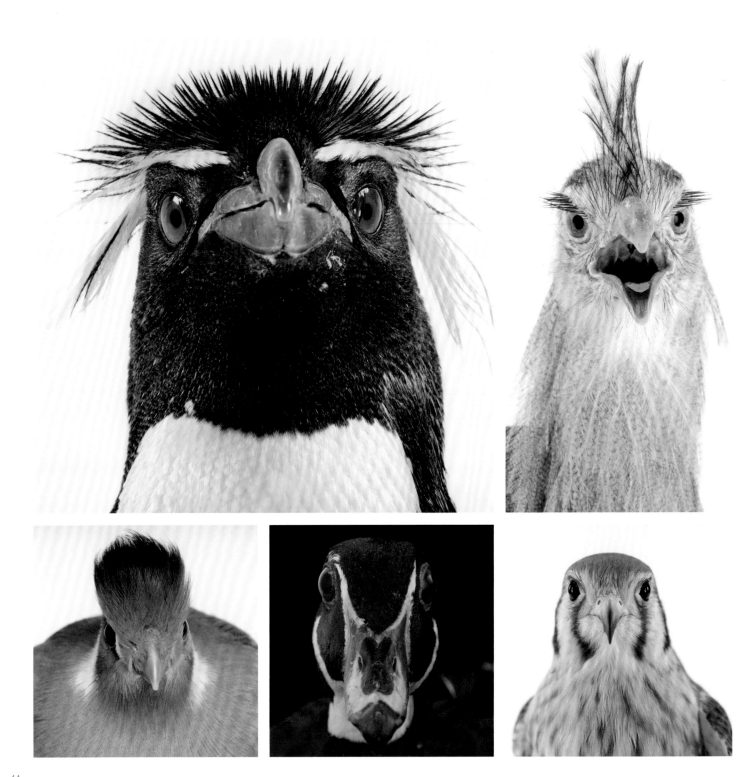

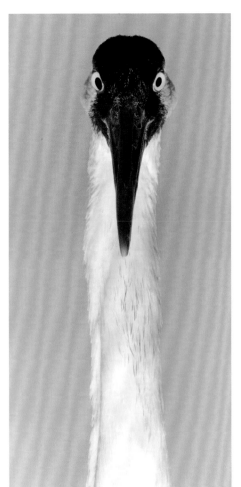

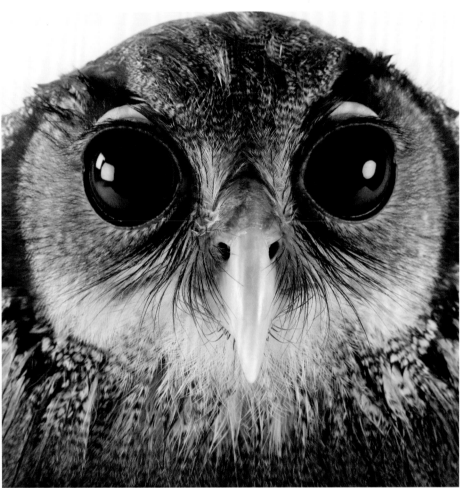

FACE TO FACE

With their eyes on the sides of their heads, many birds have excellent eyesight. Some species, like the Wood Duck, can see nearly 360 degrees. Owls' eyes face forward, offering them a better range of binocular vision and depth perception, but they must turn their heads to see behind them.

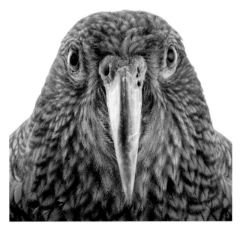

OPPOSITE, CLOCKWISE FROM TOP LEFT: **Southern Rockhopper Penguin** *(Eudyptes chrysocome)* VU **Red-legged Seriema** *(Cariama cristata)* LC **American Kestrel** *(Falco sparverius)* LC **Wood Duck** *(Aix sponsa)* LC **White-cheeked Turaco** *(Tauraco leucotis leucotis)* LC THIS PAGE, CLOCKWISE FROM TOP LEFT: **Whooping Crane** *(Grus americana)* EN **Verreaux's Eagle-Owl** *(Bubo lacteus)* LC **Kea** *(Nestor notabilis)* VU

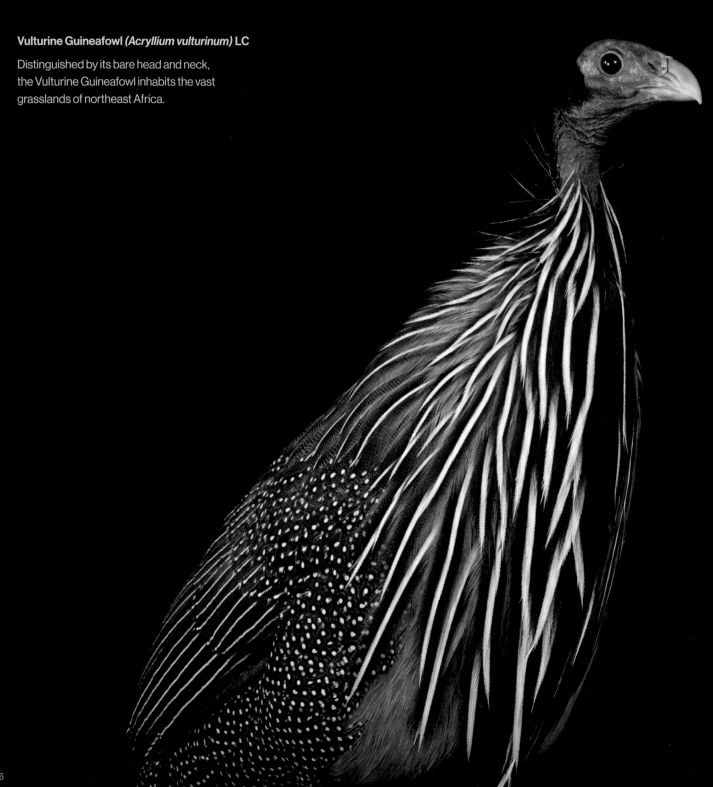

Vulturine Guineafowl *(Acryllium vulturinum)* LC

Distinguished by its bare head and neck,
the Vulturine Guineafowl inhabits the vast
grasslands of northeast Africa.

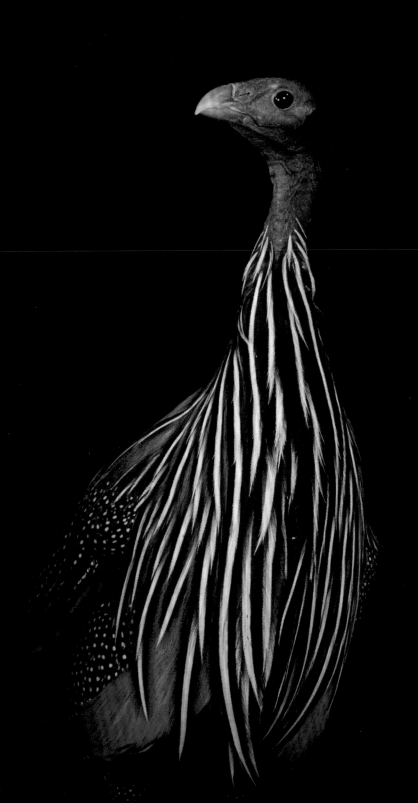

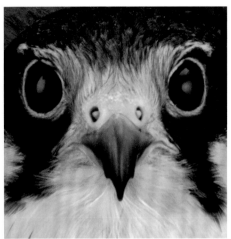

2 / FIRST IMPRESSIONS

SPEED / SIZE / SHAPE / COLOR

56 62 68 76

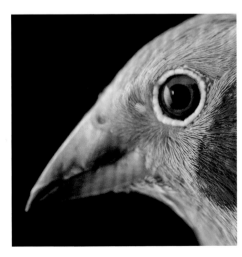
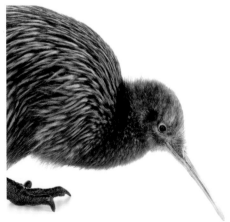
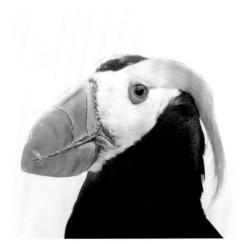

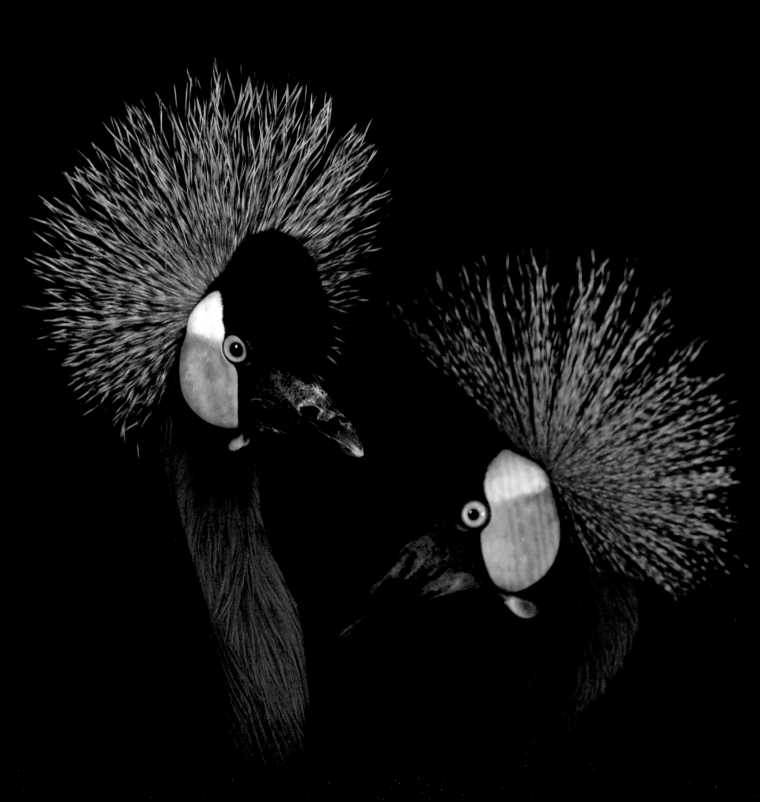

SEEING BIRDS

Because most birds don't sit still for long, our first glimpse of a bird is often fleeting, a quick rustle of feathers amid swirls of color. Watching birds is a subtle art, like painting in your imagination.

Early ornithologists and scientific illustrators used wire to prop up bird specimens, but modern optics—cameras and binoculars—make it easier to observe wild birds in their natural surroundings. In the field, birders quickly distinguish birds by their "general impression, size, and shape," or GISS. This process apparently relies on known principles of cognitive object recognition, but nevertheless identifying a bird by its field marks can seem like mental alchemy.

When we look at birds, that first glance holds a lot of information: speed, size, shape, and color. Some species can be recognized by these characteristics alone, in a split second.

Black Crowned-Crane *(Balearica pavonina)* **VU**

With its pink cheeks and stiff, golden crown feathers,
the Black Crowned-Crane of sub-Saharan Africa is hard to miss.

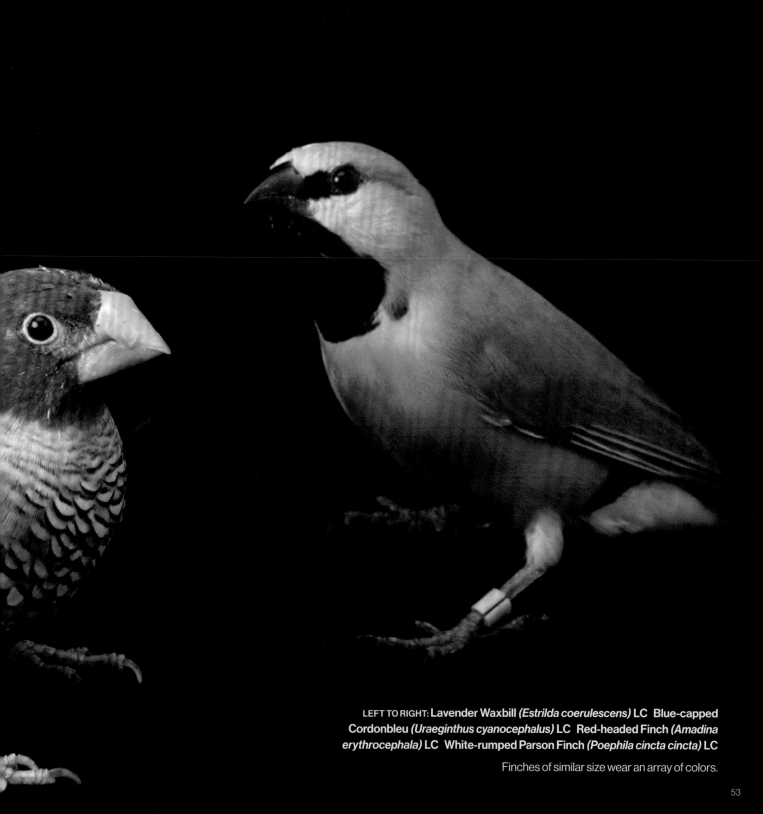

LEFT TO RIGHT: **Lavender Waxbill** *(Estrilda coerulescens)* **LC Blue-capped Cordonbleu** *(Uraeginthus cyanocephalus)* **LC Red-headed Finch** *(Amadina erythrocephala)* **LC White-rumped Parson Finch** *(Poephila cincta cincta)* **LC**

Finches of similar size wear an array of colors.

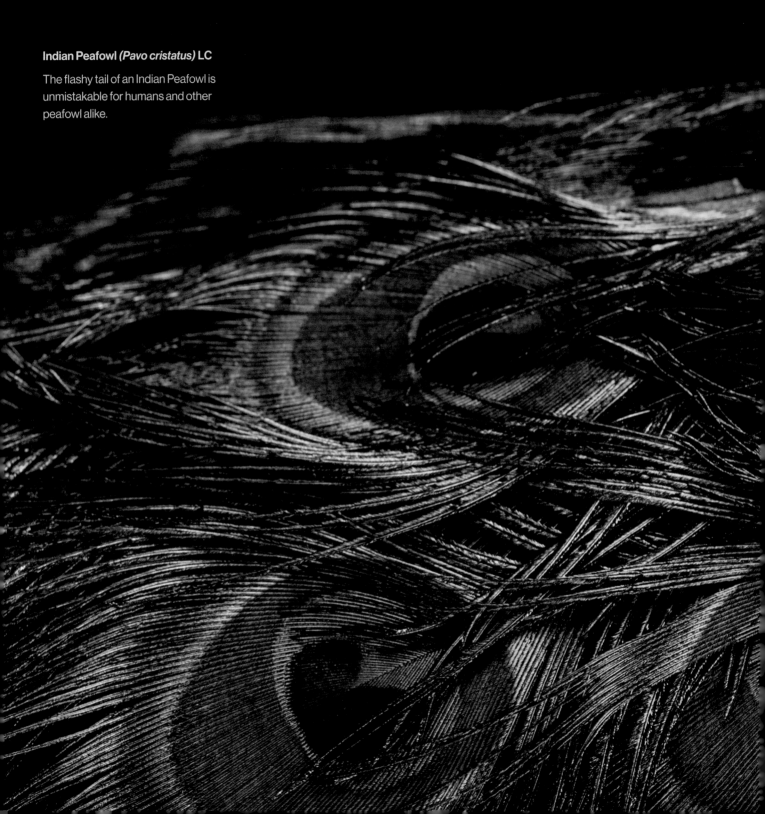

Indian Peafowl *(Pavo cristatus)* **LC**

The flashy tail of an Indian Peafowl is unmistakable for humans and other peafowl alike.

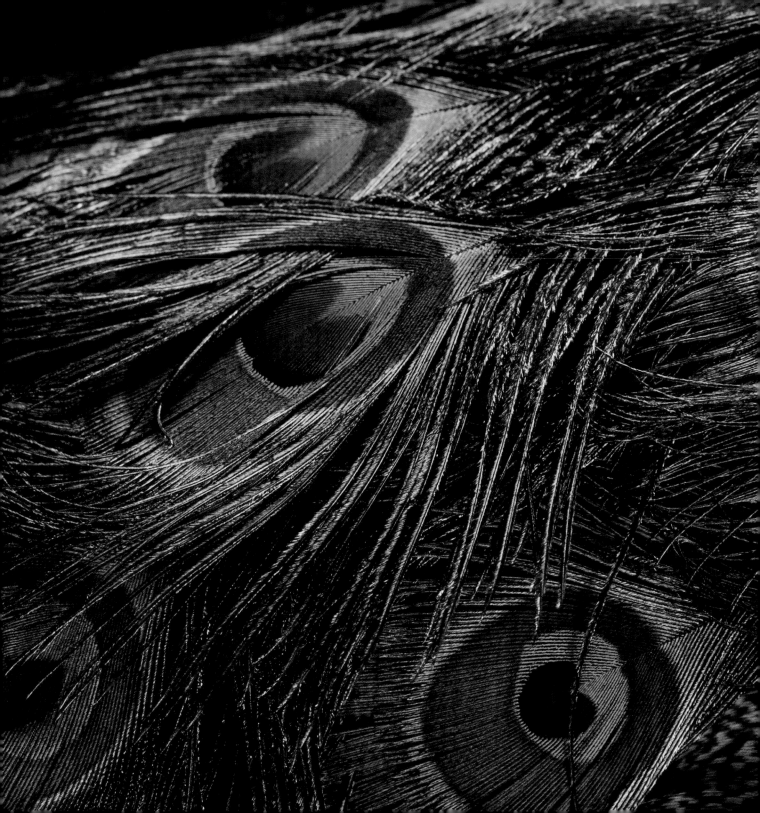

UP TO SPEED

With a flap of their wings, and sometimes a little help from nature, some birds can reach dizzying speeds. From the sheer power in a raptor's flight to the delicate but impressive clip of smaller species, some birds know how to move.

Recently, a Gray-headed Albatross sustained an average speed of 78.9 miles an hour for nine straight hours on the leading edge of an Antarctic windstorm. The aptly named Common Swift, a cigar-size bird with slender wings, has been documented flying 69.3 miles an hour under its own power, the fastest speed achieved without the help of gravity or wind. Falcons are widely hailed as the world's fastest birds. Setting a record for the animal kingdom, the Peregrine Falcon has been clocked at 242 miles an hour during diving flight, and the Gyrfalcon, a predator of the far north, can fly more than 100 miles an hour while hunting.

On the flip side, the slowest bird in the air may be the American Woodcock, which can fly five miles an hour without stalling. On the ground, penguins waddle along at a little less than two miles an hour; their sturdy feet have been known to carry them many miles without rest.

Gyrfalcon *(Falco rusticolus)* **LC**

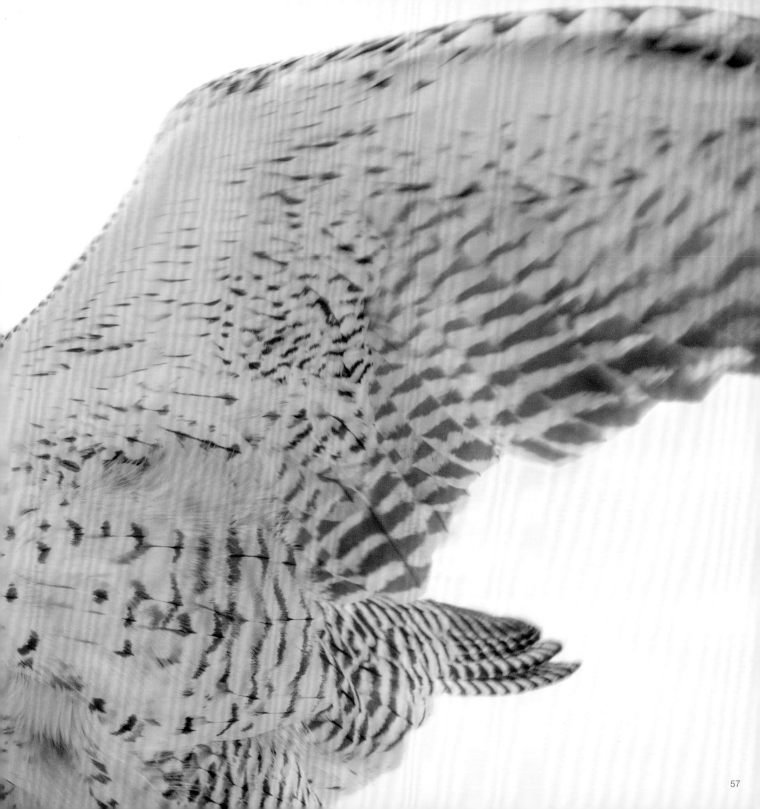

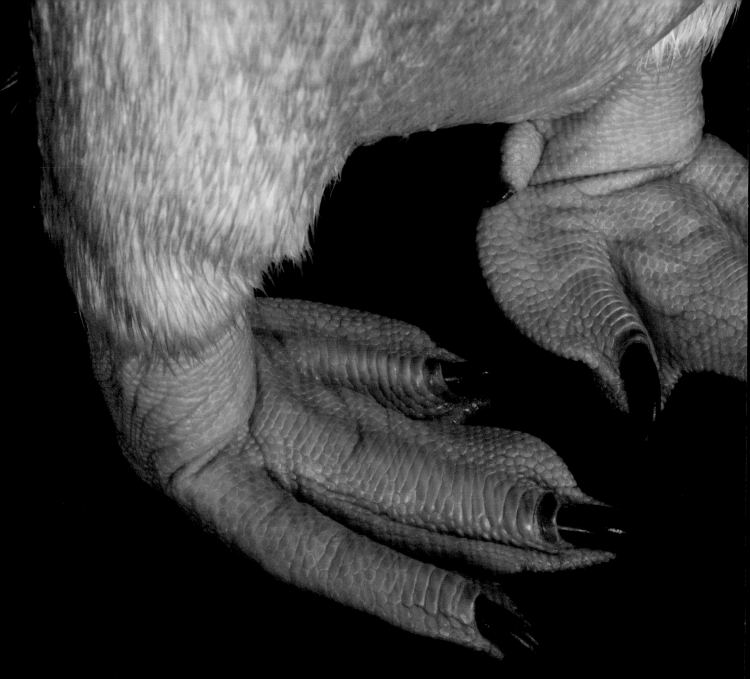

Gentoo Penguin *(Pygoscelis papua)* **LC**

Penguins have padded and sticky feet to avoid slipping on ice. Gentoo Penguins, despite their short legs, may waddle for miles without expending much energy.

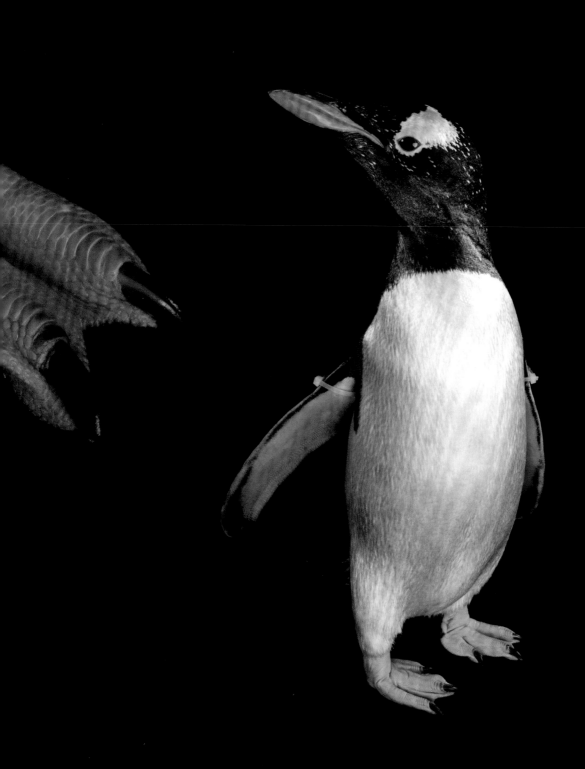

Eurasian Hobby *(Falco subbuteo)* LC

The wings of a Eurasian Hobby are sharp and triangular for maximum maneuverability in the air.

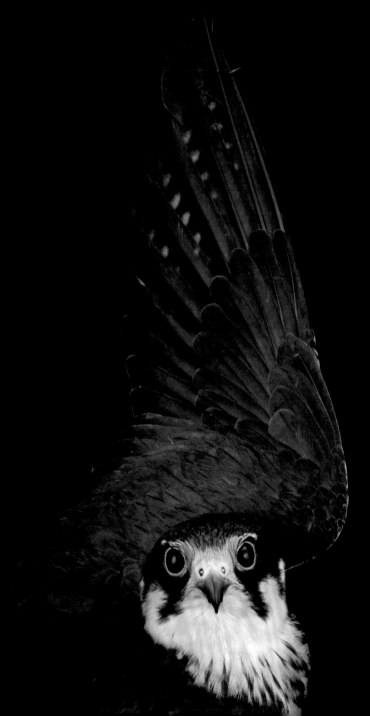

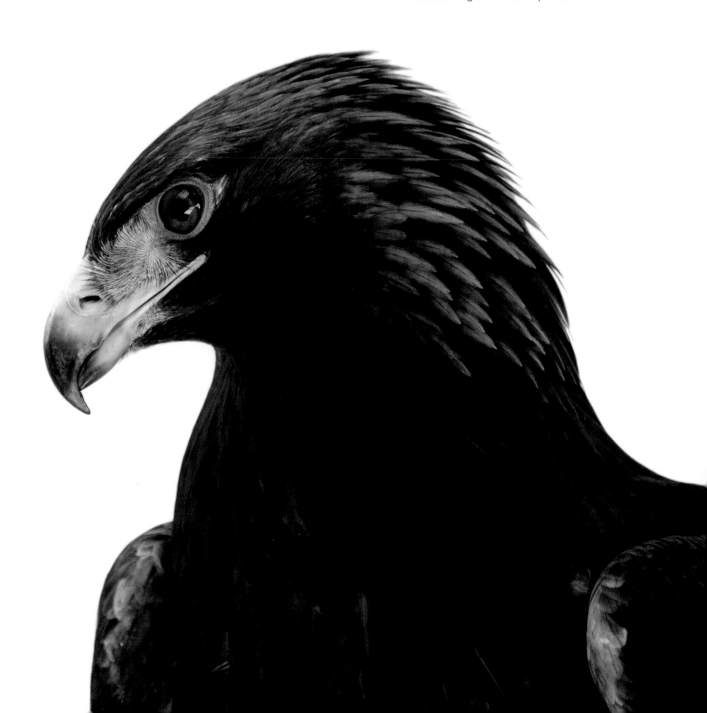

Golden Eagle *(Aquila chrysaetos)* LC

When diving on its prey from great heights, the
Golden Eagle can reach speeds of 150 miles an hour.

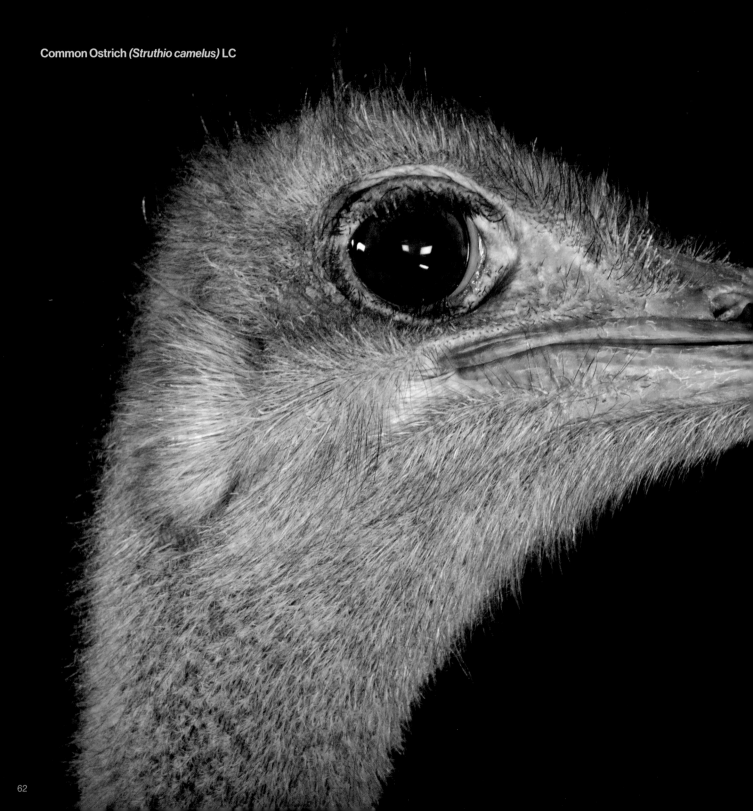

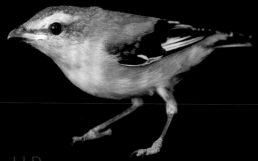

SIZING UP

Taller and heavier than any other living bird, the Common Ostrich stands nearly nine feet high and weighs a hefty 300 pounds. Ostriches also lay the largest eggs (3.1 pounds), have the largest eyes (the size of billiard balls, each one bigger than the bird's own brain), and have the longest stride (up to 15 feet while sprinting).

But even an ostrich's impressive measurements couldn't compare to the long-extinct elephant bird of Madagascar, which weighed up to 1,100 pounds and disappeared sometime within the past millennium.

At the opposite end of the scale, the tiny Bee Hummingbird, endemic to Cuba, weighs a mere two grams—the same as a U.S. dime—and lays eggs the size of coffee beans. Many birds are lighter than they look. Even a chickadee, at half an ounce, could be mailed with a single first-class U.S. postage stamp.

Striated Pardalote (*Pardalotus striatus*) LC

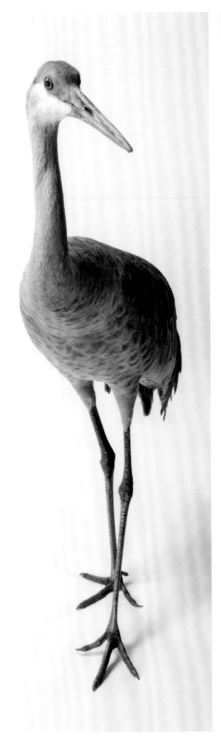

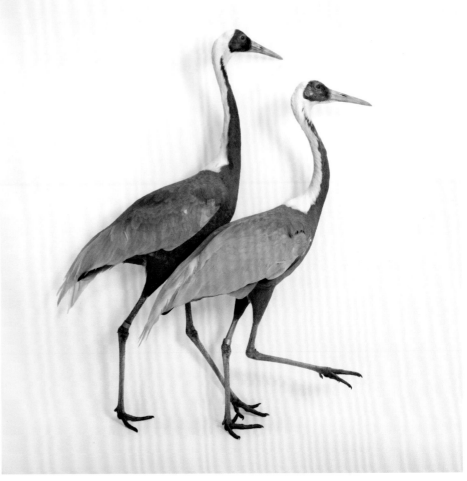

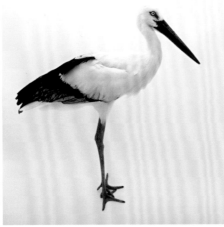

TALL TALES

Long legs help these wading birds while they wander around in shallow water, but most have correspondingly long necks, so they can reach into the water to eat.

OPPOSITE: **Yellow-billed Stork** *(Mycteria ibis)* LC THIS PAGE, CLOCKWISE FROM FAR LEFT: **Sandhill Crane** *(Antigone canadensis)* LC **White-naped Crane** *(Antigone vipio)* VU **Oriental Stork** *(Ciconia boyciana)* EN

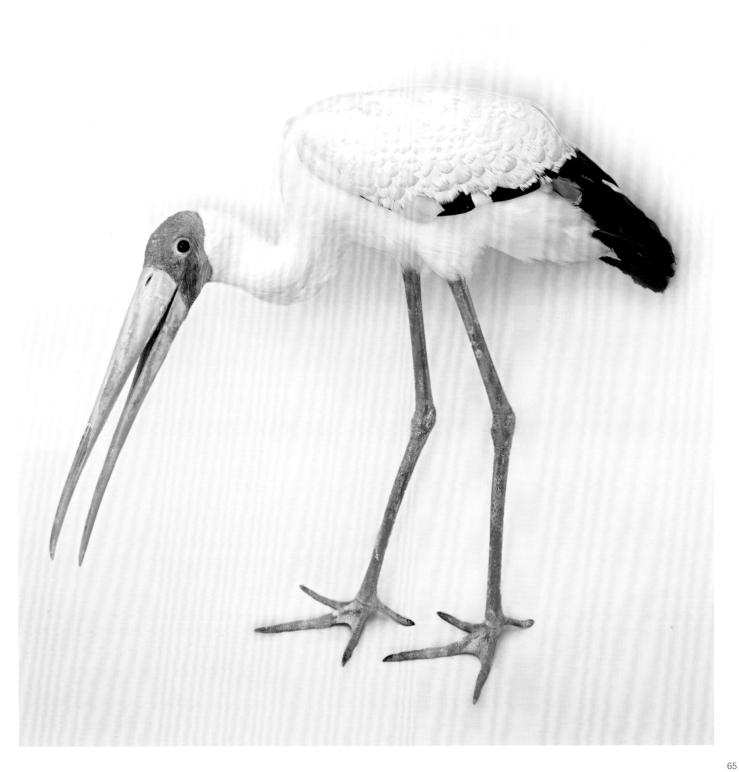

Florida Grasshopper Sparrow *(Ammodramus savannarum)* **LC**

Handling small birds requires special care, as their bodies are delicate. But they are also tough: The Florida Grasshopper Sparrow migrates hundreds of miles and survives subfreezing conditions during storms.

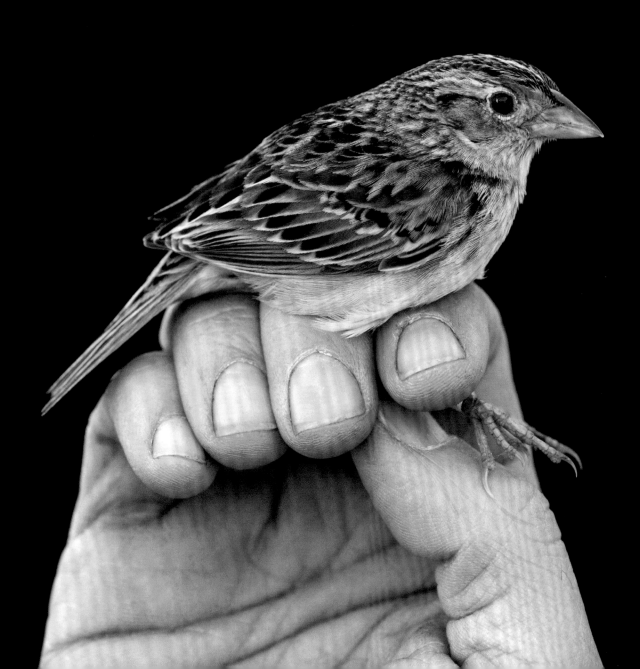

Yellow-rumped Tinkerbird *(Pogoniulus bilineatus)* LC

The mostly solitary Yellow-rumped Tinkerbird
is the size of a human's pinky finger.

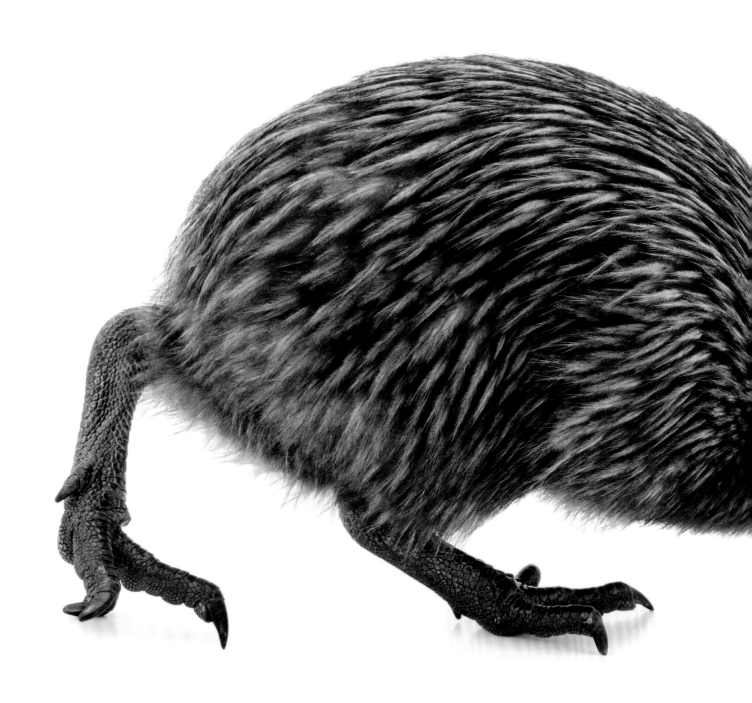

North Island Brown Kiwi *(Apteryx mantelli)* EN

GETTING INTO SHAPE

A bird's profile can be as distinct as its color. Consider the kiwi: Of the hundreds of brown birds in the world, no other species could be confused with a kiwi's squat silhouette.

All birds have characteristic shapes, from a heron's lanky S-curve to the balanced stiletto of a jacana. While size can be hard to judge without a sense of scale, shape remains constant at any distance. A bird's proportions are often described in relation to its own body: For instance, the beak of a Red-and-green Macaw is as thick as its head, and the bill of a Brown Pelican is a quarter of the bird's entire length.

Beaks are particularly variable, depending on the tasks at hand. Without arms or hands, birds must use their beaks to eat, carry objects, groom themselves, and fight. The shape of a beak tells a poignant story of each bird's evolution and survival, and helps us to understand its place in the world.

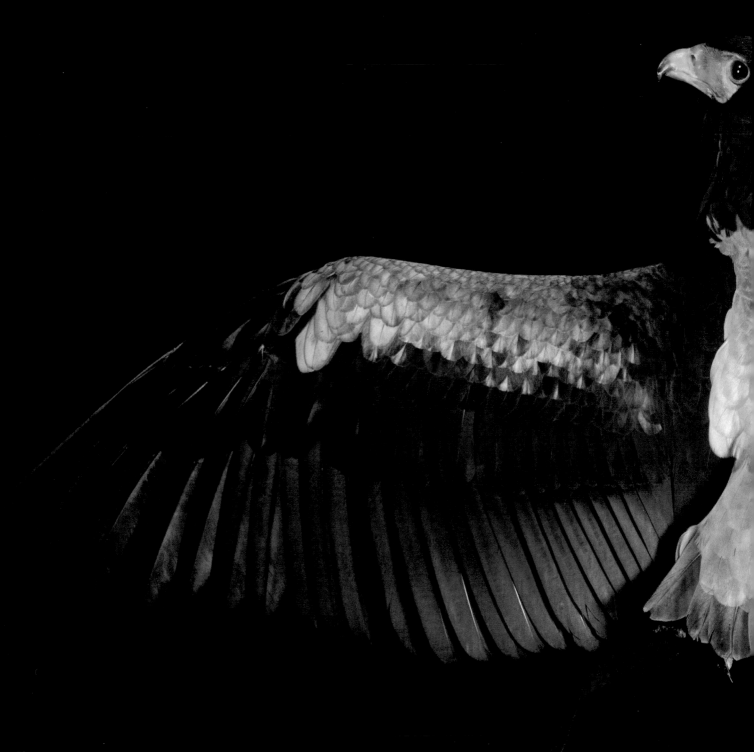

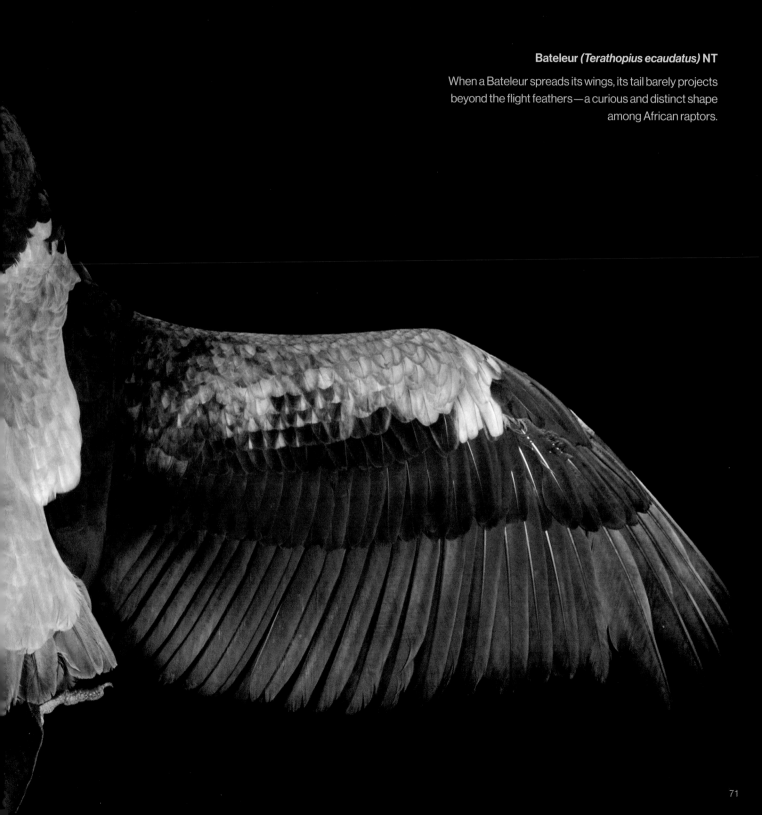

Bateleur *(Terathopius ecaudatus)* **NT**

When a Bateleur spreads its wings, its tail barely projects beyond the flight feathers—a curious and distinct shape among African raptors.

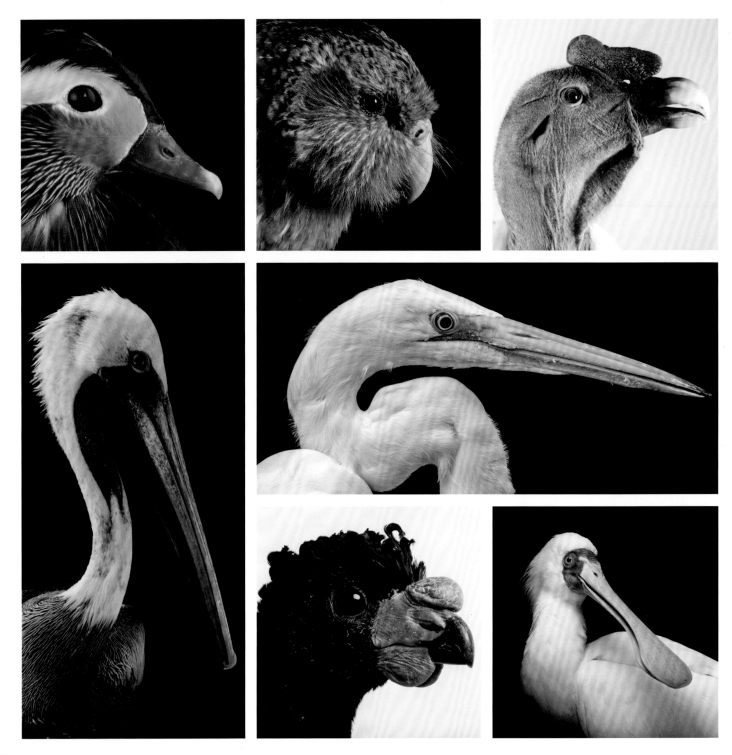

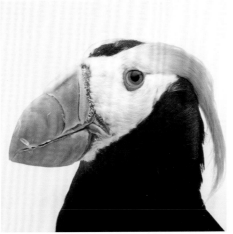

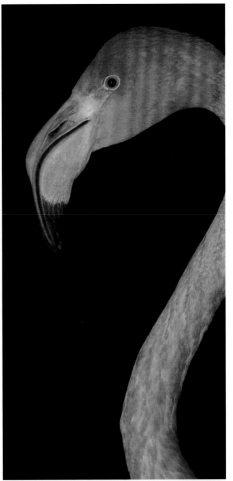

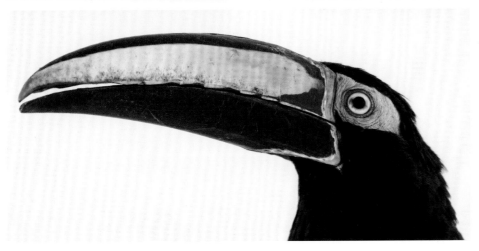

PROMINENT PROTUBERANCES

Beak shapes come in all varieties, often according to the main components of a bird's diet: Spears are for fishing, pouches for swallowing, sieves for straining, nutcrackers for crushing, spoons for sifting, straws for slurping, and hooks for tearing.

OPPOSITE, CLOCKWISE FROM TOP LEFT: **Mandarin Duck** *(Aix galericulata)* LC **Kakapo** *(Strigops habroptila)* CR **Andean Condor** *(Vultur gryphus)* NT **Great White Egret** *(Ardea alba)* LC **African Spoonbill** *(Platalea alba)* LC **Wattled Curassow** *(Crax globulosa)* EN **Peruvian Pelican** *(Pelecanus thagus)* NT THIS PAGE, CLOCKWISE FROM TOP LEFT: **Rhinoceros Hornbill** *(Buceros rhinoceros)* NT **Tufted Puffin** *(Fratercula cirrhata)* LC **American Flamingo** *(Phoenicopterus ruber)* LC **Rose-breasted Grosbeak** *(Pheucticus ludovicianus)* LC **Many-banded Aracari** *(Pteroglossus pluricinctus)* LC

Tawny Frogmouth *(Podargus strigoides)* LC

In Australia, the Tawny Frogmouth may be mistaken for an owl—but its peculiar, very wide beak is something totally unique.

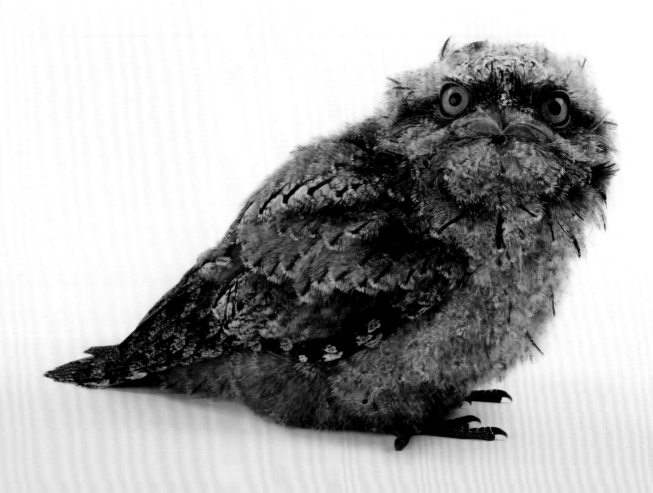

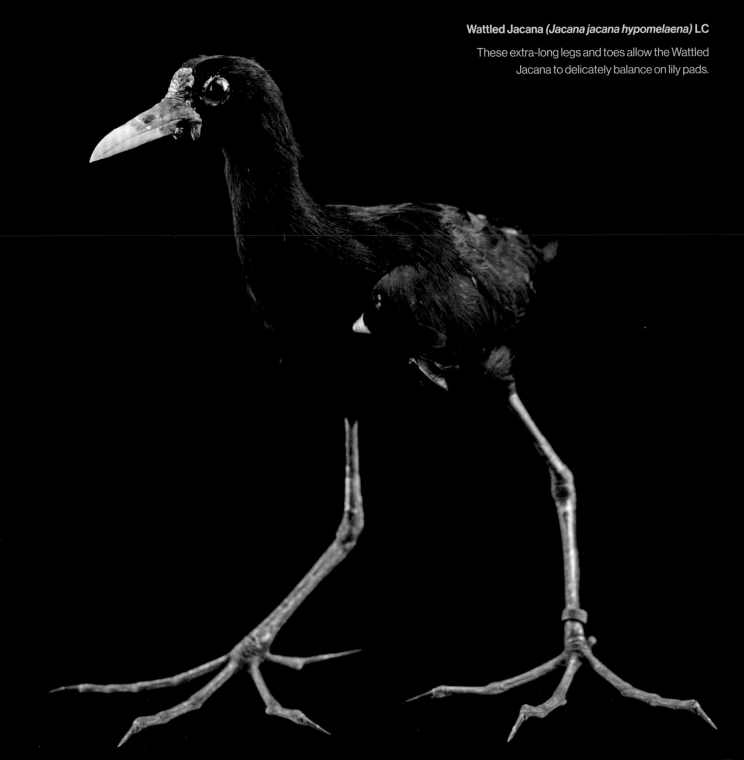

Wattled Jacana *(Jacana jacana hypomelaena)* LC

These extra-long legs and toes allow the Wattled Jacana to delicately balance on lily pads.

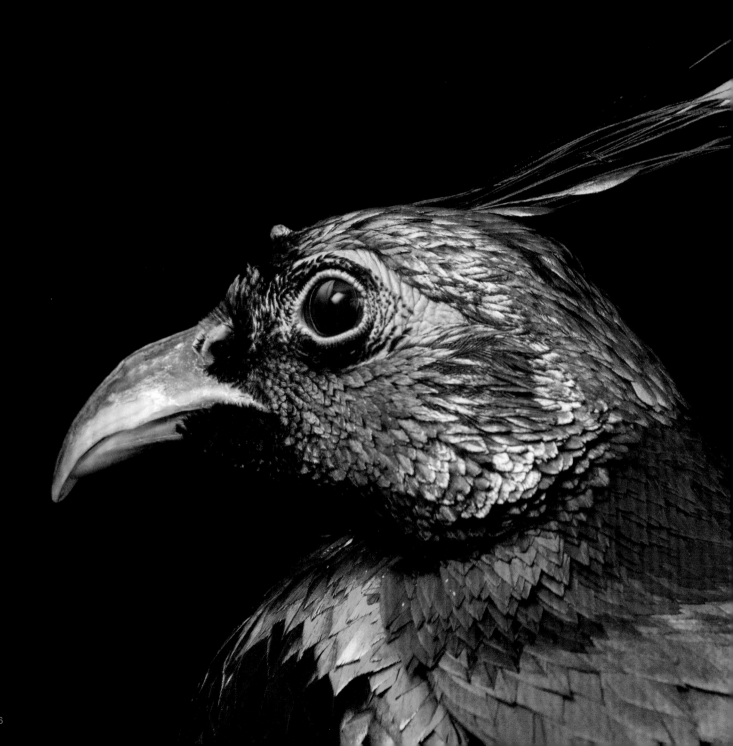

Himalayan Monal *(Lophophorus impejanus)* LC

IN LIVING COLOR

The human retina contains three types of cone cells—red, green, and blue. Birds also have a fourth, which adds a new dimension to their color vision by allowing them to detect ultraviolet light. Across many species, birds excel at differentiating slight differences in hue. It's no wonder they are such colorful creatures.

Bright hues impress mates and dull colors offer camouflage. The showiest birds eschew nesting duties, letting the drab ones do all the work. Some feathers are pigmented, usually with a combination of melanin (black or brown) and carotenoids (red, orange, or yellow). Others, including all blues and some greens, are structural: If you put light behind a blue feather instead of in front of it, it looks brown.

The shimmery iridescence of many of the most spectacular bird species—especially hummingbirds—comes from special, microscopic feather barbules that refract light like a prism, catching the sun only at certain angles.

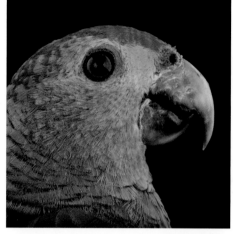
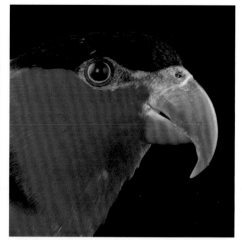
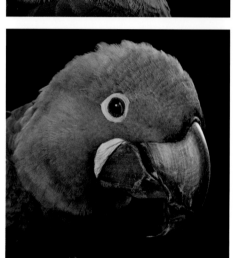
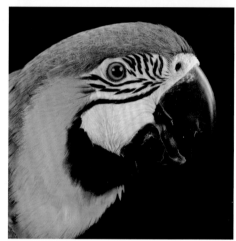
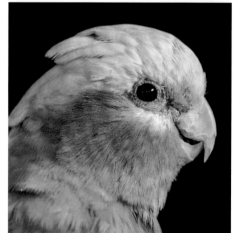
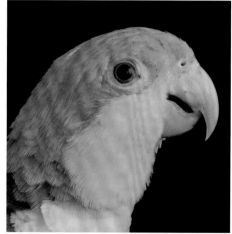

HEADS AND TAILS

THIS PAGE, CLOCKWISE FROM TOP LEFT: **Red-and-green Macaw** *(Ara chloropterus)* LC **Red-browed Amazon** *(Amazona rhodocorytha)* EN **Black-capped Lory** *(Lorius lory)* LC **Blue-and-yellow Macaw** *(Ara ararauna)* LC **Black-legged Parrot** *(Pionites xanthomerius)* LC **Galah** *(Eolophus roseicapilla)* LC **Red-lored Parrot** *(Amazona autumnalis)* LC CENTER: **Hyacinth Macaw** *(Anodorhynchus hyacinthinus)* VU OPPOSITE: **Orange-bellied Parrot** *(Neophema chrysogaster)* CR

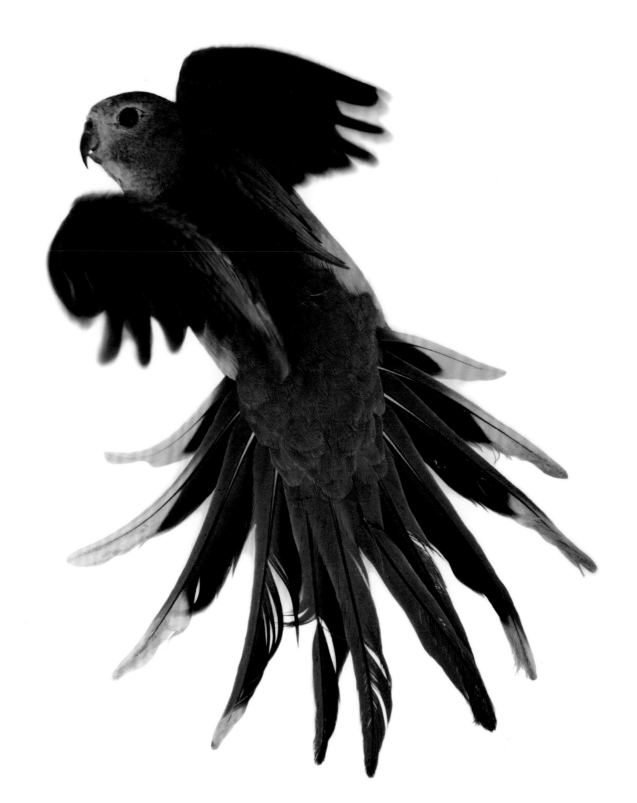

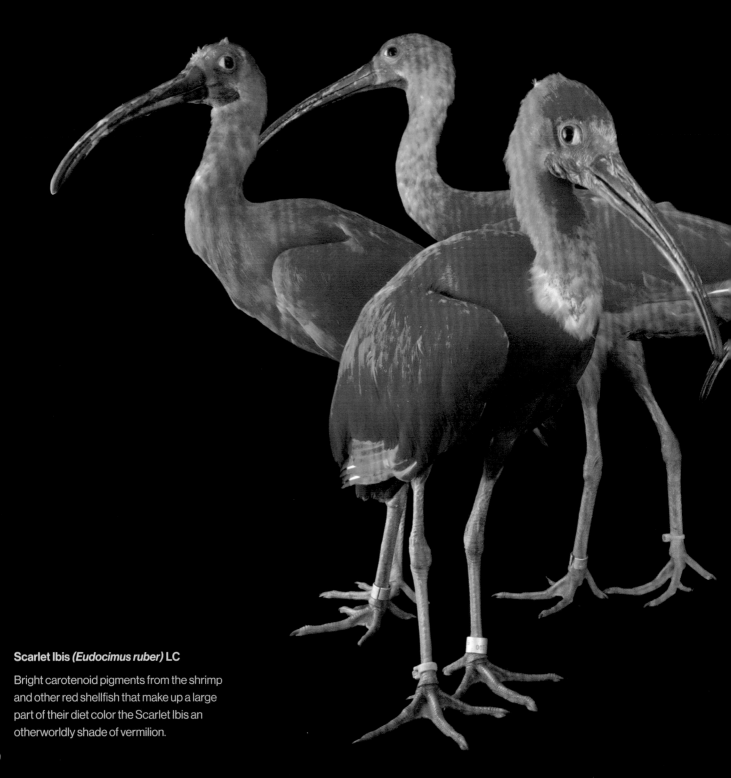

Scarlet Ibis *(Eudocimus ruber)* **LC**

Bright carotenoid pigments from the shrimp
and other red shellfish that make up a large
part of their diet color the Scarlet Ibis an
otherworldly shade of vermilion.

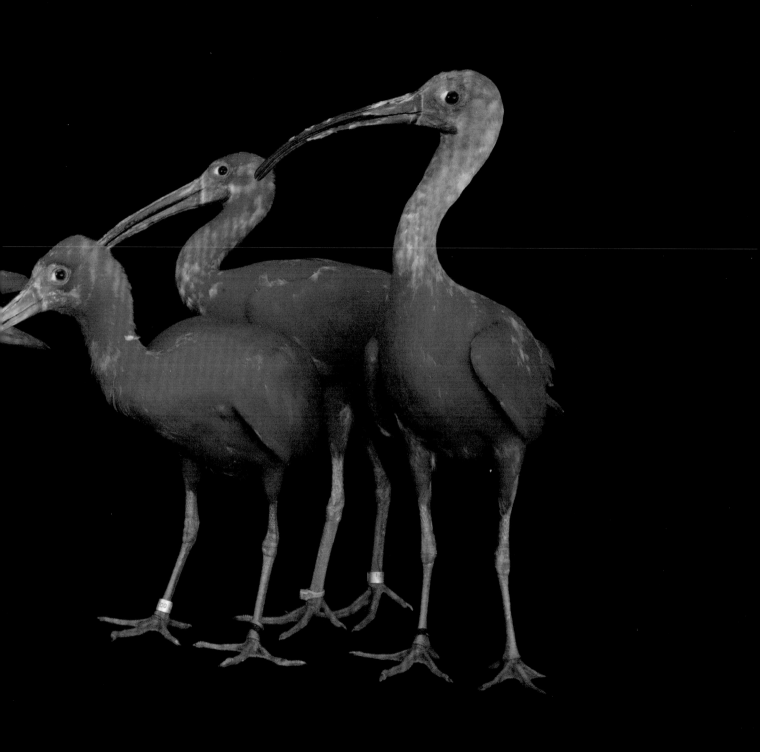

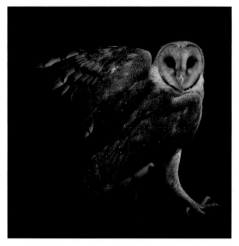

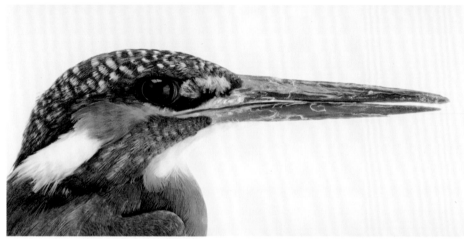
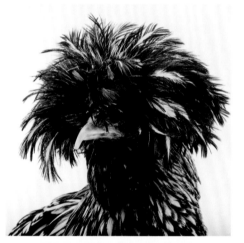
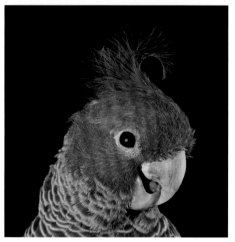
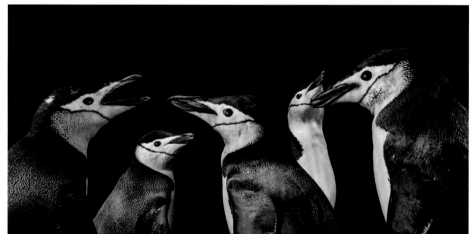

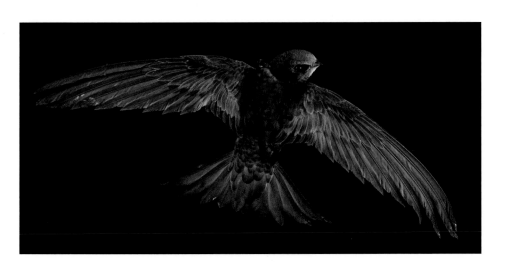

3 / IN FLIGHT

FEATHERS / FLIGHT STYLE / FLOCKING / MIGRATION

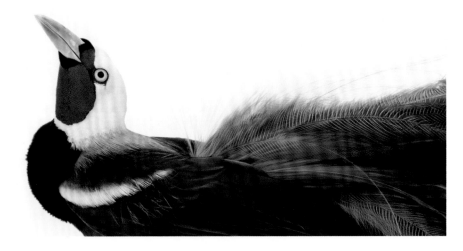

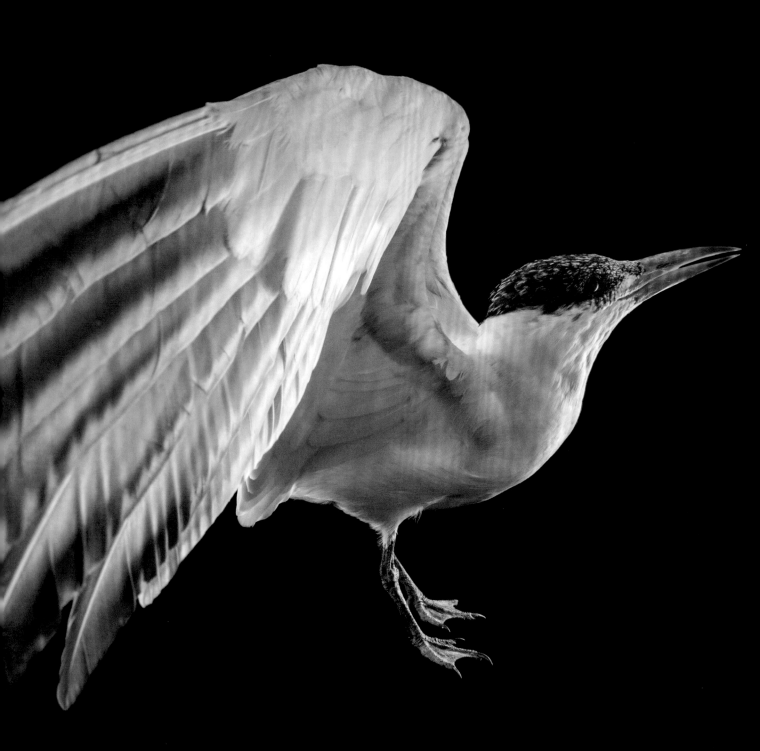

TAKING TO THE SKY

The ability to leap from the earth and fly is so alluring that many people choose flight as their most desired superpower—above things like telepathy, invisibility, immortality, and even time travel. It's a curious choice, because unlike the others, flight is a real-world phenomenon. Birds do it all the time.

If only we could fly like a bird. From aloft, we might view our world with a broader perspective and let go of more earthly distractions. Flight also conveys the poeticism of love, as though the act of spreading one's wings can reveal untapped depths. Flying seems to escape gravity.

For birds, flight is way more practical: a means of transport, getting from point A to point B. About 99.5 percent of living bird species can fly, and the few exceptions (such as penguins and kiwis) are thought to be descended from flying ancestors.

From the evolution of feathers to physical movement, social interaction, and long-distance migration, flight defines a large part of being a bird.

Caspian Tern (*Hydroprogne caspia*) LC

The largest species of tern, the Caspian Tern is a powerful flier that can be found all over the world in nesting populations that reach up to 10,000 individual birds.

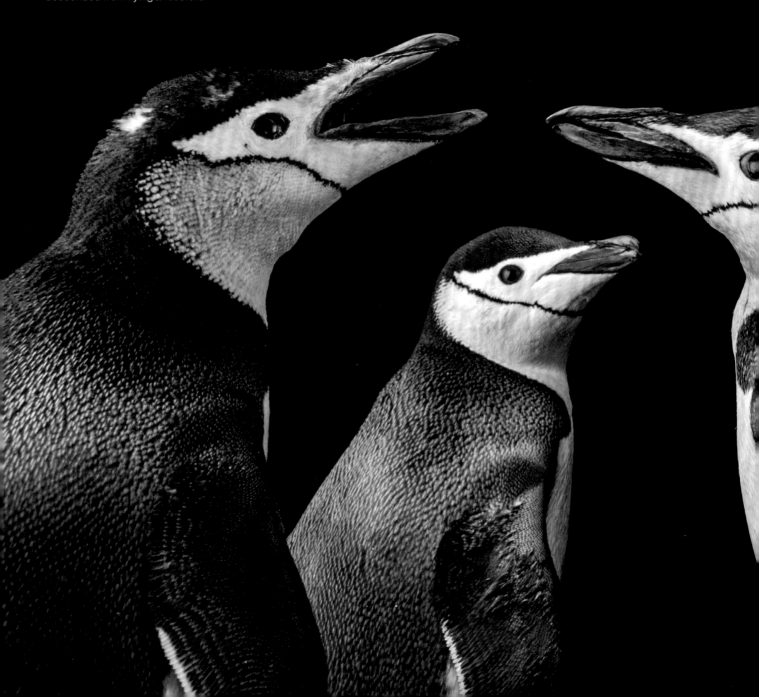

Chinstrap Penguin *(Pygoscelis antarcticus)* LC

Most birds fly, and even flightless birds, like Chinstrap Penguins from Antarctica, are thought to have descended from flying ancestors.

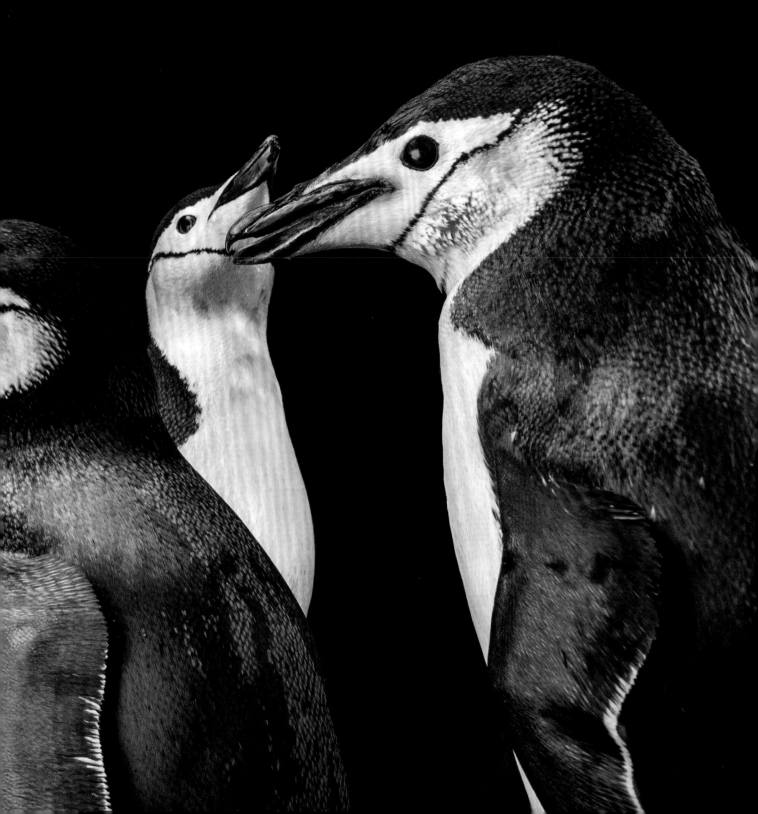

PLUMAGE PARTICULARS

Why feathers appeared, millions of years ago, remains an unanswered question. Fossils show that many dinosaurs had feathers, long before birds took to the air, and that early feathers had several functions: insulation, color, balance, and perhaps defense.

Scientists are unsure whether birds first acquired wings for running uphill (flapping for extra power), for gliding downward (like a flying squirrel), or for some yet unknown other explanation. The development of flight is a lively subject with many competing theories.

Modern feathers have evolved to be lightweight yet durable, flexible, and resilient. Besides forming an airfoil on each wing, feathers help regulate body temperature, keep out water, and provide camouflage. Some feathers, shimmered and flaunted in courtship displays, are simply beautiful.

Raggiana Bird-of-Paradise
(Paradisaea raggiana) LC

Andaman Barn-Owl
(Tyto alba deroepstorffi) LC

An Andaman Barn-Owl shows off one wing, fitted with feathers designed for silent night flight.

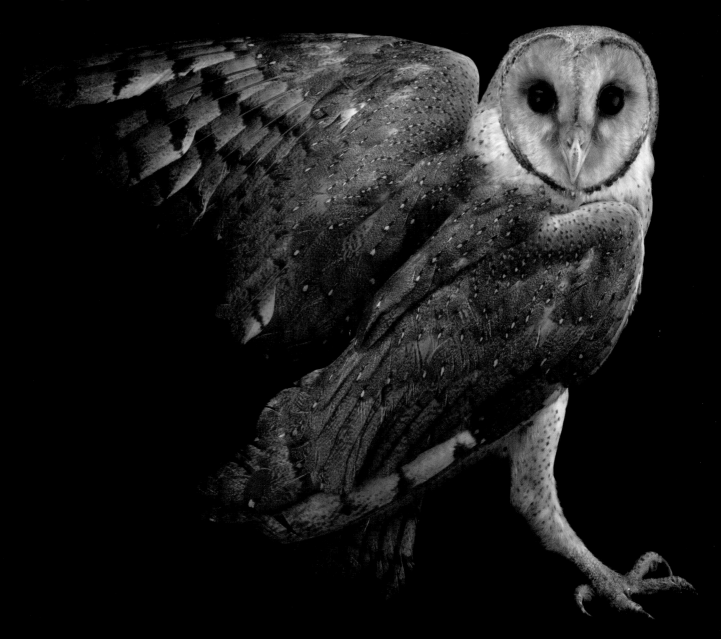

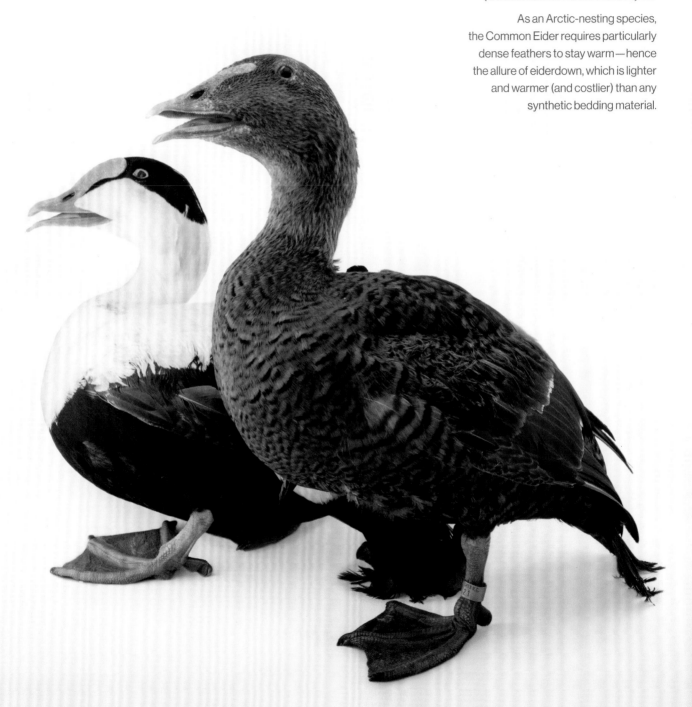

Common Eider
(Somateria mollissima dresseri) NT

As an Arctic-nesting species, the Common Eider requires particularly dense feathers to stay warm—hence the allure of eiderdown, which is lighter and warmer (and costlier) than any synthetic bedding material.

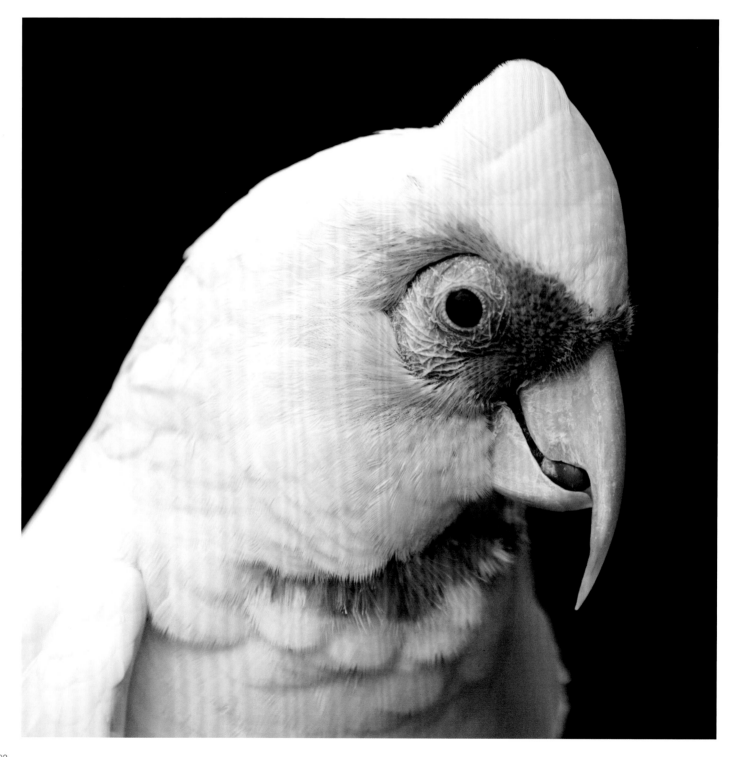

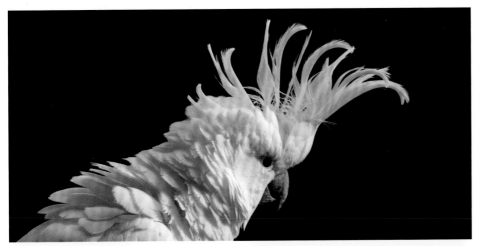

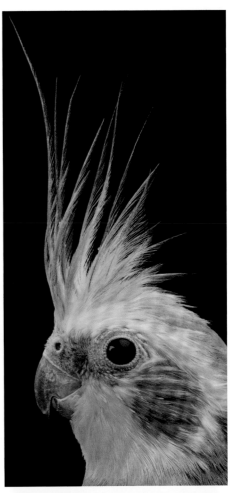

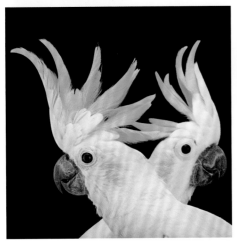

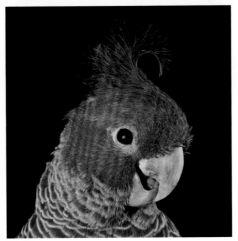

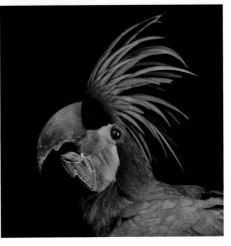

A CREST TO IMPRESS

Many parrots have special head feathers that they can raise and lower at will.
Crests help these intelligent birds communicate and convey emotions.
They are also known to be a part of intricate mating displays, and they can also be used to
frighten off potential predators by making the bird seem larger and more imposing.

OPPOSITE: **Long-billed Corella** *(Cacatua tenuirostris)* LC THIS PAGE, CLOCKWISE FROM TOP
LEFT: **Sulphur-crested Cockatoo** *(Cacatua galerita)* LC **Cockatiel** *(Nymphicus hollandicus)*
LC **Palm Cockatoo** *(Probosciger aterrimus)* LC **Gang-gang Cockatoo** *(Callocephalon
fimbriatum)* LC **Yellow-crested Cockatoo** *(Cacatua sulphurea)* CR

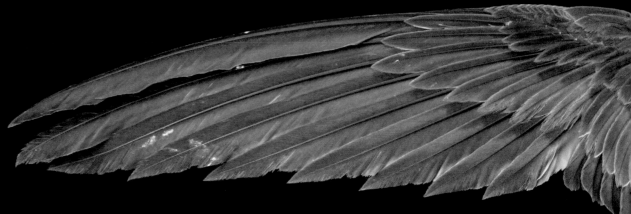

FLIGHT PATTERNS

Some birds fly with the grace of a professional ballerina, while others hurtle like a charging linebacker. Different styles require different strokes, and a single bird may make use of several flight styles, depending on the situation at hand.

You can often tell how a bird flies by the shape of its wings. The Common Swift, which nests in Europe and stays aloft for virtually its entire life, has long, narrow wings—a high "aspect ratio" that works well for gliding on subtle air currents. Species that must navigate thick forests, like some hawks and songbirds, have blunter wings to help them maneuver and avoid colliding with their surrounding environment.

Ducks, meanwhile, tend to fly in a straight line, woodpeckers undulate, and kingfishers hover before plunging headfirst into a pond. Hummingbirds, unlike any other bird, can twist their wings almost 180 degrees to fly backward and, remarkably, upside down.

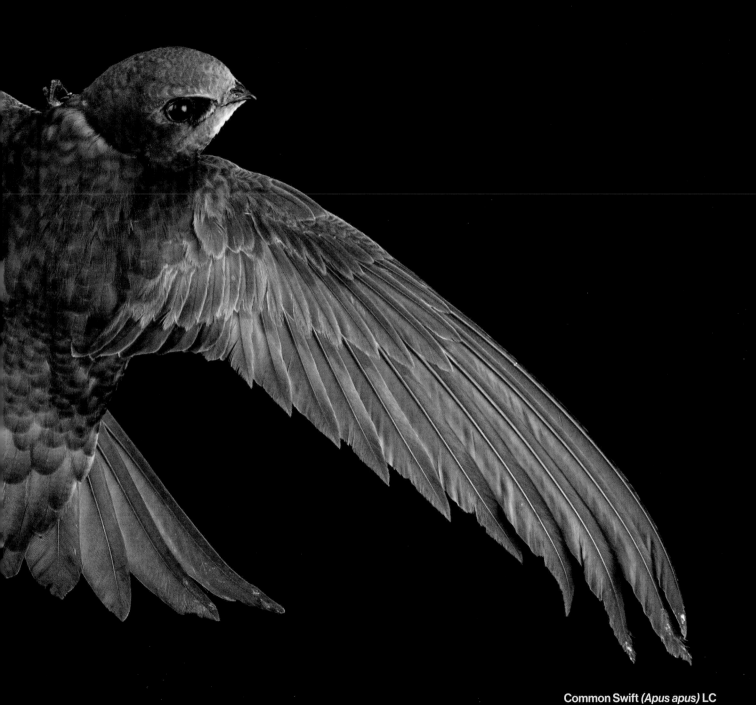

Common Swift *(Apus apus)* LC

Brown-hooded Kingfisher
(Halcyon albiventris) LC

A common sight in southern Africa,
a Brown-hooded Kingfisher flashes
sky blue plumage in flight.

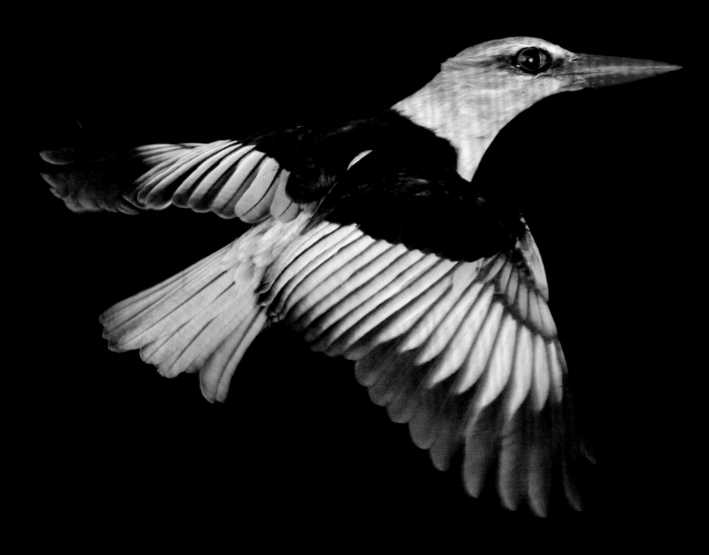

White-necked Jacobin *(Florisuga mellivora)* **LC**

Hummingbirds are unique from other species
in that they can turn their wings nearly upside down
to hover in place and even fly backward.

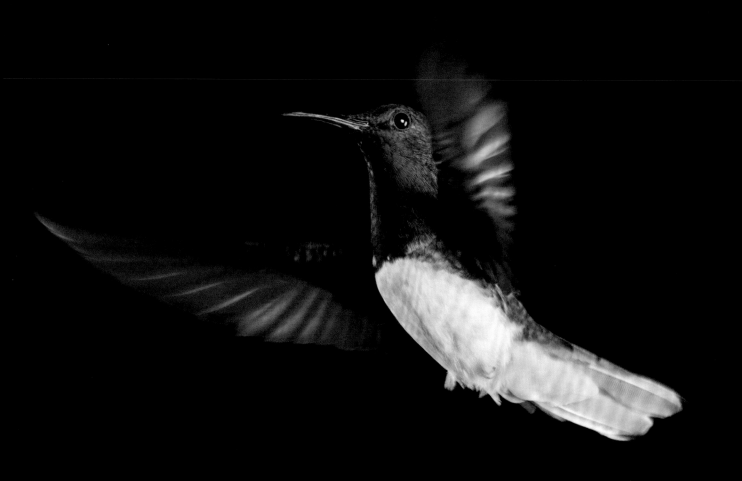

Bufflehead *(Bucephala albeola)* LC

A small, relatively compact duck, the Bufflehead flies almost like a football with whirring, fast-beating wings.

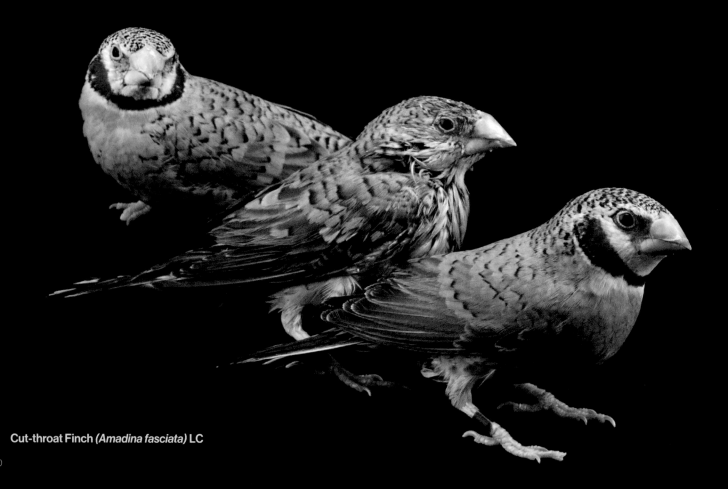

Cut-throat Finch *(Amadina fasciata)* LC

Like a herd of buffalo, school of fish, or swarm of insects, a flock of birds tends to behave in predictable ways. Many species find safety and companionship in numbers. When enough individuals group together, their movements align almost as one.

Geese benefit from V-shaped formations in the air, rotating the leader to spread out fatigue, while their dense ground flocks protect them from predators. Some starlings and finches gather by the million in winter, swirling like smoke — by the time spring arrives, they forgo the group for a single mate and territory.

But not all birds form flocks. Hummingbirds are notoriously tempestuous, unable to stay long in a cohesive group. Albatrosses are naturally solitary. They congregate only around food sources and nesting colonies, as it would be too difficult for them to stick together for most of the year at sea.

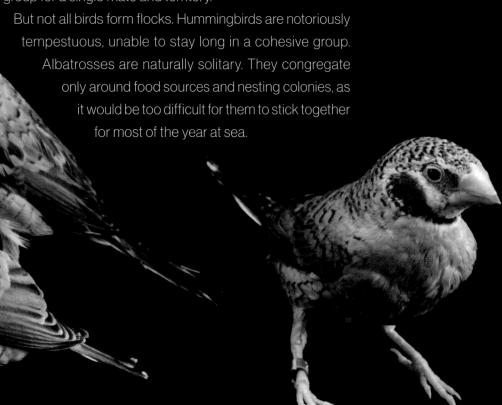

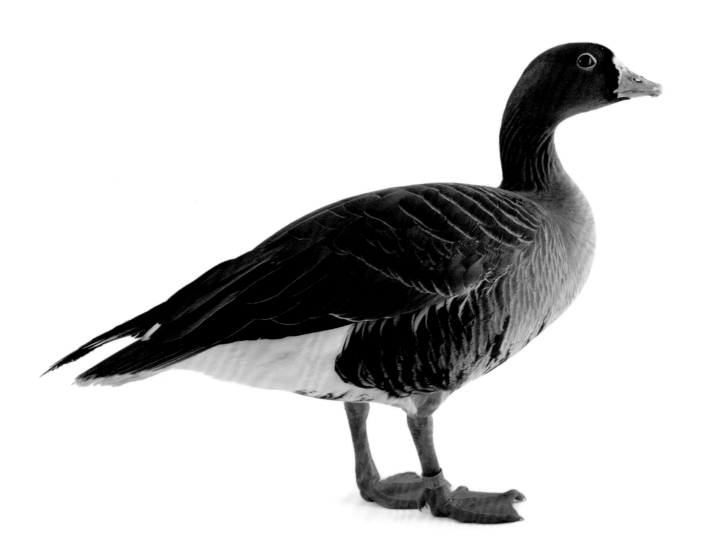

Lesser White-fronted Goose *(Anser erythropus)* VU

Many waterfowl, including the Lesser White-fronted Goose, which nests in Russia, form dense flocks during migration and in winter.

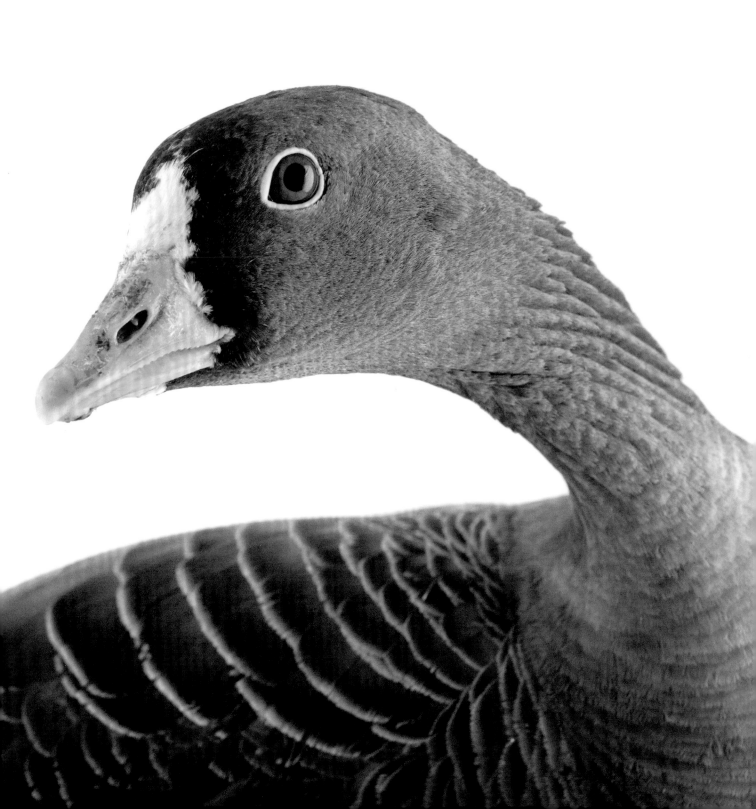

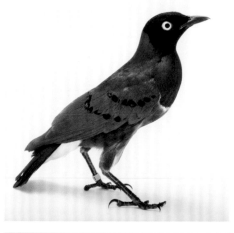

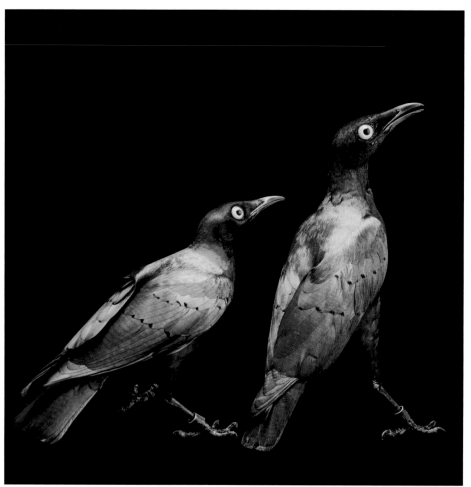

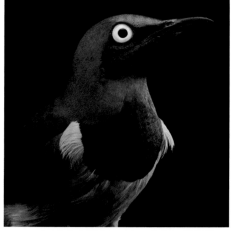

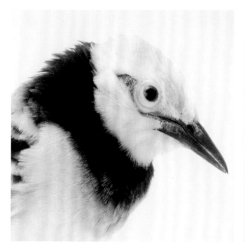

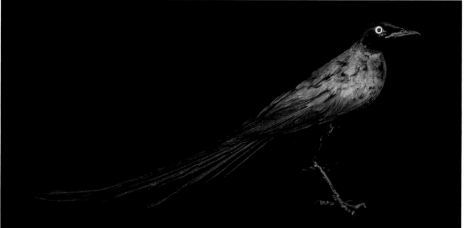

VARIATIONS ON STARLING

North American and European bird fanciers are well acquainted with the European Starling (introduced in the United States), but the starling family is surprisingly diverse, with most species residing in Africa and Asia. Starlings are gregarious, glossy, and undeniably gorgeous birds. In addition to their remarkable colors and iridescent sheen, starlings are some of the most intelligent birds around. They have been known to incorporate sounds from their environments into their vocalizations—even imitating car alarms and human speech.

OPPOSITE, CLOCKWISE FROM TOP LEFT: **Purple Starling** *(Lamprotornis purpureus)* LC **Superb Starling** *(Lamprotornis superbus)* LC **Golden-breasted Starling** *(Lamprotornis regius)* LC **Long-tailed Glossy Starling** *(Lamprotornis caudatus)* LC **Black-collared Starling** *(Gracupica nigricollis)* LC THIS PAGE, CLOCKWISE FROM TOP: **Emerald Starling** *(Lamprotornis iris)* LC **Black-winged Starling** *(Acridotheres melanopterus)* CR **Purple Starling** *(Lamprotornis purpureus)* LC

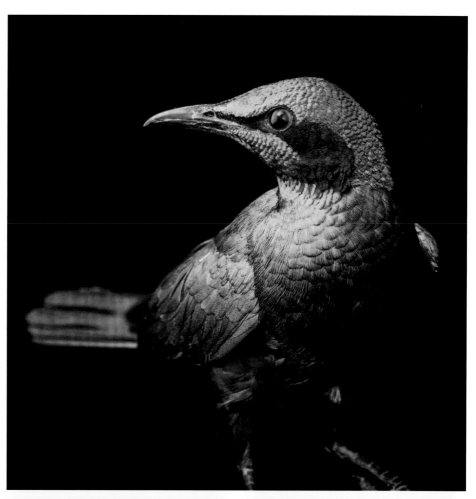

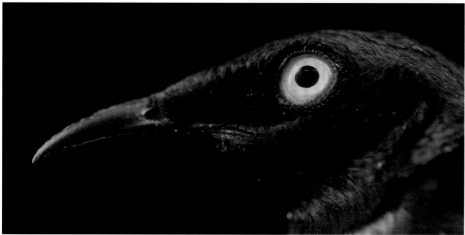

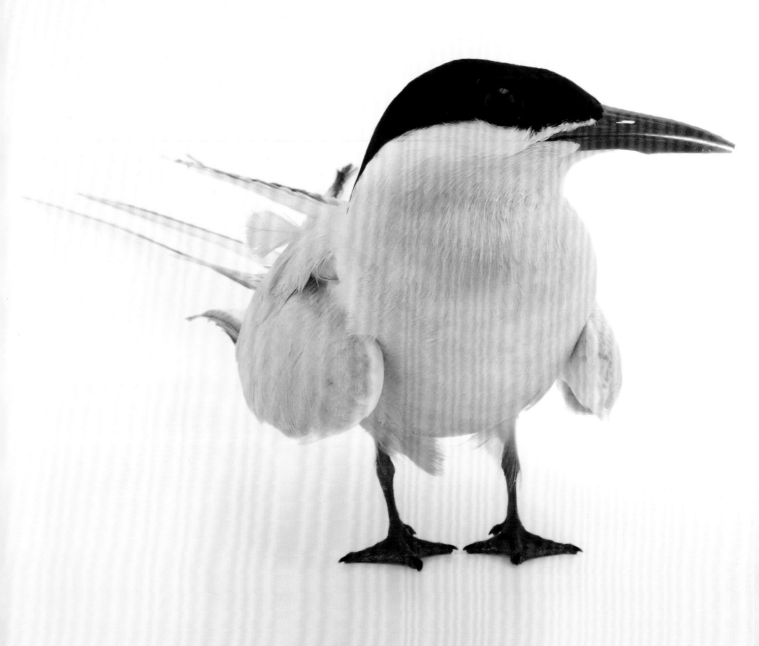

Arctic Tern *(Sterna paradisaea)* LC

MYRIAD MIGRATIONS

More than 2,000 years ago, the Greek philosopher Aristotle explained the annual disappearance of redstarts, swallows, and other European birds with transmutation and hibernation. Redstarts, he said, transformed themselves into robins each winter; swallows hibernated in holes in the ground.

These days, we know better. When birds disappear between seasons, they're often winging their way to warmer climates or far-off breeding grounds. But the study of bird migration continues to amaze: It wasn't until 2010 that an Arctic Tern was tracked through its entire 44,000-mile journey from nesting grounds in Greenland to Antarctic pack ice, the longest migration of any animal.

Through the use of modern GPS technology, we can follow birds and their incredible migrations. Bar-tailed Godwits go nonstop from Alaska to New Zealand, while Purple Martins spend their winters in the Amazon after nesting in Canada. Aristotle's redstarts fly from Greece to central Africa, a feat nearly as impressive as transmutation.

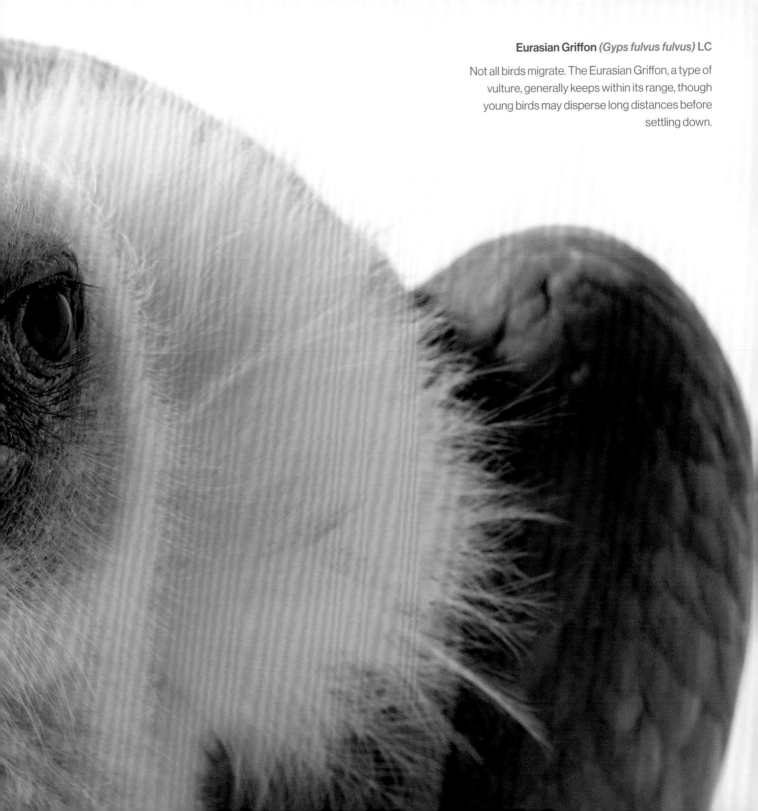

Eurasian Griffon *(Gyps fulvus fulvus)* LC

Not all birds migrate. The Eurasian Griffon, a type of vulture, generally keeps within its range, though young birds may disperse long distances before settling down.

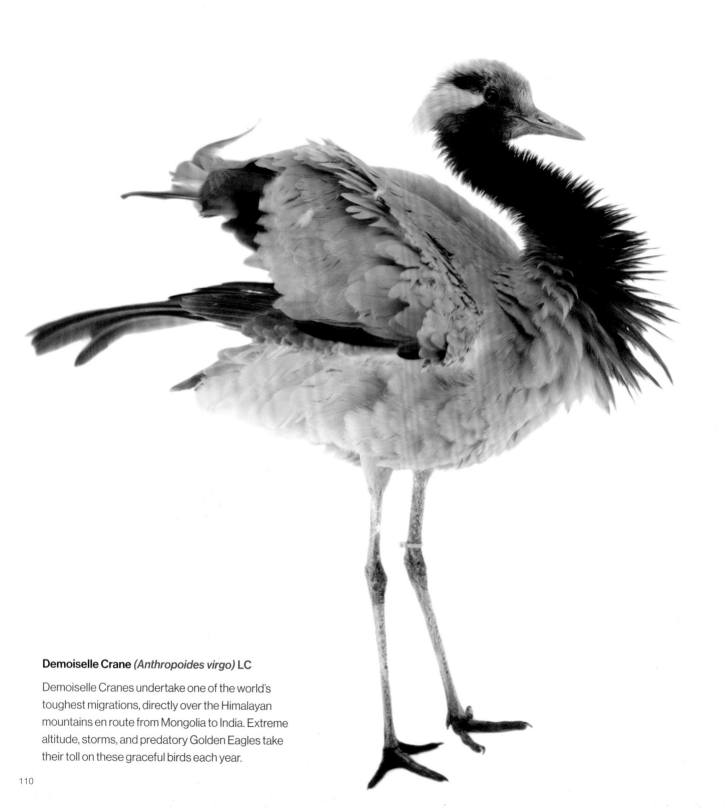

Demoiselle Crane *(Anthropoides virgo)* LC

Demoiselle Cranes undertake one of the world's toughest migrations, directly over the Himalayan mountains en route from Mongolia to India. Extreme altitude, storms, and predatory Golden Eagles take their toll on these graceful birds each year.

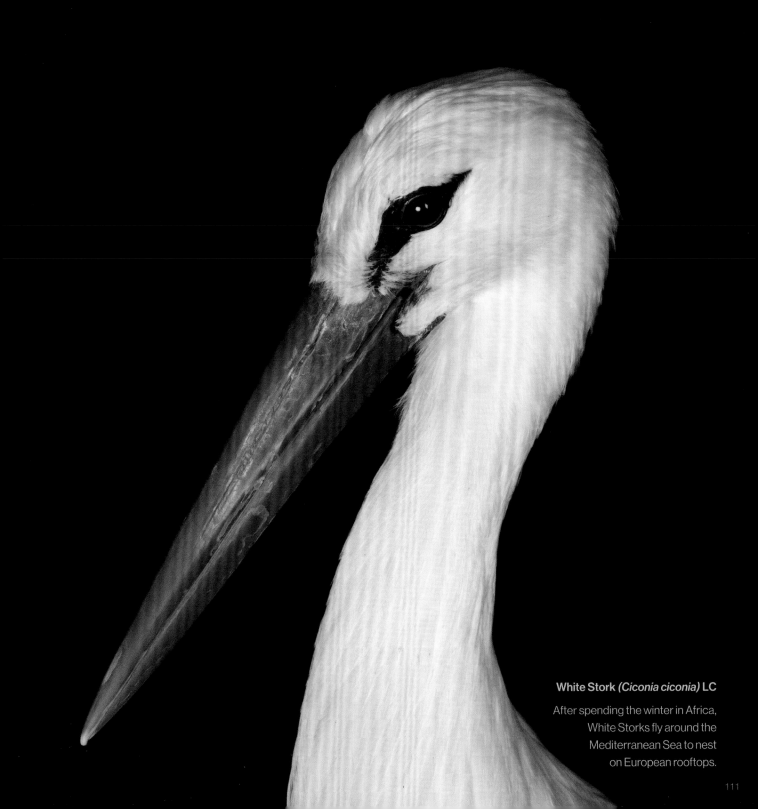

White Stork *(Ciconia ciconia)* LC

After spending the winter in Africa,
White Storks fly around the
Mediterranean Sea to nest
on European rooftops.

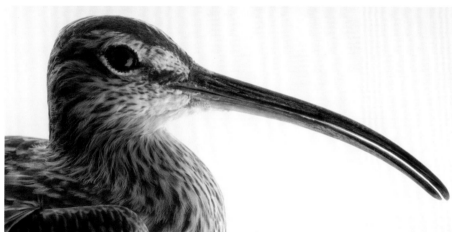

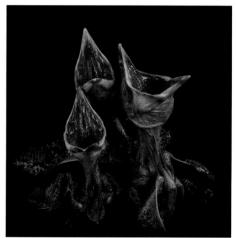

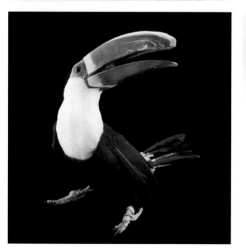

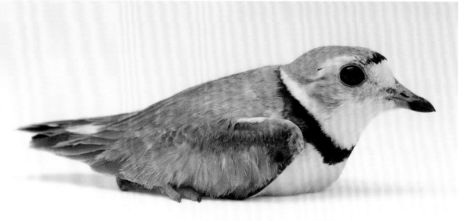

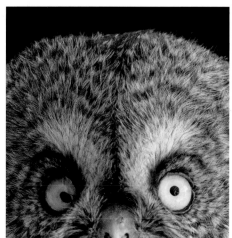

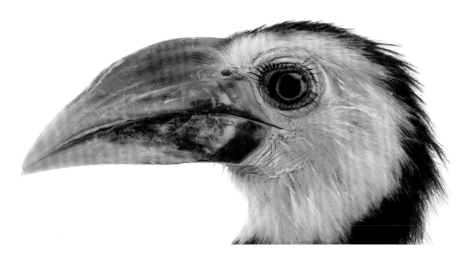

4 / FOOD

DIET / FORAGING / SCAVENGING

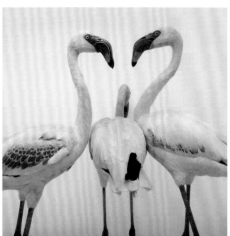

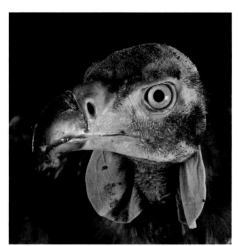

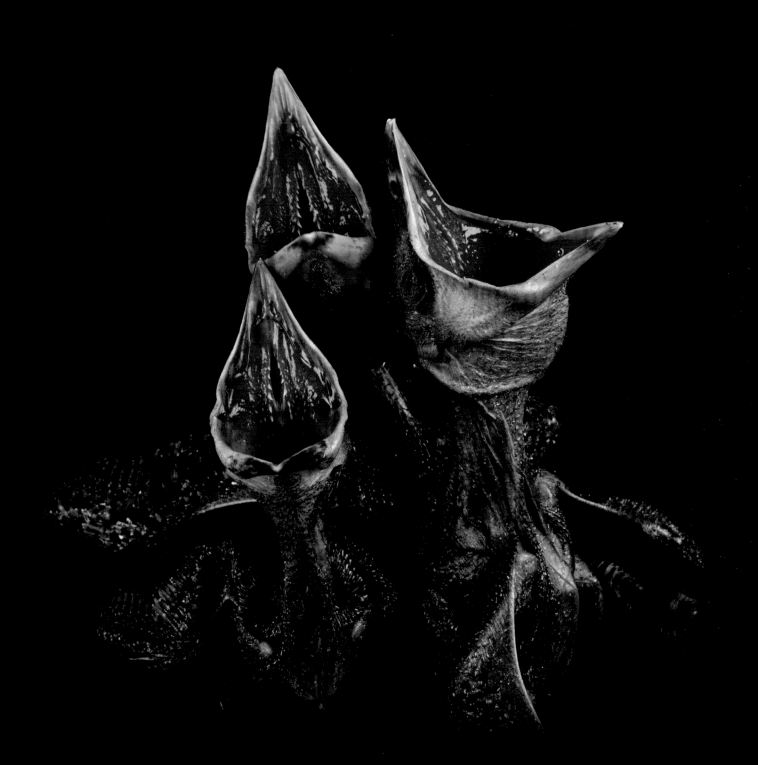

MOUTHS TO FEED

Anyone with a light appetite is said to "eat like a bird," but it would be hard for a human to keep up with most birds in an eating contest. A chickadee, for instance, consumes a third of its own weight each day—that's like a 150-pound human putting away 50 pounds between breakfast and dinner! Hummingbirds may drink their body weight in nectar, and one 12-pound Canada Goose can digest (and discharge) three pounds of grass every day. No wonder golf course owners feel plagued by geese.

Many birds must expend a lot of effort just searching for food, which means that eating can be a seemingly endless task—by the time they finish one meal, it's time to start looking for the next one. A warbler might catch 1,000 insects during a long day's foraging, and an owl can hunt straight through the night. Not all birds need to work quite so tirelessly for their dinner, though: The African Fish-Eagle can catch a fish in less than 10 minutes.

Birds' foraging habits differ according to their diets, and what's for dinner can be anything from birdseed to seafood, live prey to roadkill.

Torresian Crow nestlings *(Corvus orru)* **LC**

Hungry nestlings call out for a meal from their parents. It takes about 40 days for young Torresian Crows to be able to leave the nest—even then, they'll stay with their parents for several months, learning how to feed and fend for themselves.

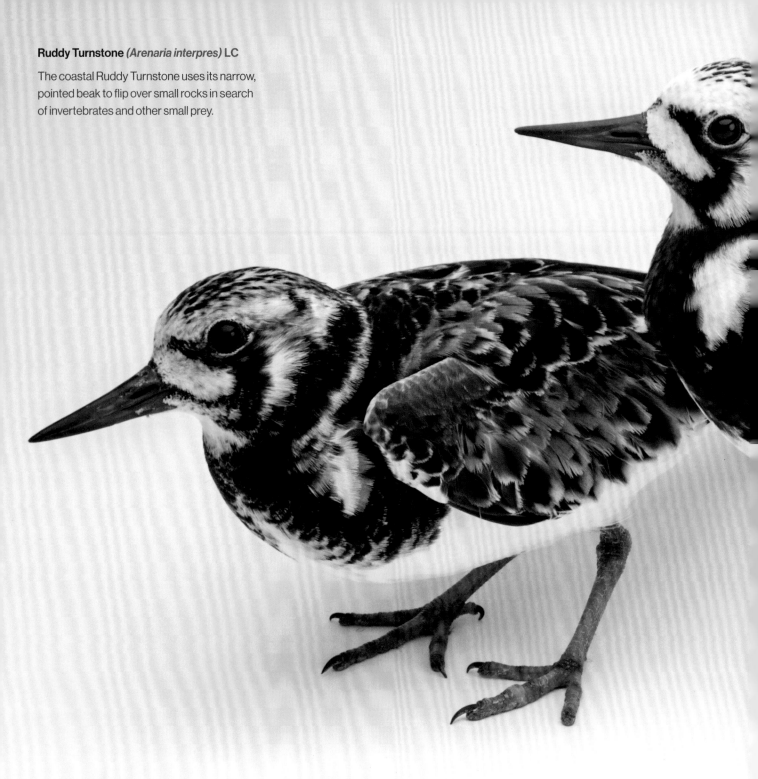

Ruddy Turnstone *(Arenaria interpres)* LC

The coastal Ruddy Turnstone uses its narrow, pointed beak to flip over small rocks in search of invertebrates and other small prey.

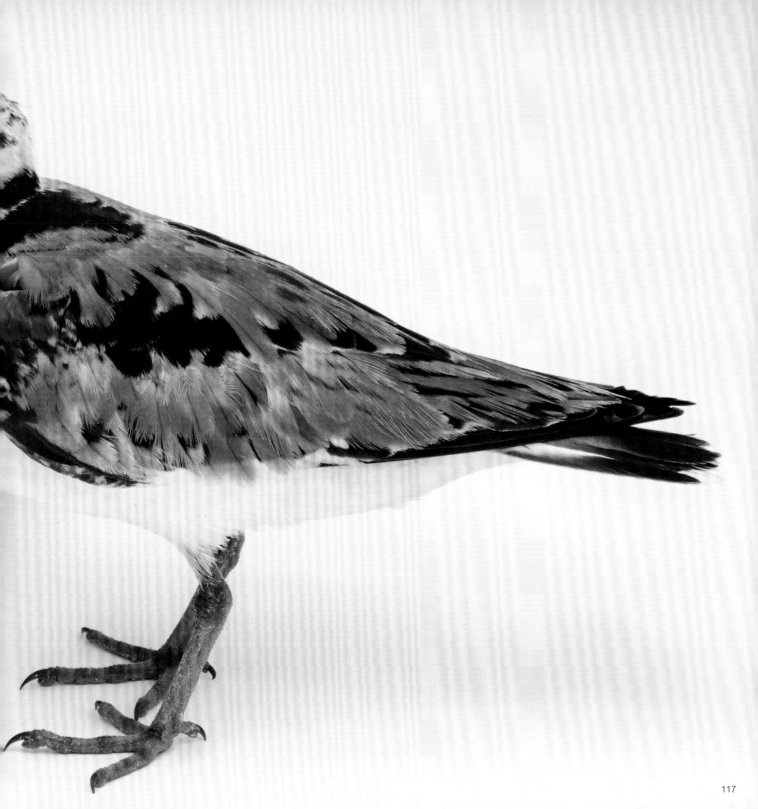

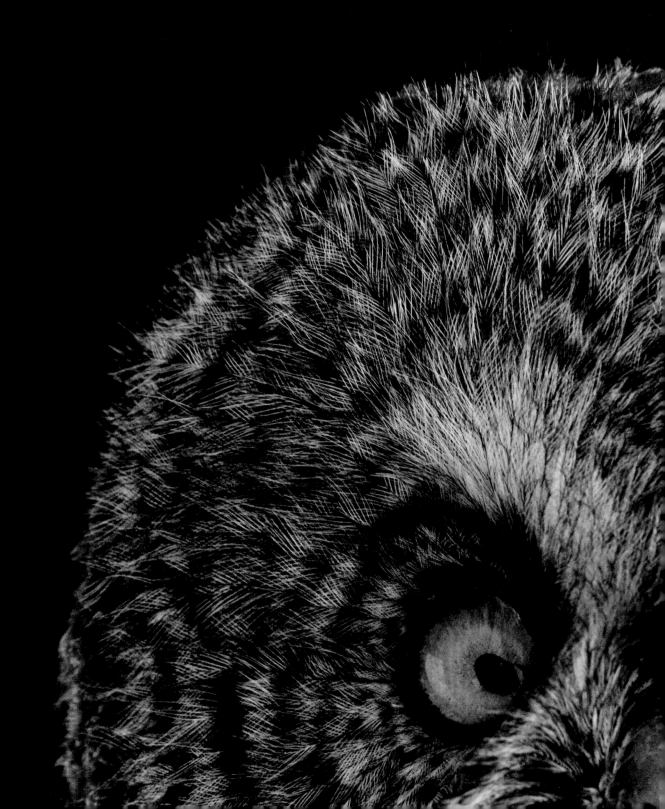

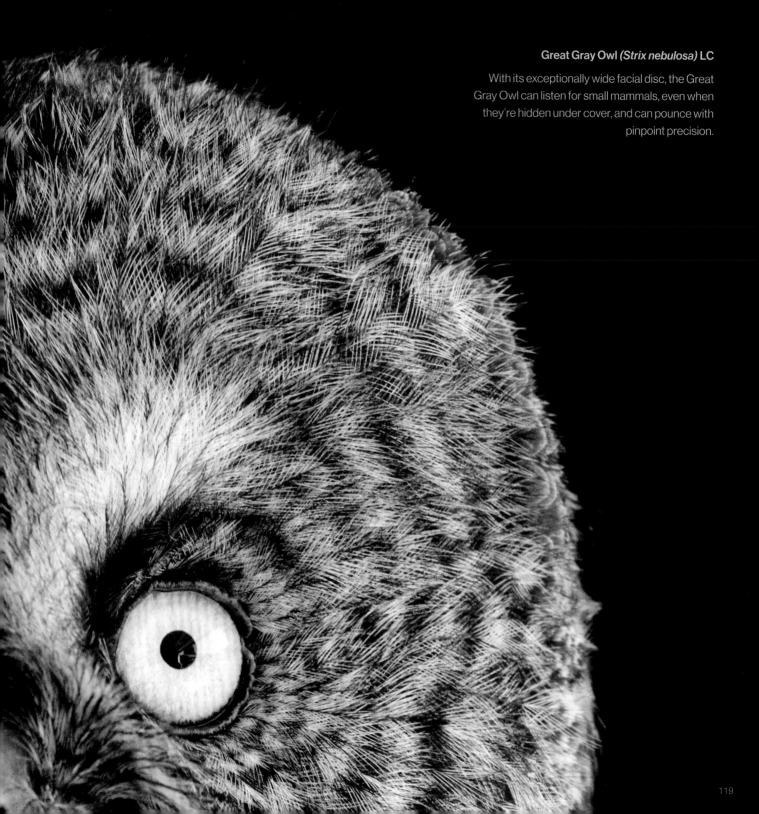

Great Gray Owl *(Strix nebulosa)* **LC**

With its exceptionally wide facial disc, the Great Gray Owl can listen for small mammals, even when they're hidden under cover, and can pounce with pinpoint precision.

WHAT'S TO EAT?

Like most living things, birds need carbohydrates, fat, protein, vitamins, and minerals to stay healthy. Some are what we might call picky eaters, honed for specialized diets, while others are scavengers who will take what they can find. Each species has its own methods, learned or instinctive (or a combination of both), to find enough food to survive.

Many bird diets are fairly monotonous. Snail Kites, for instance, eat practically nothing but freshwater snails for their entire lives. Do they really, really like snails—or do they just take them for granted?

Birds probably have a sense of taste similar to humans, as their taste buds can differentiate between sour, sweet, and bitter foods. But people have about 10,000 taste buds and most birds have fewer than 500—they are not known for a particularly refined palate.

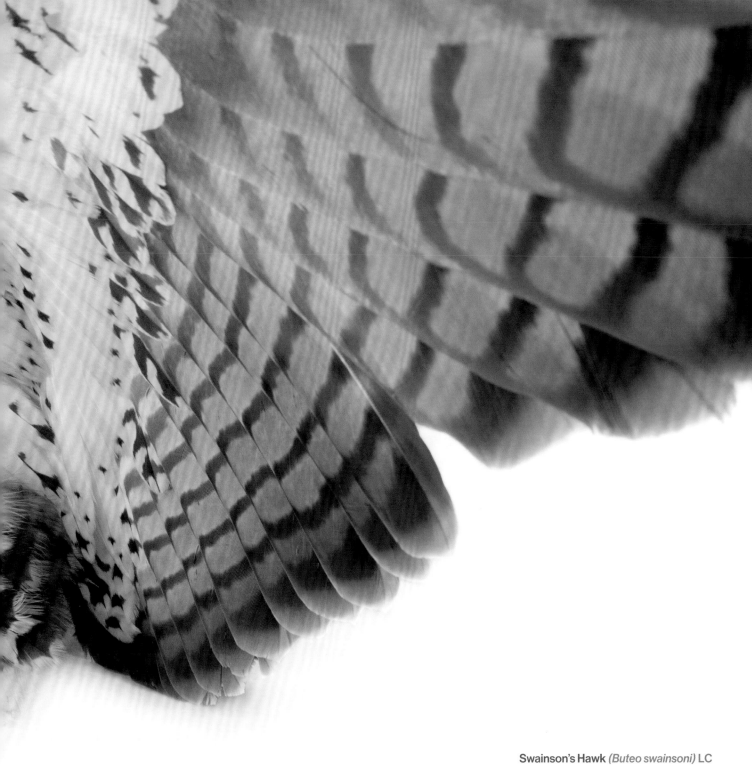

Swainson's Hawk *(Buteo swainsoni)* LC

Capuchinbird *(Perissocephalus tricolor)* **LC**

The fruit-eating Capuchinbird of northeast
South America sometimes mixes up its diet
with a few insects.

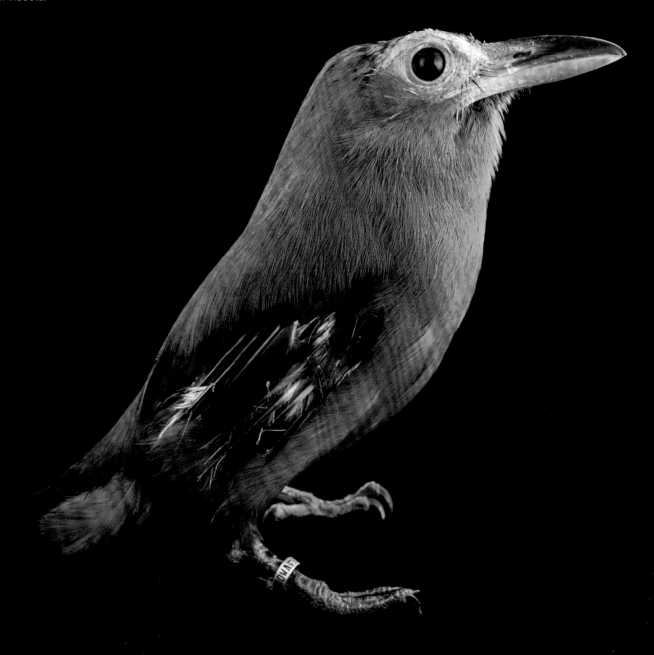

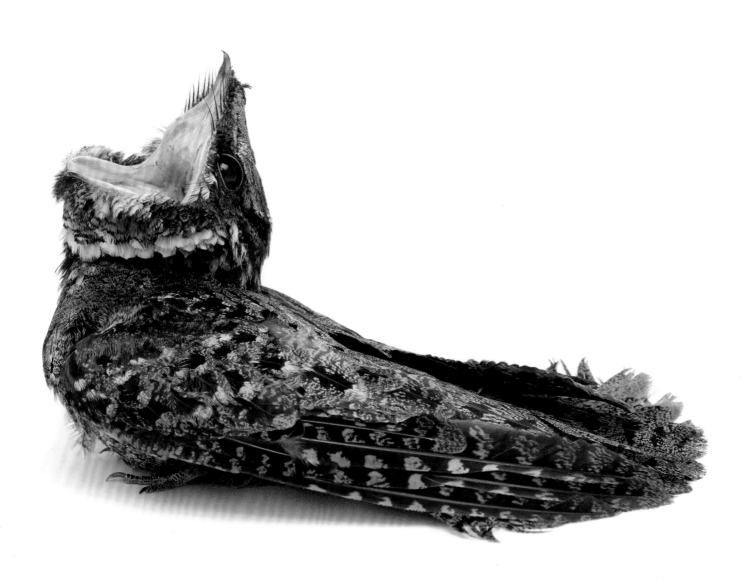

Chuck-will's-widow
(Antrostomus carolinensis) LC

A wide mouth helps this nocturnal bird capture night-flying insects, including moths and beetles. "Chucks" also occasionally swallow especially small birds and bats.

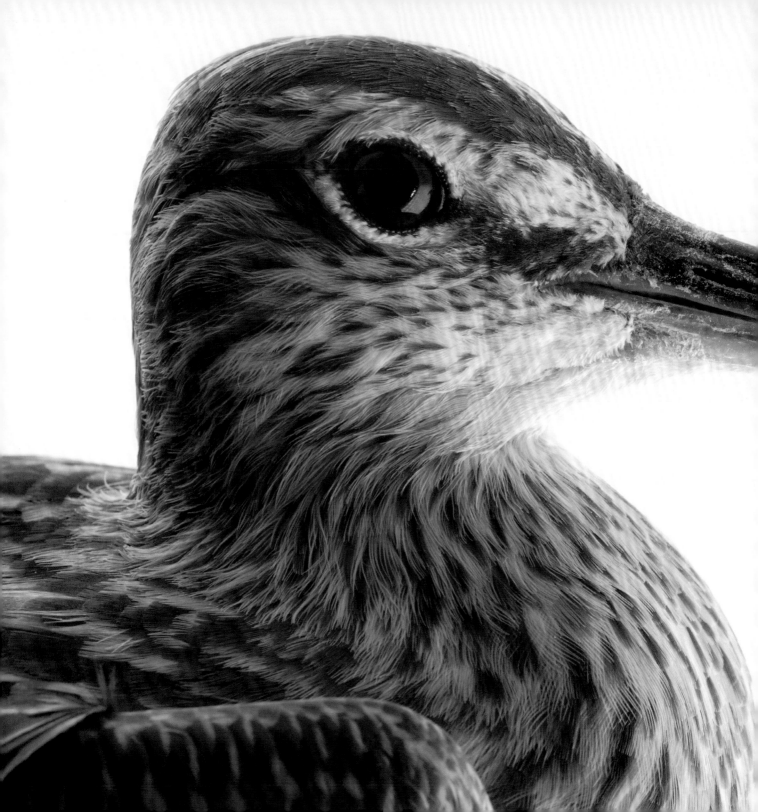

Whimbrel *(Numenius phaeopus)* LC

Many shorebirds, including the Whimbrel, have long, narrow beaks that let them probe through sand and mud. The tips of their beaks are sensitive enough to feel a wriggling worm underneath the surface.

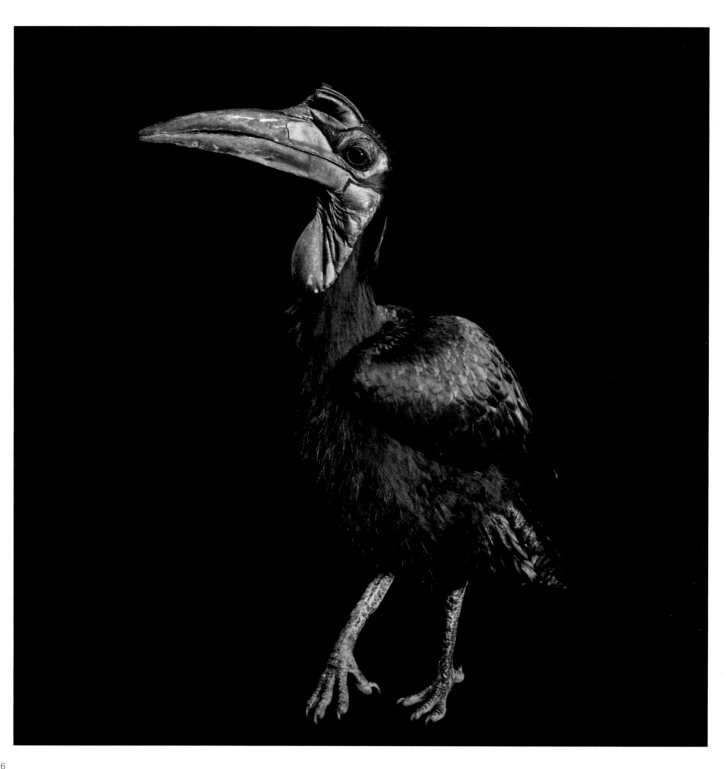

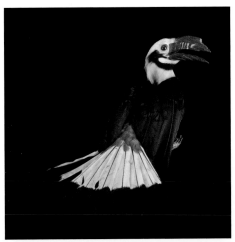

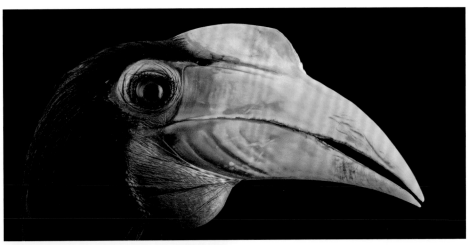

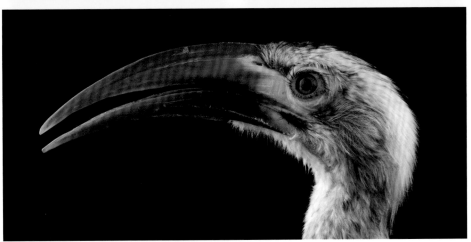

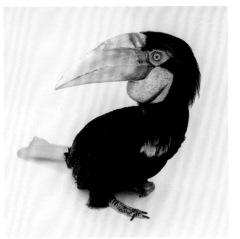

HORNBILL HUNGER

Wild hornbills—found across Africa, Asia, and Melanesia—are omnivorous, consuming a variety of fruits and small animals. They toss morsels held at the tip of the beak back into their throats.

OPPOSITE: **Northern Ground-Hornbill** *(Bucorvus abyssinicus)* LC THIS PAGE, CLOCKWISE FROM TOP LEFT: **Visayan Hornbill** *(Penelopides panini panini)* EN **Wrinkled Hornbill** *(Rhabdotorrhinus corrugatus)* NT **Wreathed Hornbill** *(Rhyticeros undulatus)* LC **Sulawesi Hornbill** *(Rhabdotorrhinus exarhatus)* VU **Red-billed Hornbill** *(Tockus erythrorhynchus)* LC

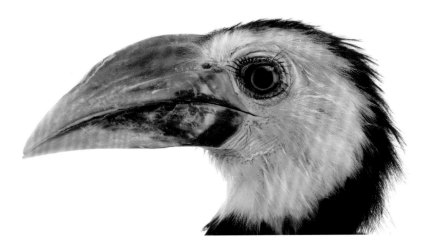

FIT FOR
FORAGING

The smaller the bird, the more it tends to eat in proportion to its body size. Tiny birds require a constant supply of calories to make up for heat lost through the surface area of their bodies. Hummingbirds, the smallest of all, are fine-tuned eating machines; by contrast, large raptors can starve for a while without getting too hungry.

As a group, birds exploit an impressive variety of niches. King Penguins dive to catch lanternfish in the so-called "deep scattering layer," more than 900 feet beneath the surface of the sea. Lesser Flamingos flock on African lakes with water so alkaline that plants cannot grow, and use their deep-keeled beaks to gather up blue-green algae. In a remarkable adaptation for catching fish, the Australian Pelican's beak holds more than its belly can: about three gallons to one gallon, respectively.

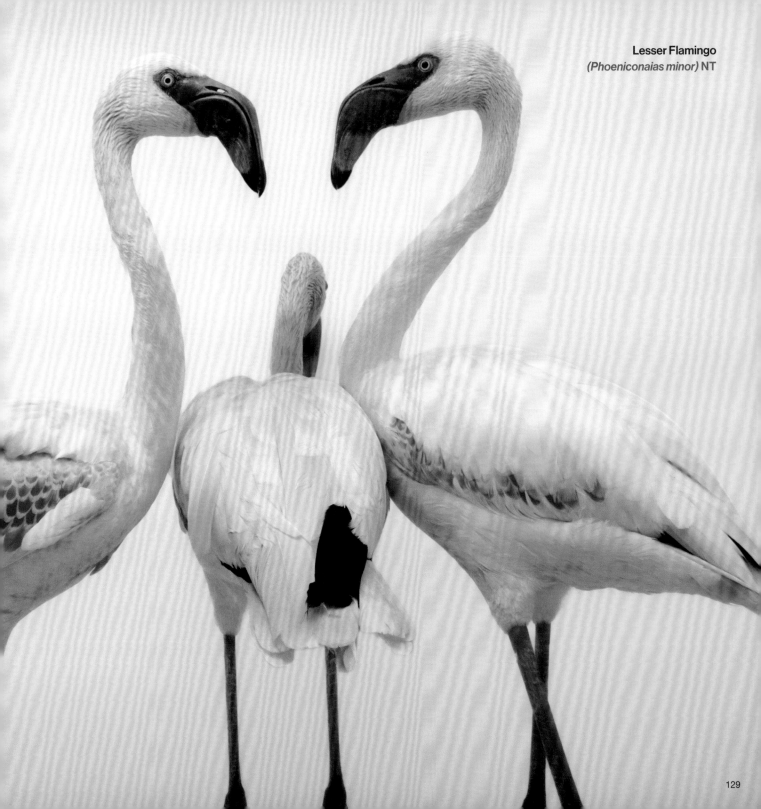

Australian Pelican *(Pelecanus conspicillatus)* LC

The beak of an Australian Pelican is half a meter long and can hold three gallons of water.

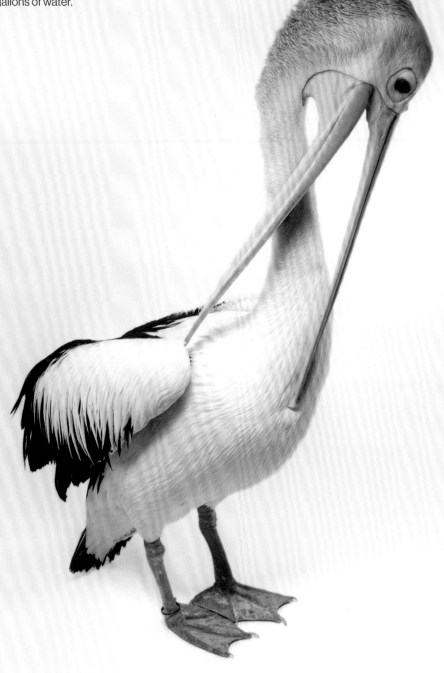

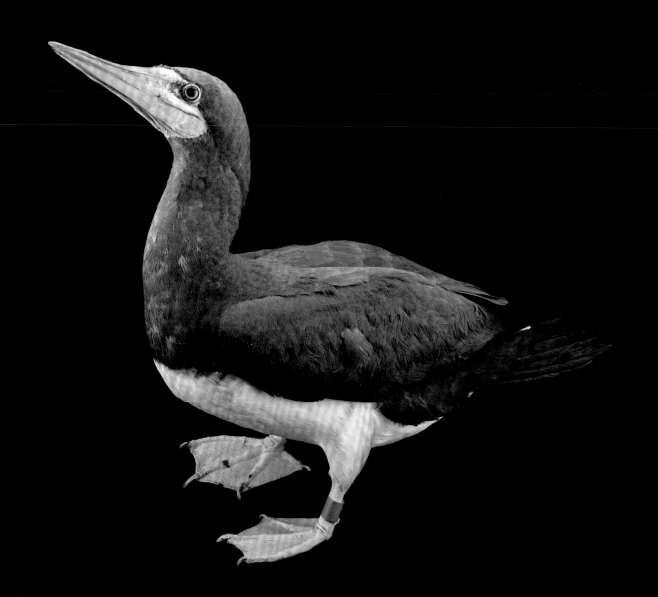

Brown Booby *(Sula leucogaster)* LC

To grab fish near the ocean's surface,
the Brown Booby plunge-dives in the water.

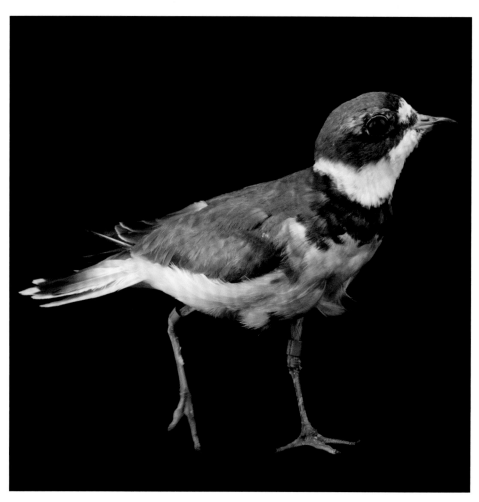

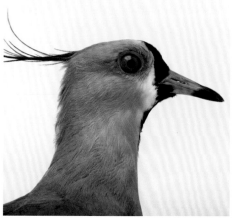
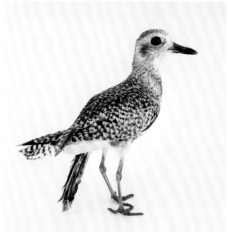
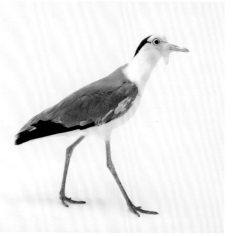
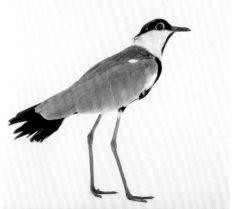

A PASSEL OF PLOVERS

A common sight on shorelines, plovers are small and medium wading birds. There are 60-some species of plover, scatted around the world (except for the Sahara and the poles), mainly in water-adjacent habitats. Unlike longer-beaked shorebirds, plovers have short bills and hunt by sight, standing stock-still while spotting their prey. They tend to run and pause in short bursts, as if playing a game of freeze.

OPPOSITE, CLOCKWISE FROM TOP LEFT: **Semipalmated Plover** (Charadrius semipalmatus) LC **Killdeer** (Charadrius vociferus) LC **Southern Lapwing** (Vanellus chilensis) LC **Spur-winged Lapwing** (Vanellus spinosus) LC **Masked Lapwing** (Vanellus miles) LC **Grey Plover** (Pluvialis squatarola) LC THIS PAGE, CLOCKWISE FROM TOP LEFT: **Masked Lapwing, juvenile** (Vanellus miles) LC **Snowy Plover** (Charadrius nivosus) NT **Piping Plover** (Charadrius melodus) NT

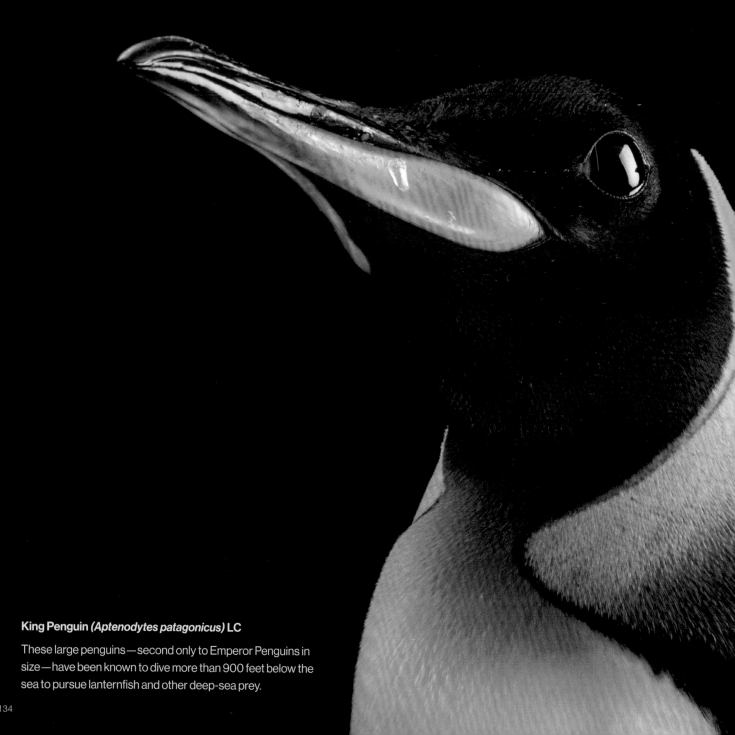

King Penguin *(Aptenodytes patagonicus)* **LC**

These large penguins—second only to Emperor Penguins in size—have been known to dive more than 900 feet below the sea to pursue lanternfish and other deep-sea prey.

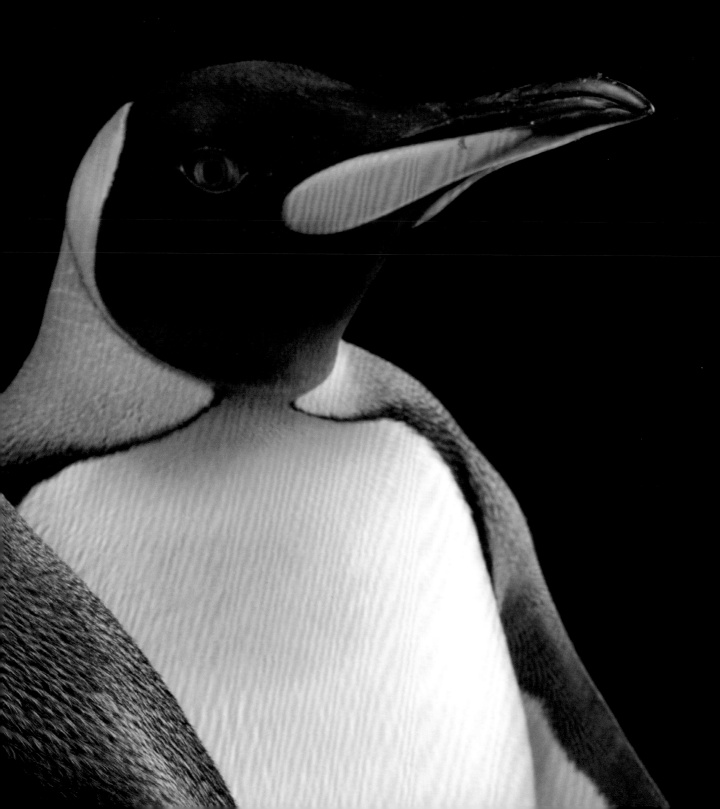

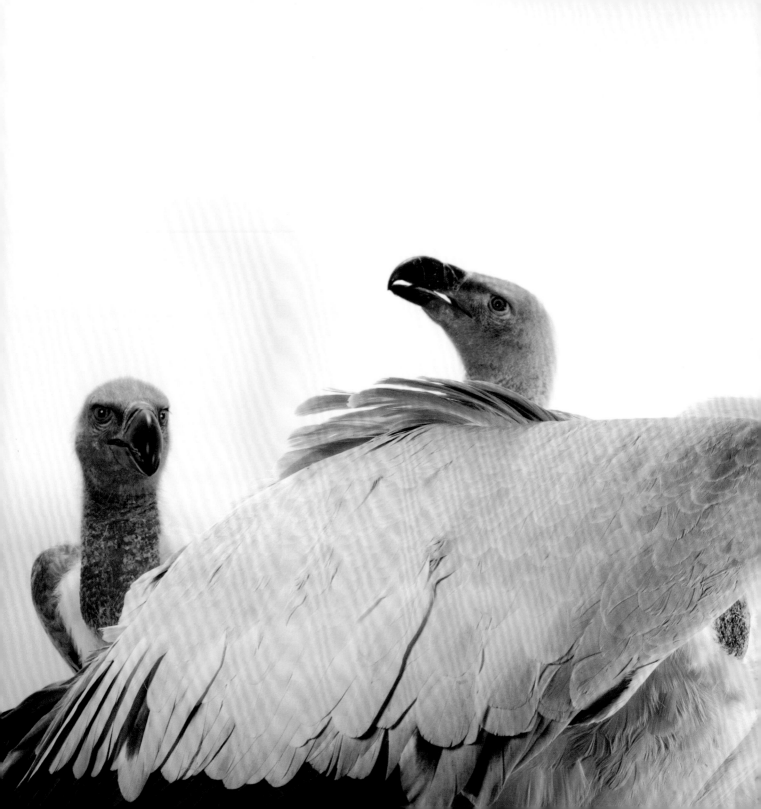

SUITED FOR SCAVENGING

Vultures are nature's garbage disposals. They rid the landscape of putrid carcasses, and for this they are often disparaged as ugly, creepy, and filthy. But they should be celebrated for helping to keep the world clean and the circle of life moving.

These birds deserve more credit, as they are among nature's most fascinating creatures. On the wing, vultures soar with confidence and elegance, rising on hot thermals with hardly a flap. Their bare heads, adorned in some species with bright colors, are kept fastidiously clean. Many vultures are surprisingly shy, nesting only in remote cliffs and caves. Some use a keen sense of smell to find food, while others rely on sharp, long-distance vision.

A vulture's stomach is corrosively acidic, able to sterilize even botulism and anthrax spores. Accordingly, vulture poop is not infectious — it could actually, in a pinch, work as a sanitizer.

Cape Griffon *(Gyps coprotheres)* **EN**

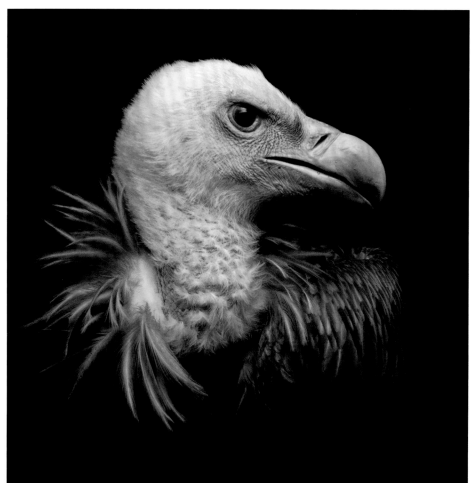

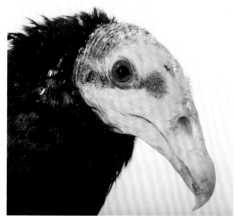
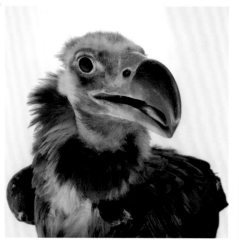
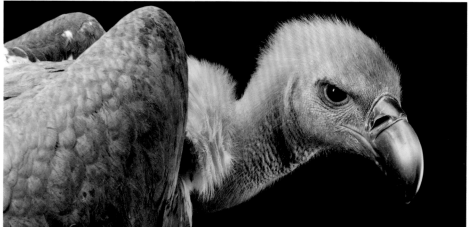

VULTURE CULTURE

Most vultures have hooked beaks (for tearing flesh), bare heads (to stay clean and regulate body temperature), and long, broad wings for efficient soaring. Up close, these birds are quiet and curious. They are found on nearly every continent: Only Australia and Antarctica have no native species. Some vultures are sociable, gathering to feast on large carcasses together. In some places, a group of feeding vultures is called a "wake."

OPPOSITE, CLOCKWISE FROM TOP LEFT: **Himalayan Griffon** *(Gyps himalayensis)* NT **Egyptian Vulture** *(Neophron percnopterus ginginianus)* EN **Greater Yellow-headed Vulture** *(Cathartes melambrotus)* LC **White-rumped Vulture** *(Gyps bengalensis)* CR **Cinereous Vulture** *(Aegypius monachus)* NT THIS PAGE, CLOCKWISE FROM TOP: **Red-headed Vulture** *(Sarcogyps calvus)* CR **American Black Vulture** *(Coragyps atratus)* LC **Palm-nut Vulture** *(Gypohierax angolensis)* LC

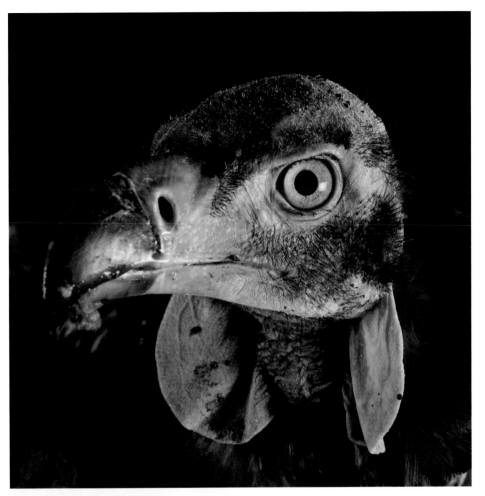

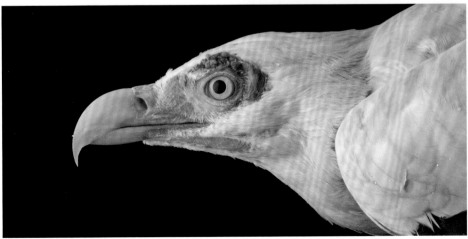

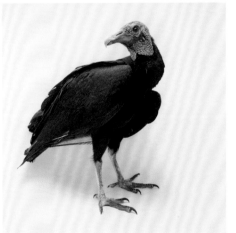

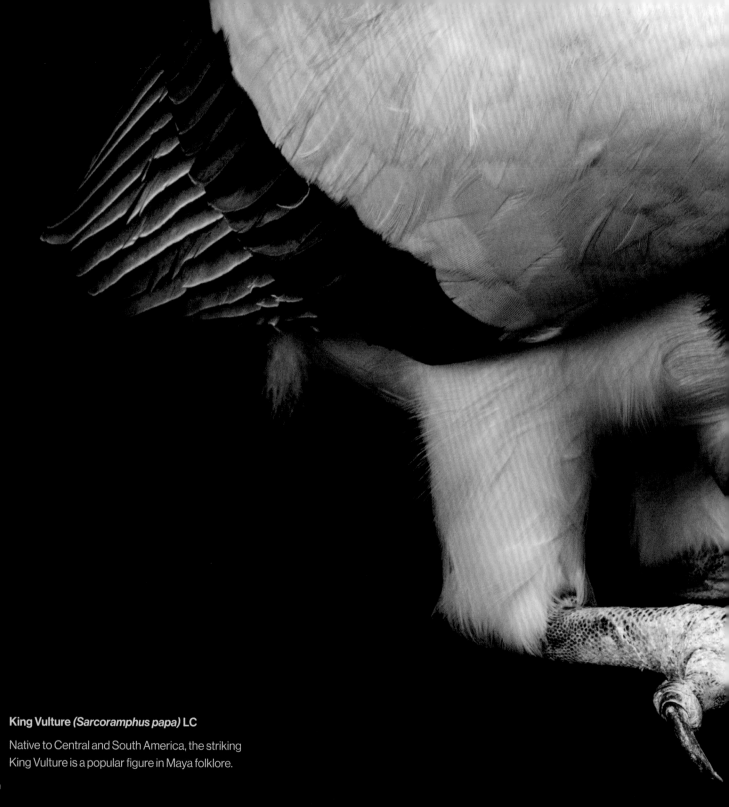

King Vulture *(Sarcoramphus papa)* **LC**

Native to Central and South America, the striking
King Vulture is a popular figure in Maya folklore.

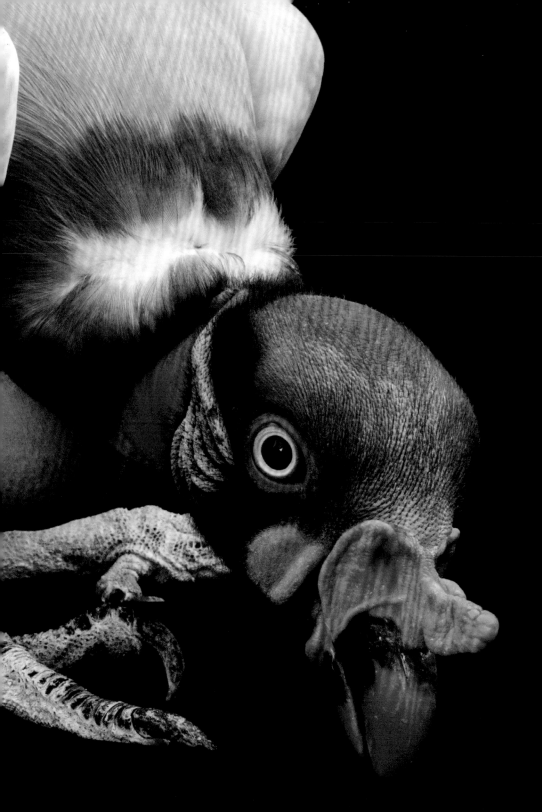

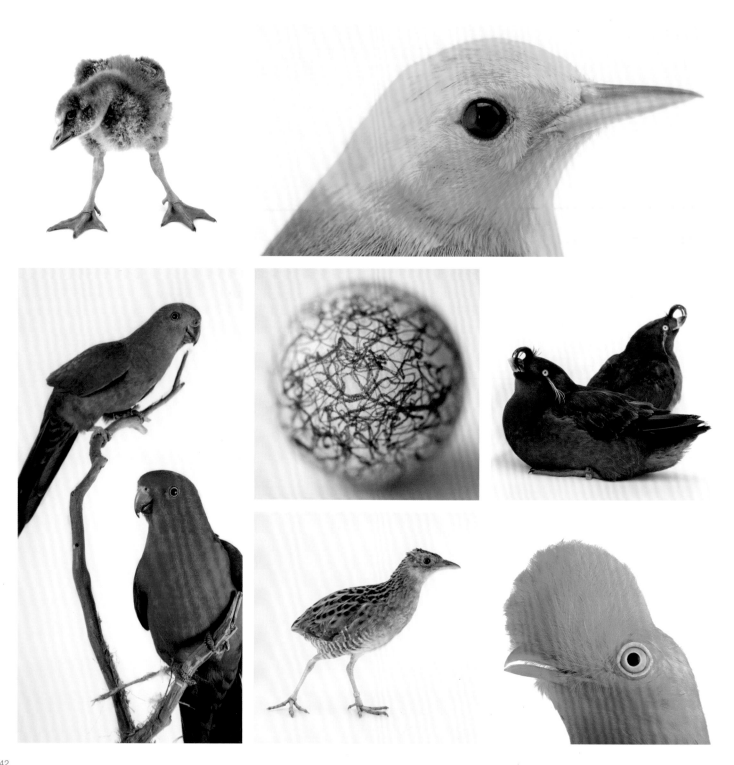

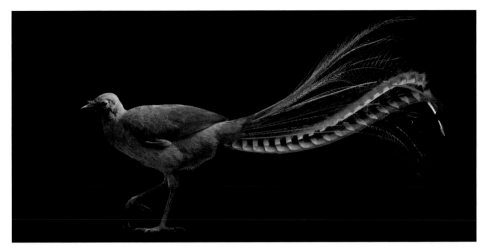

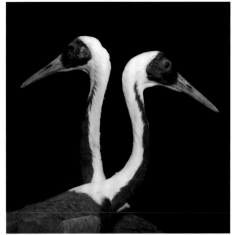

5 / NEXT GENERATION

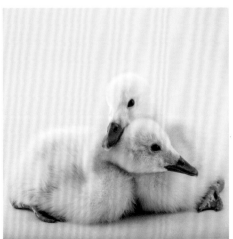

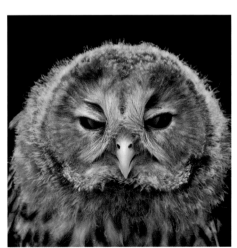

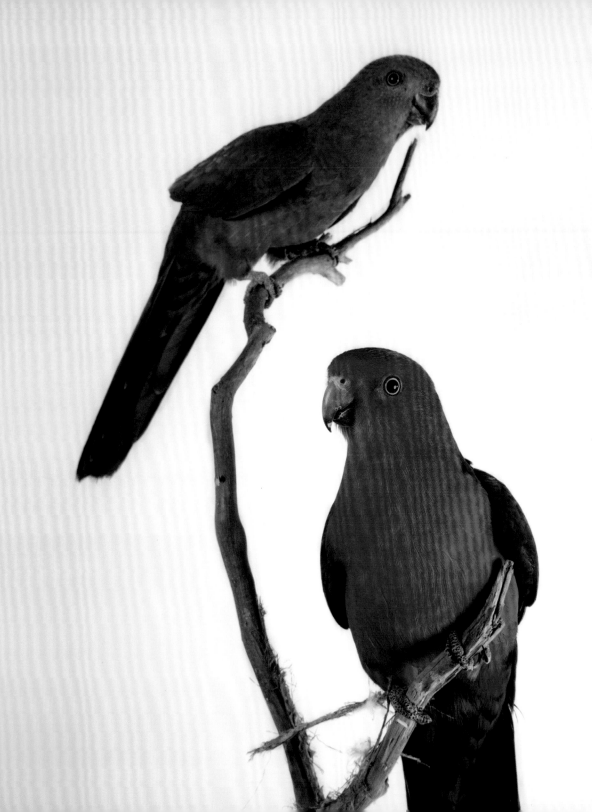

COURTSHIP COMPLEXITIES

Like all other living things, birds must pass on a legacy—or, more literally, replace themselves—for their species to survive. The story of reproduction is as old as the birds and the bees.

Sometimes it's hard to imagine how, with all the complications involved, one generation successfully creates another. So many things must go exactly right: Males and females have to find each other, songs must be sung, and dances danced. Youngsters need nurture and guidance (some more than others!) to stay healthy and grow. Each individual plays its part in an intricate flow of genes, transferring the information necessary for a new cohort to take on the world.

Yet somehow, tens of millions of generations of birds have given rise to the ones we see today. They've developed complex systems to ensure continuity, from the courtship display of a Superb Lyrebird to the pointy, speckled egg of a Common Murre—because no matter how many generations have passed, the whole future depends on the next one.

Australian King-Parrot (*Alisterus scapularis*) **LC**

As with many birds, male and female Australian King-Parrots have different color presentations, with the male being brighter and showier.

Superb Lyrebird *(Menura novaehollandiae)* **LC**

One of the world's largest songbirds, the Superb
Lyrebird is easily identifiable by its long, elaborate
tailfeathers.

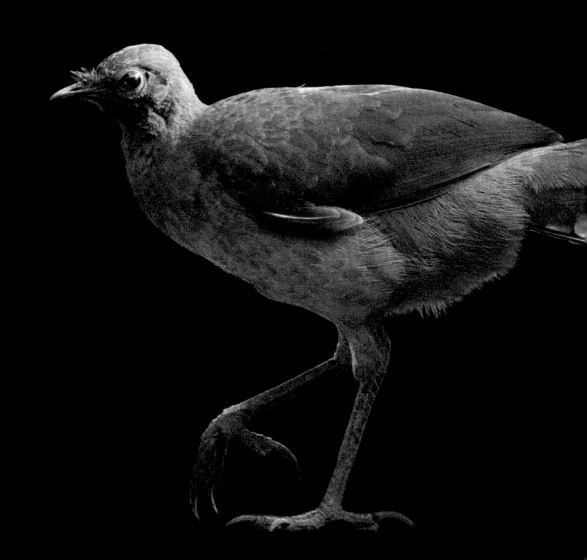

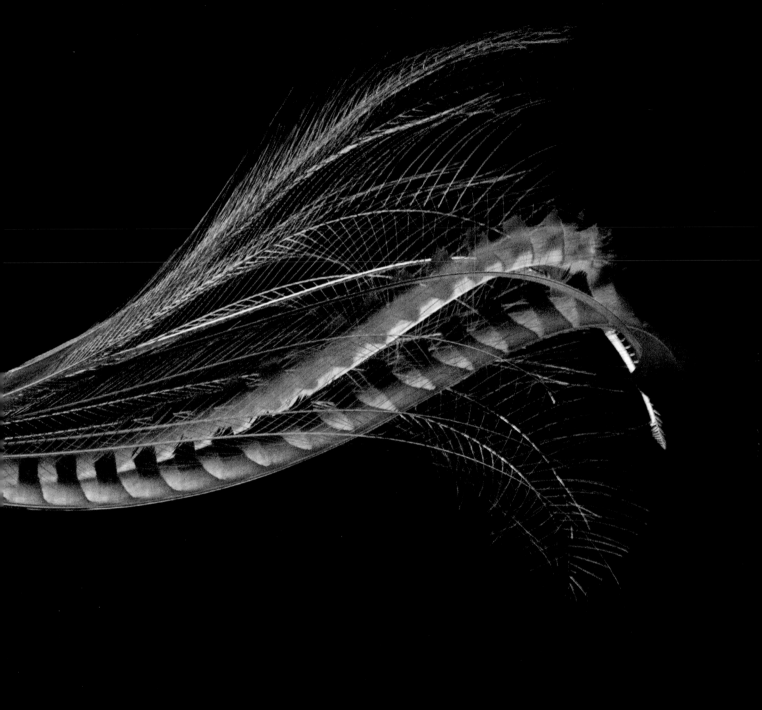

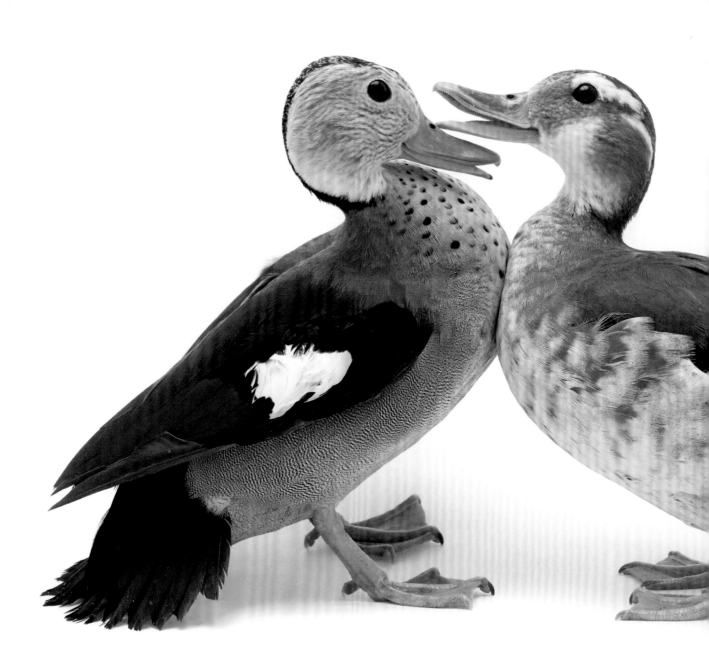

Ringed Teal *(Callonetta leucophrys)* LC

MALE & FEMALE

In many bird species, the sexes look alike (at least to the human eye). But in others, they appear remarkably different. Male and female Eclectus Parrots, for instance, are so distinct that for many years they were thought to be separate species.

These contrasts can give clues about nesting habits. Monogamous parents that share incubation and feeding duties, like geese, are often indistinguishable from each other. In species in which the mother rears the young, including many ducks, males and females may look very different. The female needs camouflage to sit on the nest while an idle male can afford to be conspicuously flashy.

It might seem unfair that males get to be more colorful, but females take note: It's because of you! The bright plumage of male birds is driven by sexual selection. In other words, those colors evolved because females picked the showiest mates—a sign of health and vitality.

Rosy-faced Lovebird
(Agapornis roseicollis) LC

Though they look similar, the male Rosy-faced Lovebird has a brighter red head than the female.

Crested Auklets share the duties of incubation and caring for their chicks — males and females are nearly indistinguishable from each other.

Malayan Peacock-Pheasant
(Polyplectron malacense) VU

Adult Malayan Peacock-Pheasants all have spotted tails, but the female *(left)* is slightly smaller and lacks the male's pointy crest.

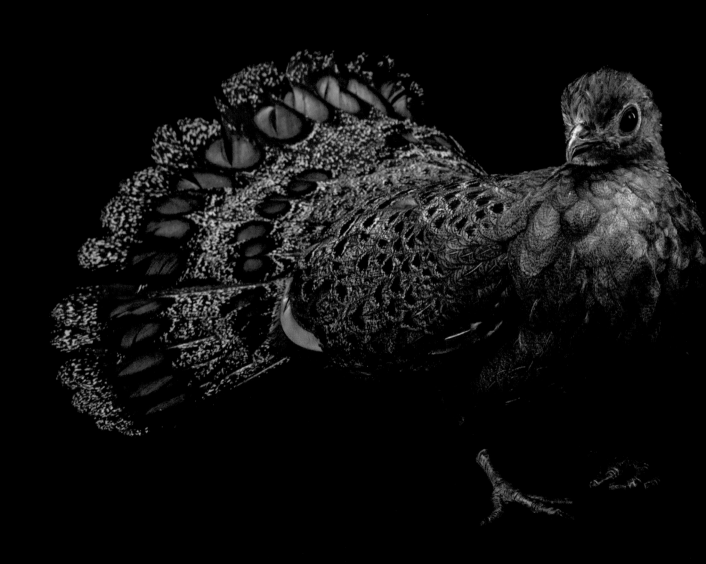

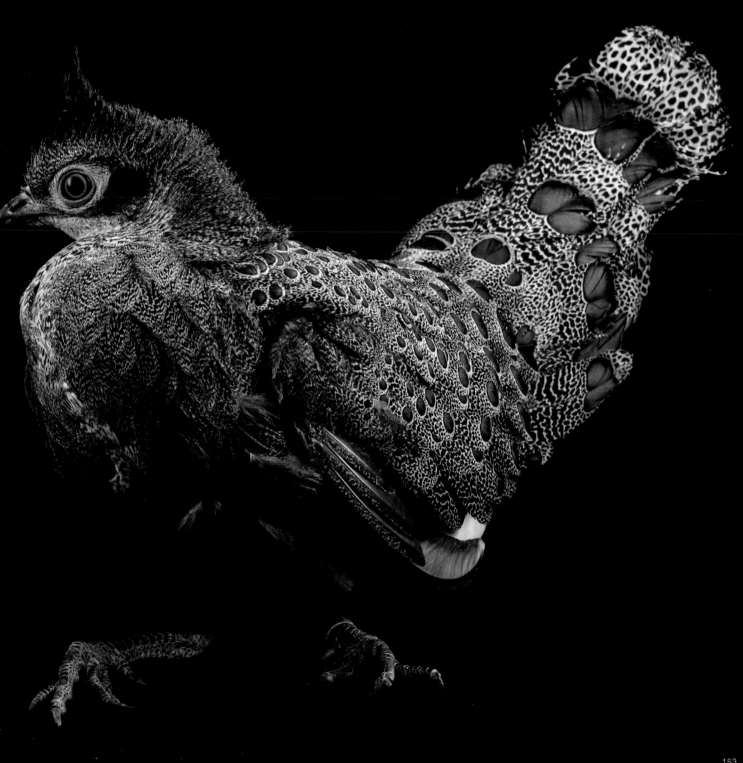

MATING CALLS

The melodies of nightingales and skylarks have inspired poets throughout history, although fewer have rhapsodized about the chain saw–like "song" of a Yellow-headed Blackbird or the grating call of a Corncrake. In the world of birds, vocalizations are as diverse and distinctive as appearances.

Birdsong has many practical uses. Males sing to defend their territories against other males, and parents sing to their chicks. Females of some species, especially in the tropics, join their mates in duets of such precision that to the untrained ear, it sounds like a single bird is singing. A few birds, including mockingbirds and starlings, can learn to incorporate elements of other species' songs into their own repertoire.

In courtship, sound is especially important because visuals only go so far. A song can carry across fields, through forests, and over rushing streams, announcing a bird's presence to any who might listen.

Corncrake (Crex crex) LC

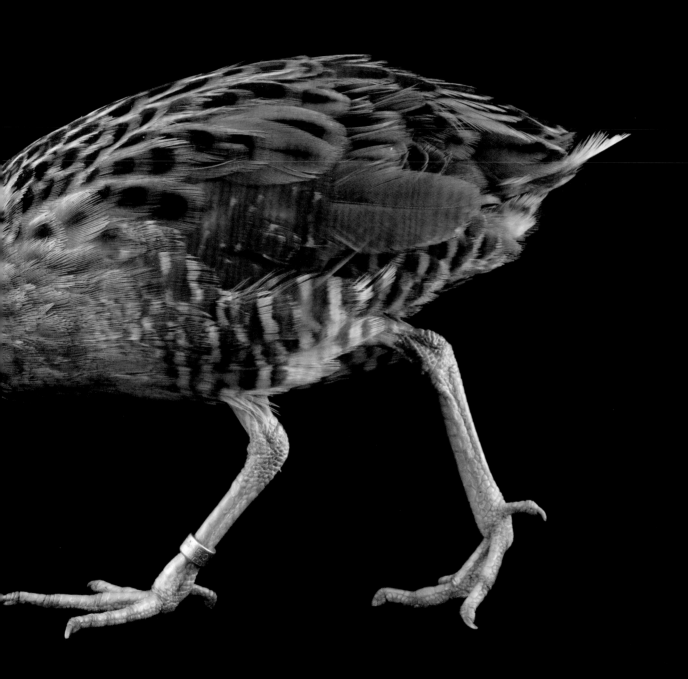

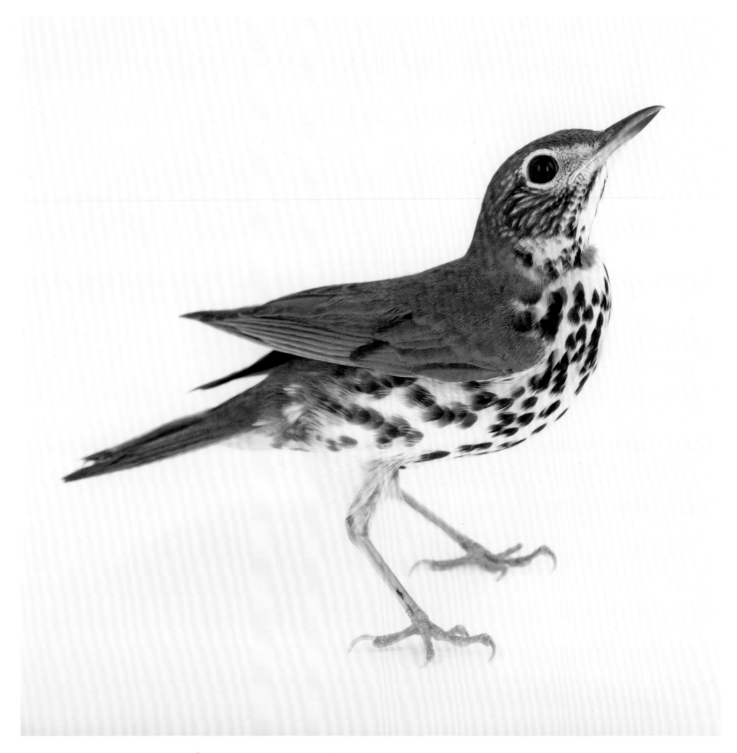

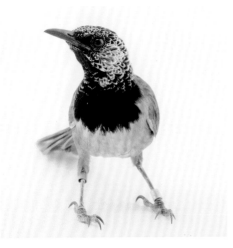

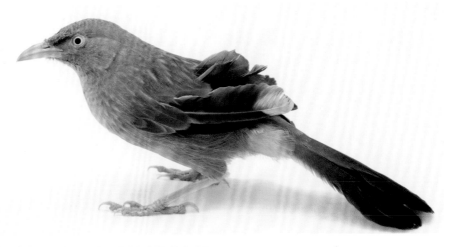

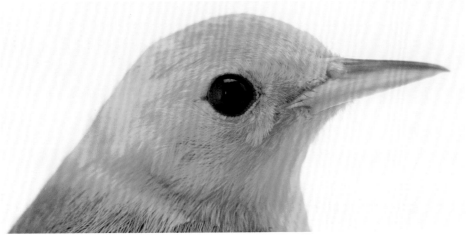

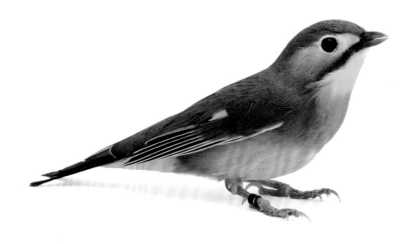

SONGS OF NOTE

Birdsongs have range. A Wood Thrush sings like a flute, a Yellow-headed Blackbird revs like a chain saw, other songbirds fill the notes in between.

OPPOSITE: **Wood Thrush** *(Hylocichla mustelina)* NT THIS PAGE, CLOCKWISE FROM TOP LEFT: **Oriole Warbler** *(Hypergerus atriceps)* LC **Jungle Babbler** *(Turdoides striata)* LC **Yellow-headed Blackbird** *(Xanthocephalus xanthocephalus)* LC **Red-billed Leiothrix** *(Leiothrix lutea)* LC **Prothonotary Warbler** *(Protonotaria citrea)* LC

THE MATING GAME

When a bird sets out to choose a mate, fitness and commitment are the best indications of good breeding stock. Some birds are essentially slackers, too weak or inexperienced to properly care for their young. No bird wants to get stuck with a lazy partner.

Accordingly, some species size each other up by performing a courtship dance. Cranes are famed for their graceful routines, posturing with spread wings while alternately leaping in the air. Adolescent albatrosses sometimes dance for years on windswept islands before choosing one partner. And deep in the South American cloud forest, male Andean Cocks-of-the-rock caper in frenzies of ritualistic displays.

For sheer effort, it's hard to beat New Guinea's birds-of-paradise, which contort themselves into abstract shapes during dawn dance-offs. Endowed with bizarre plumes and loud songs, they are the ultimate performance artists.

Sandhill Crane (*Antigone canadensis*) LC

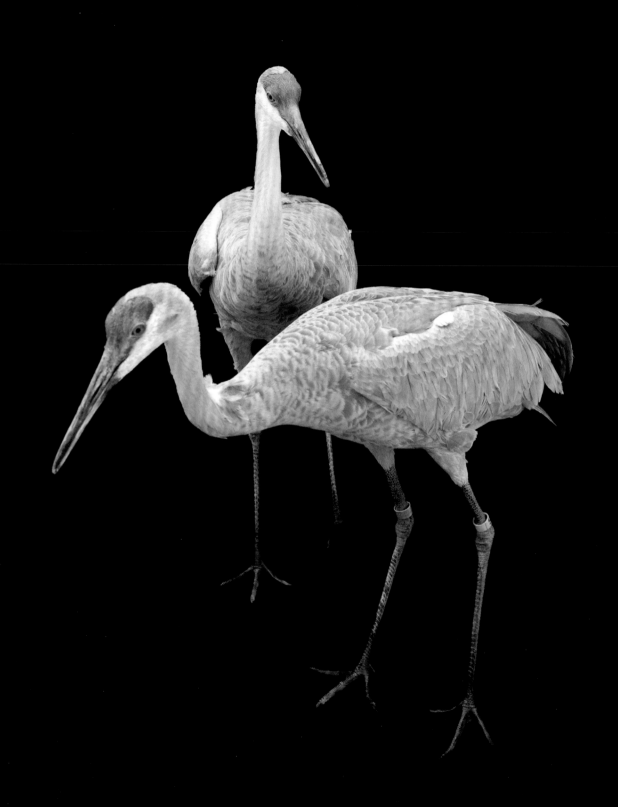

Superb Bird-of-Paradise *(Lophorina superba)* LC

A cape of iridescent feathers is the Superb
Bird-of-Paradise's accessory of choice while
dancing to attract a mate.

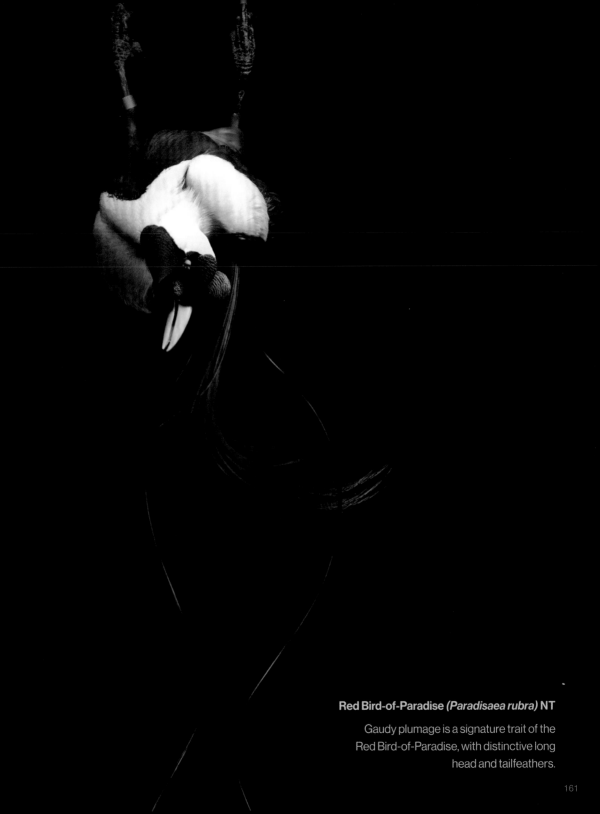

Red Bird-of-Paradise *(Paradisaea rubra)* **NT**

Gaudy plumage is a signature trait of the
Red Bird-of-Paradise, with distinctive long
head and tailfeathers.

Andean Cock-of-the-rock
(Rupicola peruvianus aequatorialis) LC

In the cloud forests of South America, male Andean Cocks-of-the-rock gather in competitive dance-offs to vie for the affection of passing females.

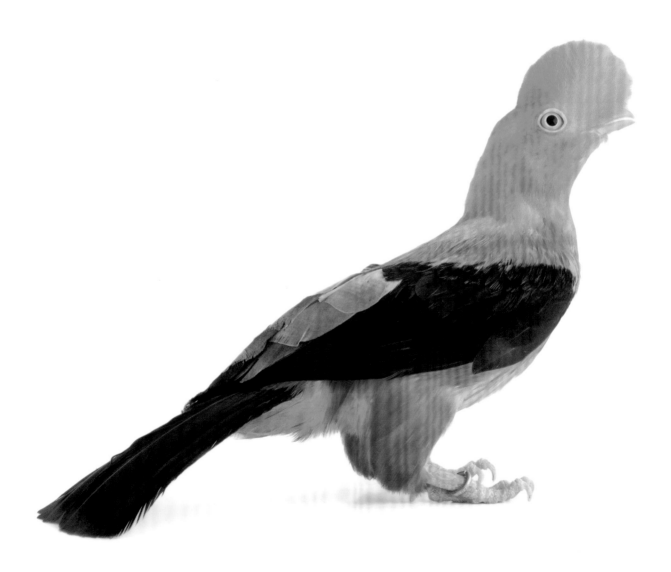

PARTNERSHIP PARAMETERS

About 90 percent of all birds are monogamous, sticking with a single partner—at least to some extent. Pairs often remain together to raise their young during the nesting season. A few species mate for life, while others are totally promiscuous—but most fall somewhere in between.

Swans, as a traditional symbol of enduring love, usually stick together for many years. Owls, cranes, vultures, penguins, kookaburras, eagles, and geese also form long-term bonds.

Hummingbirds split up immediately after copulating, as do some cowbirds, grouse, and sandpipers. Many songbirds pair up for one summer before going their separate ways, perhaps because their short life span doesn't especially motivate them for a longer commitment.

Monogamy doesn't imply fidelity, though; even albatrosses, which have "divorce" rates near zero, will occasionally raise chicks with different fathers.

Blue-winged Kookaburra *(Dacelo leachii)* LC

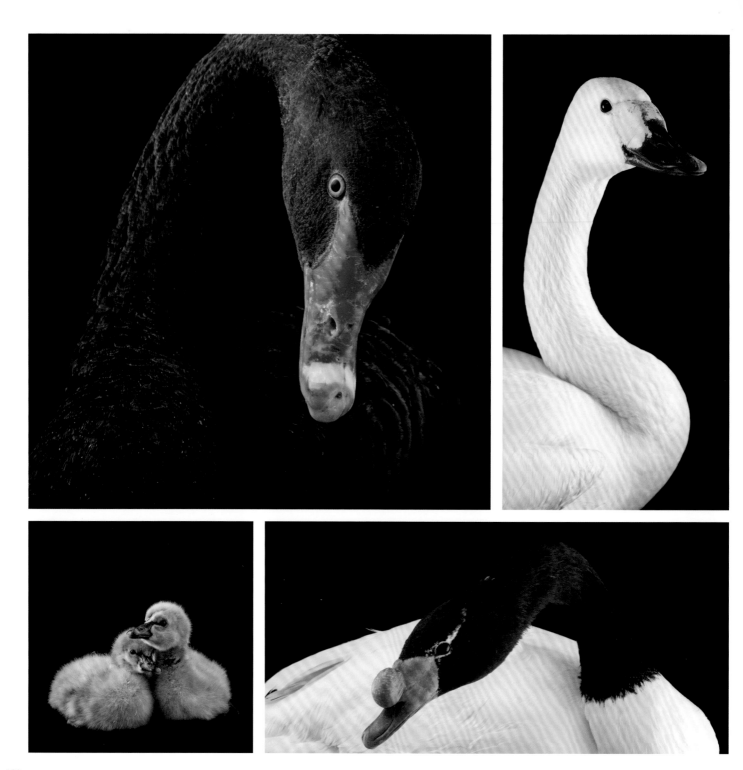

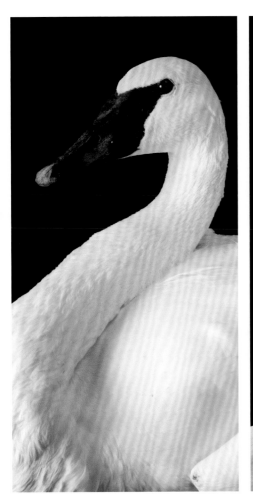

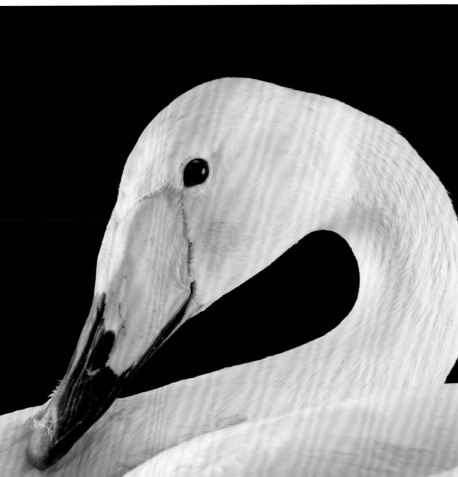

SWAN SONGS

Graceful and immaculate, swans are a traditional symbol of love and romance. The mating rituals of swans are an intricate and elaborate combination of songs and dances. But once a swan finds its mate, they're often tied together for a long time. Mating pairs form bonds that last for years, and sometimes for life, though they do occasionally "divorce." Swans will fiercely protect their mates, and especially their offspring. Young swans often stick around the nest for several months while they grow and develop, learning from their parents' examples.

OPPOSITE, CLOCKWISE FROM TOP LEFT: **Black Swan** (*Cygnus atratus*) LC **Tundra Swan** (*Cygnus columbianus*) LC **Black-necked Swan** (*Cygnus melancoryphus*) LC **Black Swan** (*Cygnus atratus*) LC THIS PAGE, CLOCKWISE FROM TOP LEFT: **Trumpeter Swan** (*Cygnus buccinator*) LC **Whooper Swan** (*Cygnus cygnus*) LC **Black-necked Swan** (*Cygnus melancoryphus*) LC

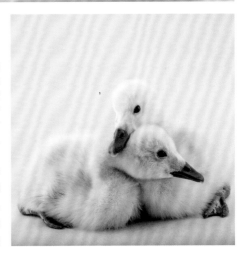

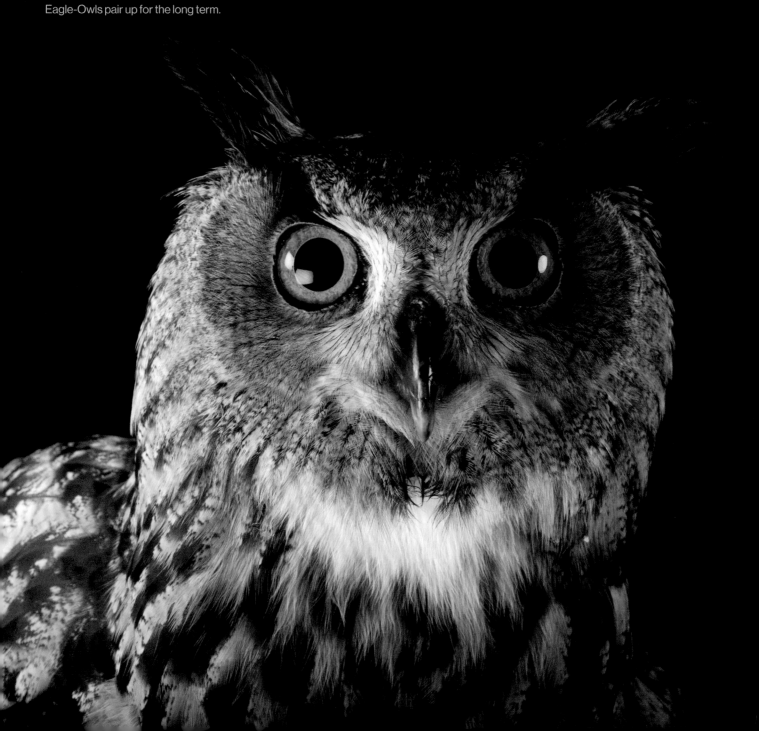

Eurasian Eagle-Owl *(Bubo bubo)* **LC**

Like many other owl species, Eurasian
Eagle-Owls pair up for the long term.

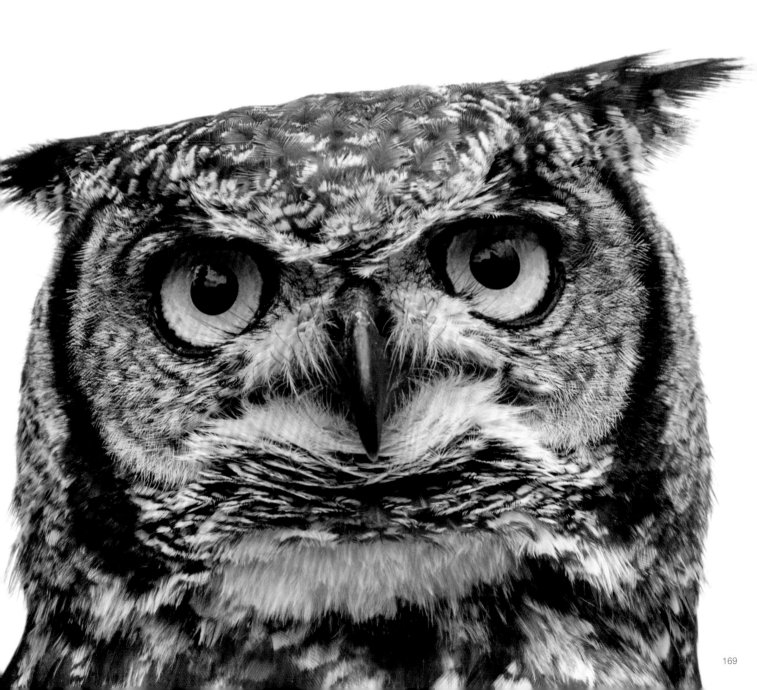

Spotted Eagle-Owl *(Bubo africanus)* LC

Although a female Spotted Eagle-Owl incubates
her eggs alone, the male brings her food at the nest.
Pairs often stay together for life.

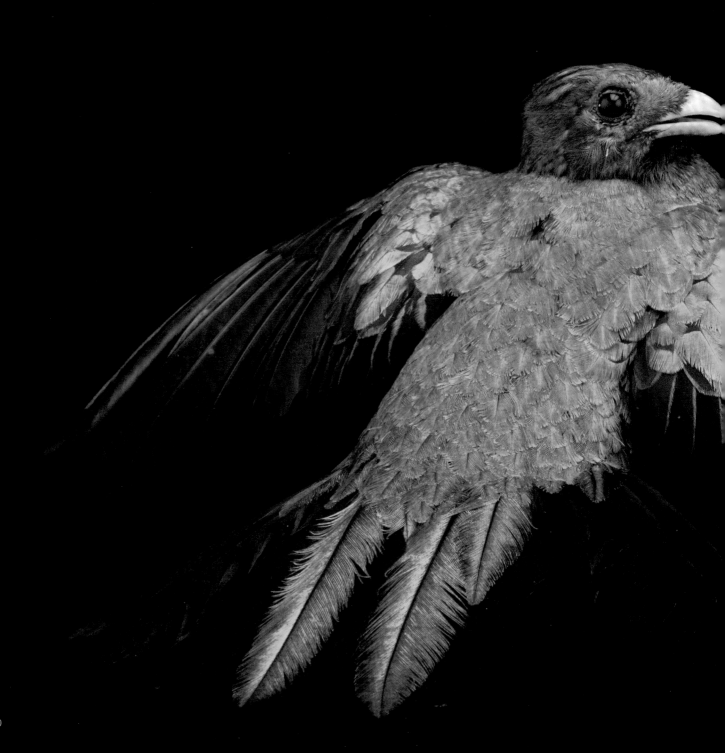

NESTING INSTINCTS

All birds must find a place to protect and incubate their eggs, whether it's in a pouch on top of the feet, in a tree cavity, or in an aerie the size of a bus. Bird nests inspire and amaze, but they are practical constructions: Once the eggs hatch, nests hold the chicks and keep them safe from any harm.

Imagine trying to build a home without arms, hands, or tools! Birds have evolved all kinds of solutions, from motmots that dig 10-foot-long tunnels to flamingos that pile up mud in vertical podiums.

Some species have figured out how to appropriate the work of others: Owls will move into crow nests, and many birds claim old woodpecker cavities. A few, including Eurasian cuckoos, sneak their eggs into other species' clutches, hoping the foster parents won't notice the difference.

Golden-headed Quetzal *(Pharomachrus auriceps)* LC

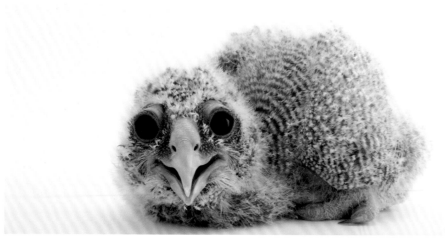

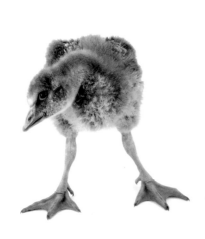
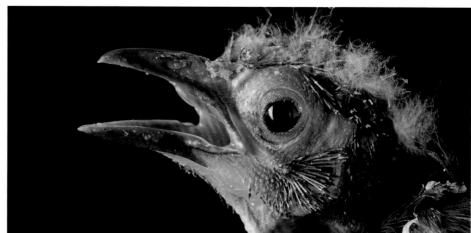
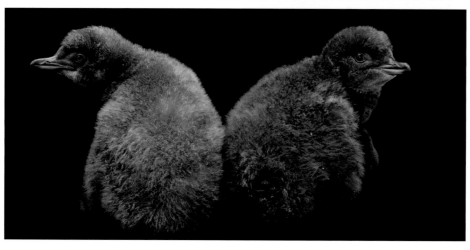
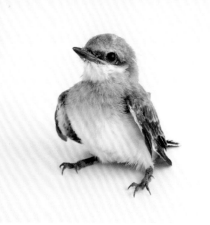

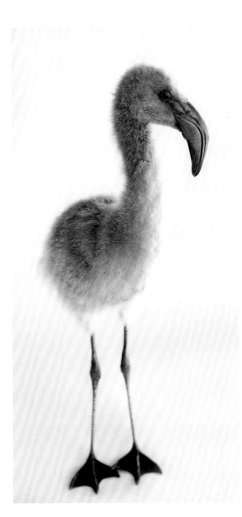

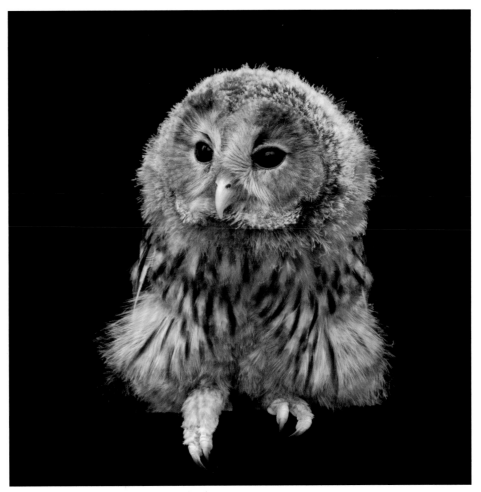

JUST HATCHED

Baby birds grow quickly, in some cases reaching adult size in just a few days. Those with more secure nests (in cavities or well-built structures) can take longer, but each day is fraught with exposure. A good nest gives chicks room to stretch their wings.

OPPOSITE, CLOCKWISE FROM TOP LEFT: **Verreaux's Eagle-Owl** (*Bubo lacteus*) LC **Common Murre egg** (*Uria aalge*) LC **Common Grackle** (*Quiscalus quiscula*) LC **Western Kingbird** (*Tyrannus verticalis*) LC **Little Penguin** (*Eudyptula minor*) LC **Hawaiian Goose** (*Branta sandvicensis*) VU THIS PAGE, CLOCKWISE FROM TOP LEFT: **Chilean Flamingo** (*Phoenicopterus chilensis*) NT **Ural Owl** (*Strix uralensis*) LC **Bufflehead** (*Bucephala albeola*) LC

Whooping Motmot *(Momotus subrufescens)* LC

The Whooping Motmot tunnels up to 10 feet into a dirt bank to lay its eggs. Instead of reusing the old burrow, these birds dig a new one each year.

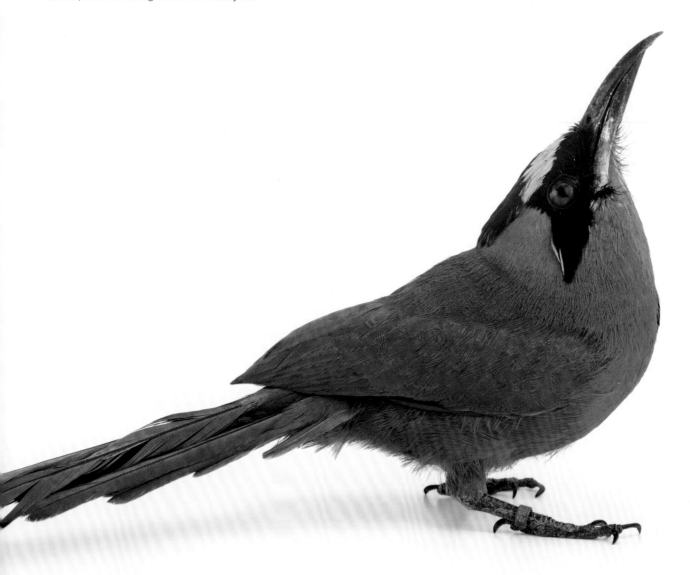

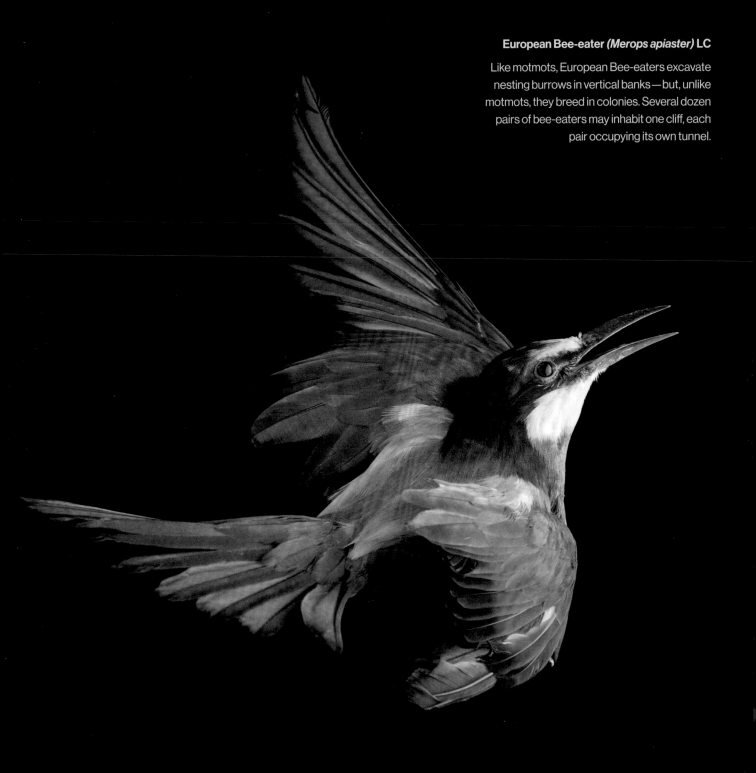

European Bee-eater *(Merops apiaster)* **LC**

Like motmots, European Bee-eaters excavate nesting burrows in vertical banks—but, unlike motmots, they breed in colonies. Several dozen pairs of bee-eaters may inhabit one cliff, each pair occupying its own tunnel.

6 / BIRD BRAINS

SOCIAL NATURE / EMOTION / INTELLIGENCE
184 188 192

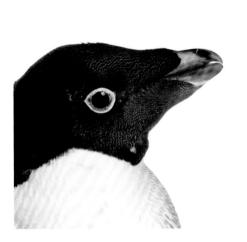
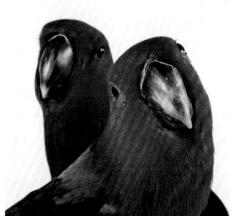
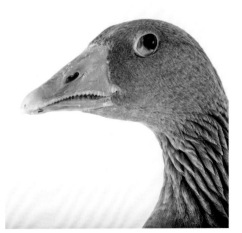

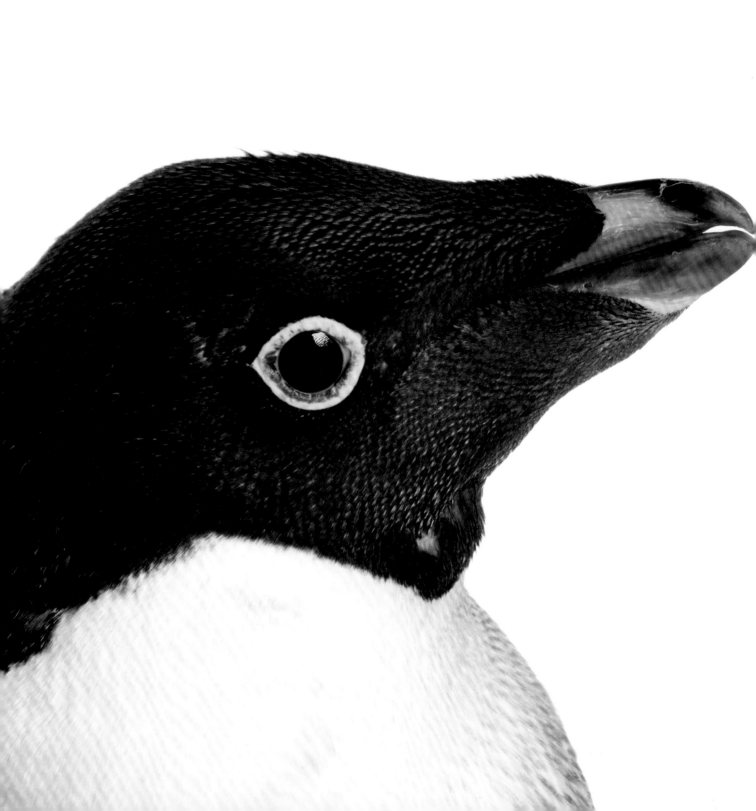

BIRD SMARTS

Nobody wants to be called a "bird brain," but research suggests that it should really be considered a compliment. The more we study bird behavior, the more we realize that birds have a complex system of thoughts, feelings, and emotions similar to people.

Hundreds of millions of years ago, humans and birds diverged from a common ancestor, so our brains have developed in many different ways over time. But it's wrong to think that birds lack intellect; in fact, some birds share characteristics with us shown by no other animal. Anyone who has spent time around crows, ravens, or parrots knows that these curious creatures are capable of sophisticated mental feats.

The distinct pressures and environments that birds inhabit have shaped the way their minds work—some have been known to use simple tools, and others can perfectly mimic the sounds of other animals (even humans). They think differently than us, but just because we are smart doesn't mean birds can't think on their feet, too.

Adélie Penguin *(Pygoscelis adeliae)* **LC**

Birds have evolved mental capabilities in tune with their habits and environments. The Adélie Penguin is perfectly adapted for life on the ice and snow of Antarctica.

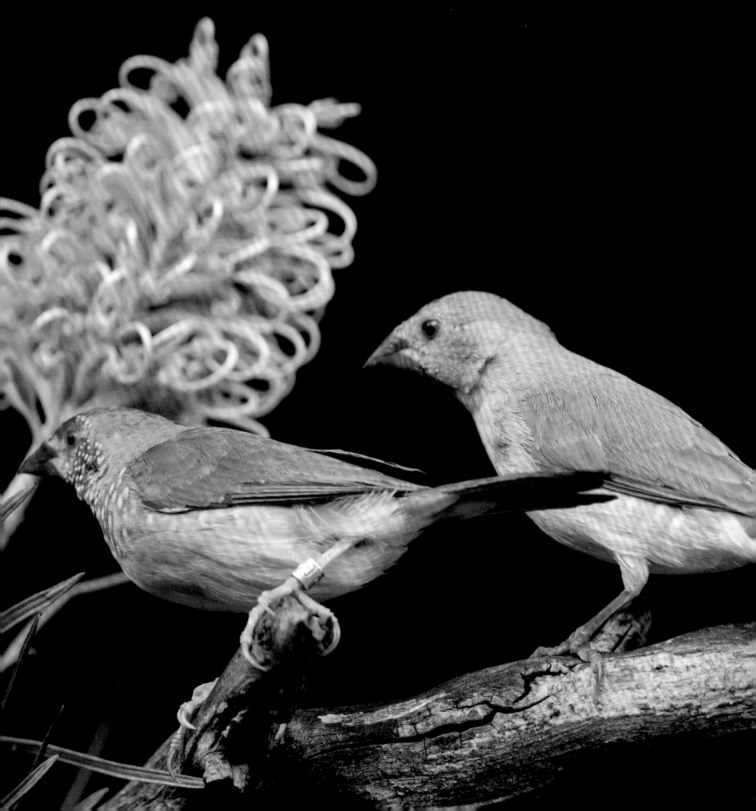

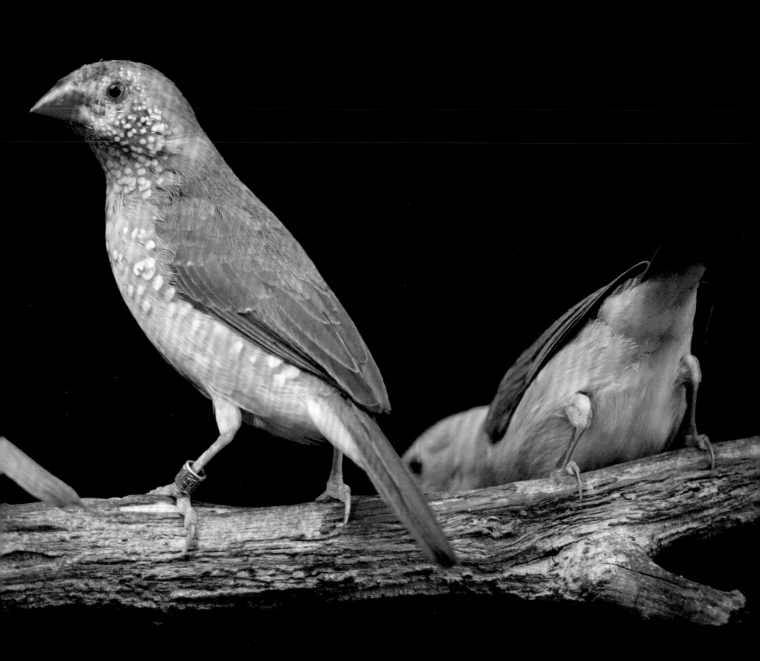

Star Finch *(Neochmia ruficauda)* LC

Out on the wild Australian grasslands, the
Star Finch survives on seeds and grain.

Red-billed Blue Magpie *(Urocissa erythroryncha)* LC

Like many birds in the corvid family, the Red-billed Blue
Magpie of East Asia is a sociable species.

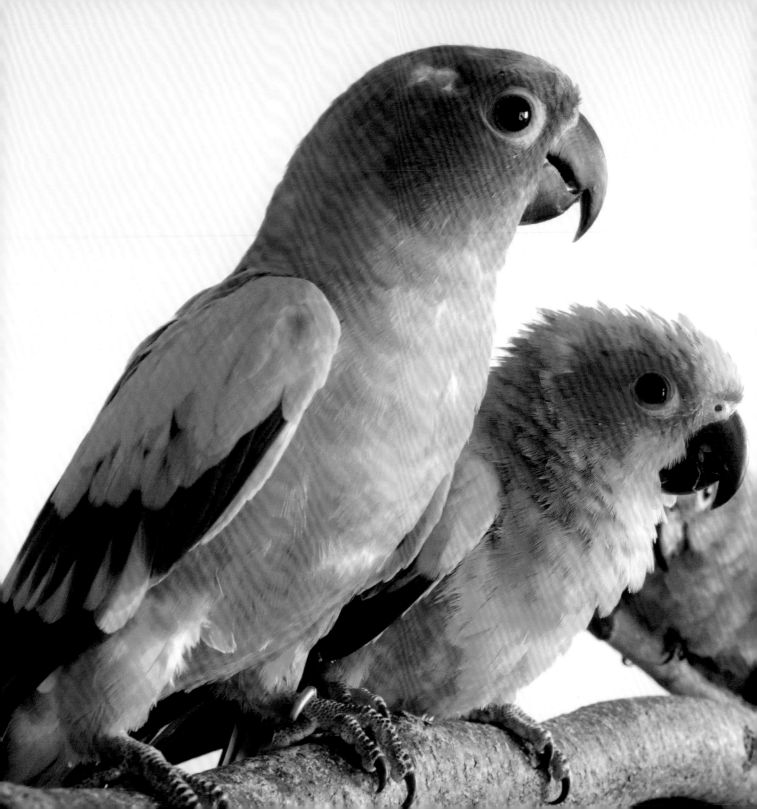

STRENGTH IN NUMBERS

In some animals, intelligence arises from regular interactions with both friends and foes. Social species tend to have bigger brains—perhaps to help them keep tabs on their allies and competitors.

Many birds form groups, so does that alone make them smarter? It probably depends on the bird. Large starling flocks apparently have no leaders, and they behave like mobs. A variety of other birds live in hierarchical groups that are organized according to specific relationships; they maintain these social structures over time. Parrots and crows are highly gregarious; so are some hawks, owls, woodpeckers, chickadees, finches, fairywrens, and many others. Even chickens, not generally known for their smarts, keep a strict social order within the coop.

Sun Parakeet (*Aratinga solstitialis*) **EN**

Common Moorhen
(Gallinula chloropus) LC

These birds form monogamous pairs
and sometimes gather on freshwater
ponds, but the species does not have a
complex social structure.

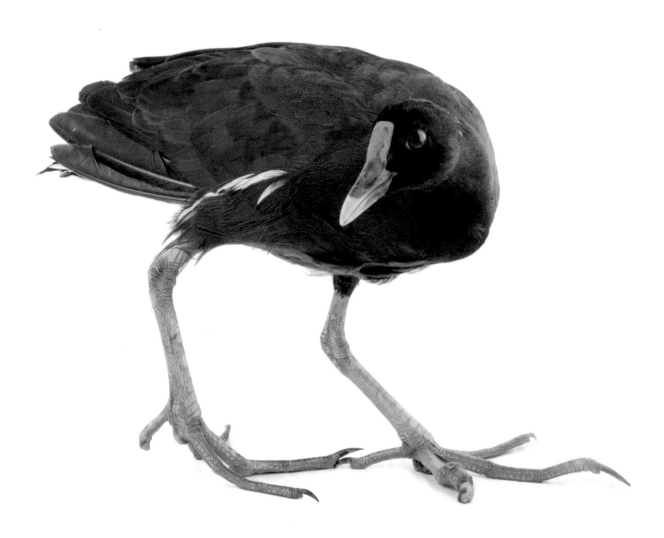

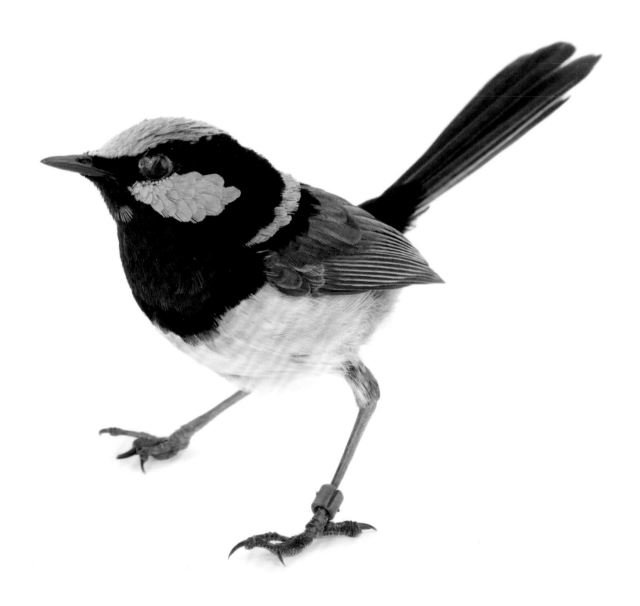

Superb Fairywren *(Malurus cyaneus)* LC

Fairywrens maintain family groups year-round, and subordinate birds cooperate to raise the chicks. This social organization does not translate into fidelity, though: Most chicks are sired by fathers outside the family unit.

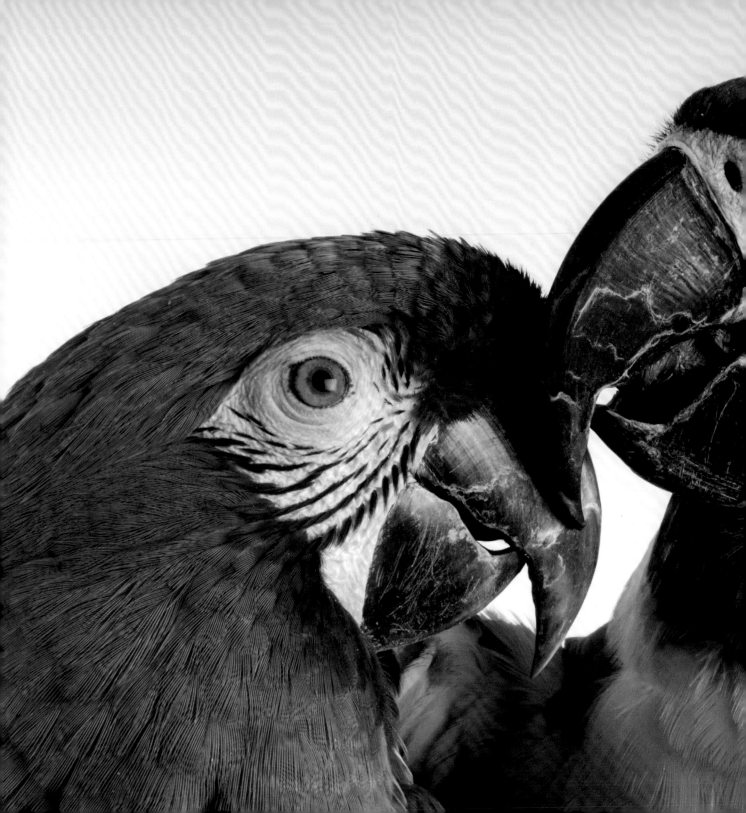

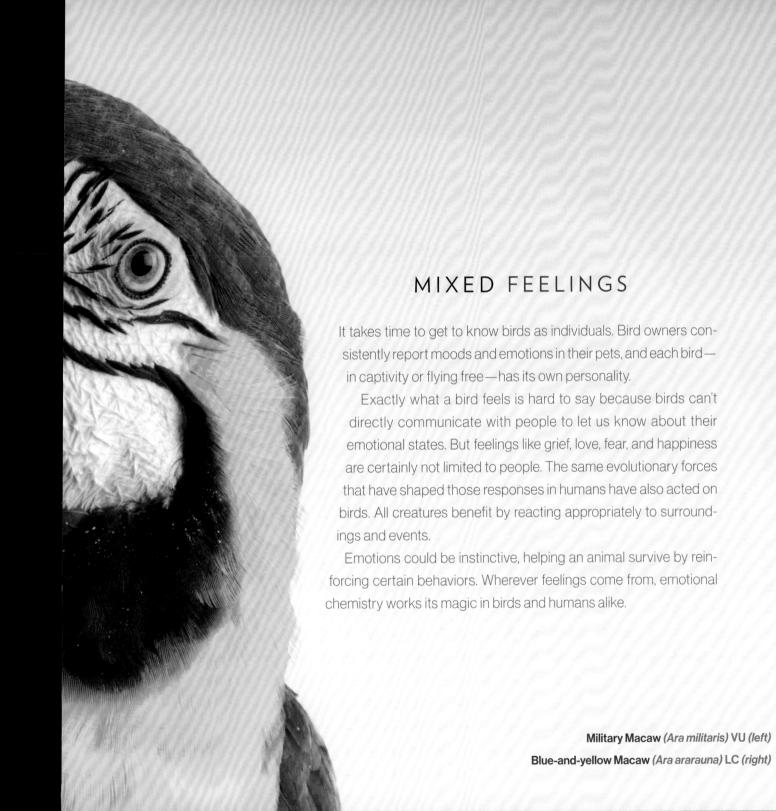

MIXED FEELINGS

It takes time to get to know birds as individuals. Bird owners consistently report moods and emotions in their pets, and each bird—in captivity or flying free—has its own personality.

Exactly what a bird feels is hard to say because birds can't directly communicate with people to let us know about their emotional states. But feelings like grief, love, fear, and happiness are certainly not limited to people. The same evolutionary forces that have shaped those responses in humans have also acted on birds. All creatures benefit by reacting appropriately to surroundings and events.

Emotions could be instinctive, helping an animal survive by reinforcing certain behaviors. Wherever feelings come from, emotional chemistry works its magic in birds and humans alike.

Military Macaw *(Ara militaris)* **VU** *(left)*

Blue-and-yellow Macaw *(Ara ararauna)* **LC** *(right)*

Apostlebird *(Struthidea cinerea)* **LC**

In the dry country of east Australia, Apostlebirds
travel in noisy family groups of up to 20 birds.

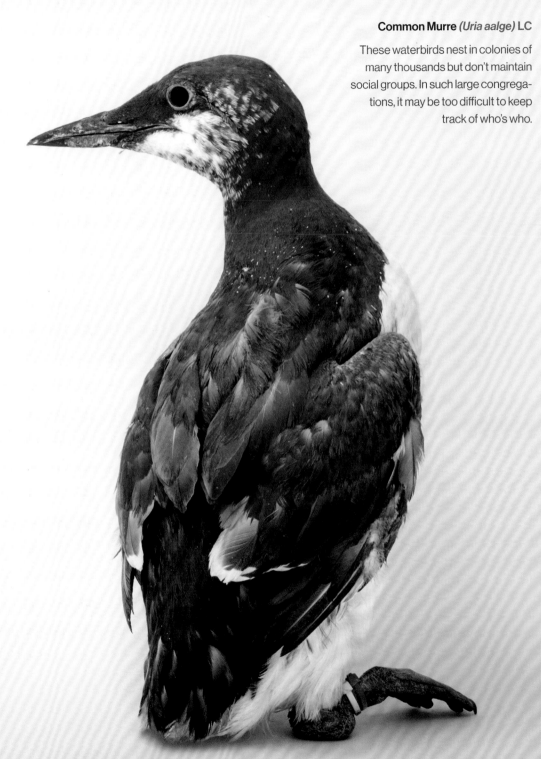

Common Murre *(Uria aalge)* LC

These waterbirds nest in colonies of many thousands but don't maintain social groups. In such large congregations, it may be too difficult to keep track of who's who.

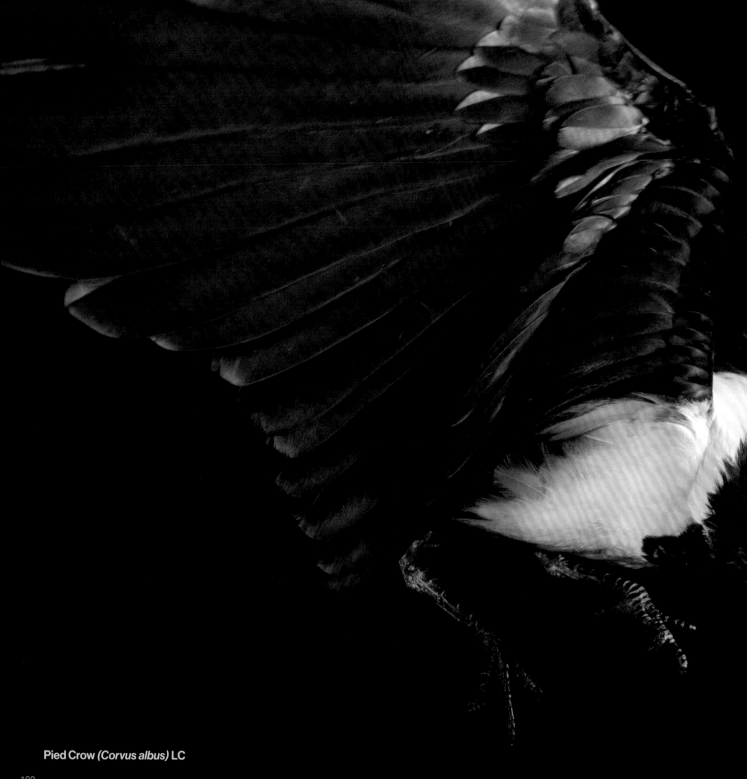

Pied Crow *(Corvus albus)* LC

SIGNS OF
INTELLIGENCE

Among all birds, the corvids (crows, ravens, magpies, jays, jackdaws, rooks, choughs, treepies, and nutcrackers) and parrots (nearly 400 species) are the smartest, at least as judged by the human definition of intelligence.

Like people, these birds are naturally social, develop over a long time, and have relatively large brains. Studies on communication, counting, tool use, learning, and self-awareness indicate that corvids and parrots can and do engage in creative, abstract thought.

Other species, like bowerbirds and bee-eaters, show signs of cleverness, and it's possible that as-yet-unrecognized geniuses are still hiding in the bird world. The search for avian intelligence is still fairly new. Only in the past decade have birds been attributed a "theory of mind," able to conceive that another has a viewpoint separate from its own.

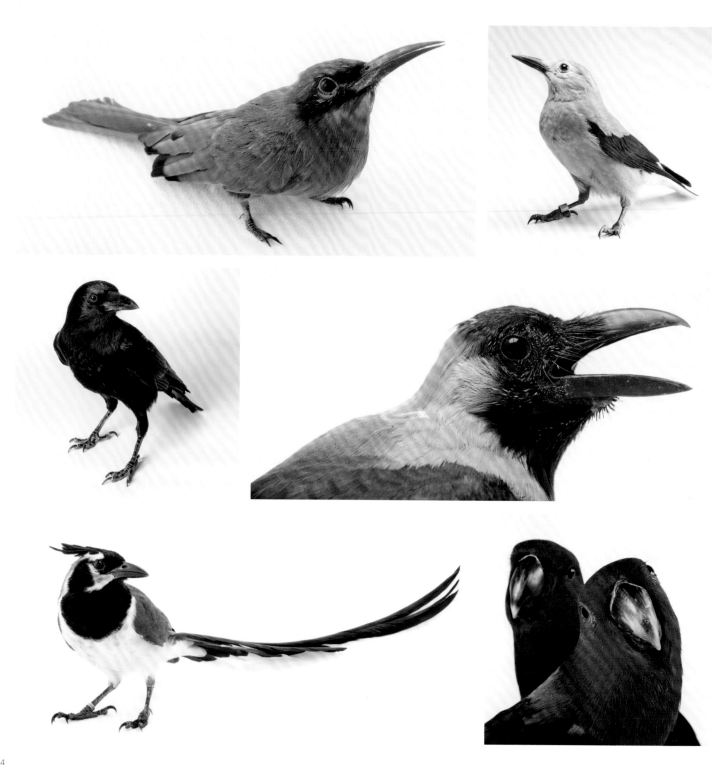

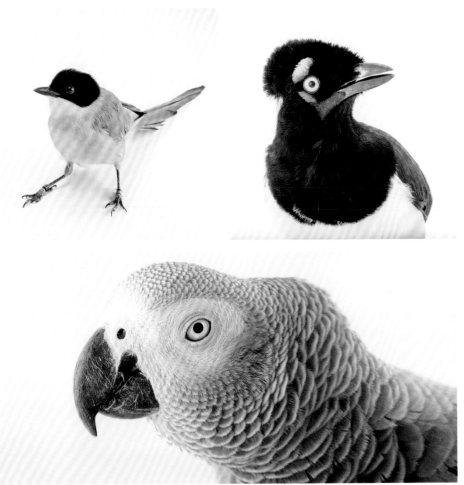

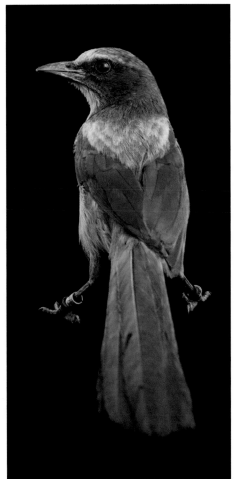

APPROACHING GENIUS

Crows, ravens, jays, magpies, and other corvids—as well as parrots—are commonly regarded as the most intelligent families of birds. In studies, these birds have shown the ability to use complex reasoning and even pick up a little bit of human language. One Gray Parrot named Alex was famous for being part of a 30-year-long experiment where he learned to communicate in basic English. Other families of birds, such as bee-eaters, have their own claims to cleverness. These birds are generally curious, social, widespread, and long-lived.

OPPOSITE, CLOCKWISE FROM TOP LEFT: **Red-throated Bee-eater** *(Merops bulocki)* LC **Clark's Nutcracker** *(Nucifraga columbiana)* LC **House Crow** *(Corvus splendens)* LC **Eclectus Parrot** *(Eclectus roratus)* LC **Black-throated Magpie-Jay** *(Cyanocorax colliei)* LC **American Crow** *(Corvus brachyrhynchos)* LC THIS PAGE, CLOCKWISE FROM TOP LEFT: **Asian Azure-winged Magpie** *(Cyanopica cyanus)* LC **Plush-crested Jay** *(Cyanocorax chrysops)* LC **Florida Scrub-Jay** *(Aphelocoma coerulescens)* VU **Hooded Crow** *(Corvus cornix)* LC **Gray Parrot** *(Psittacus erithacus)* EN

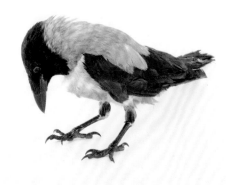

Common Raven *(Corvus corax)* LC

The wheels never stop turning in the
mind of a Common Raven.

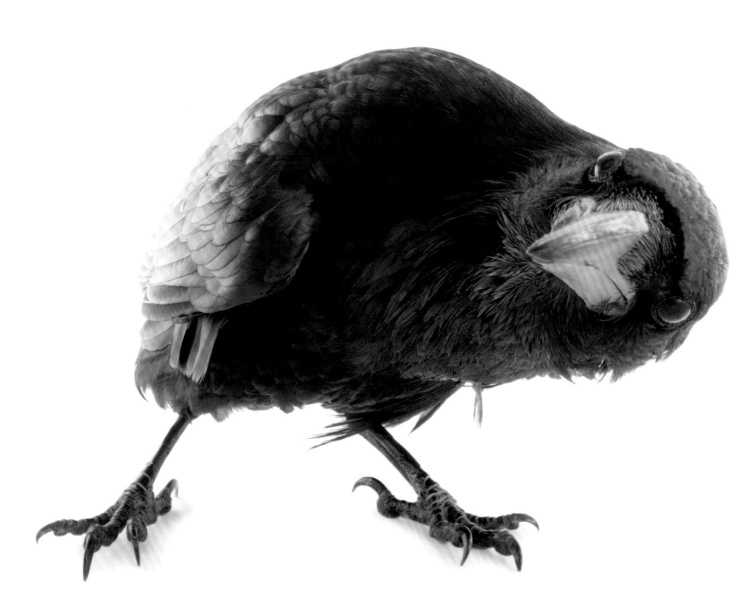

Kea *(Nestor notabilis)* **VU**

In its native habitat on the South Island of New Zealand, a Kea—the world's only alpine parrot—uses tools and solves logical puzzles.

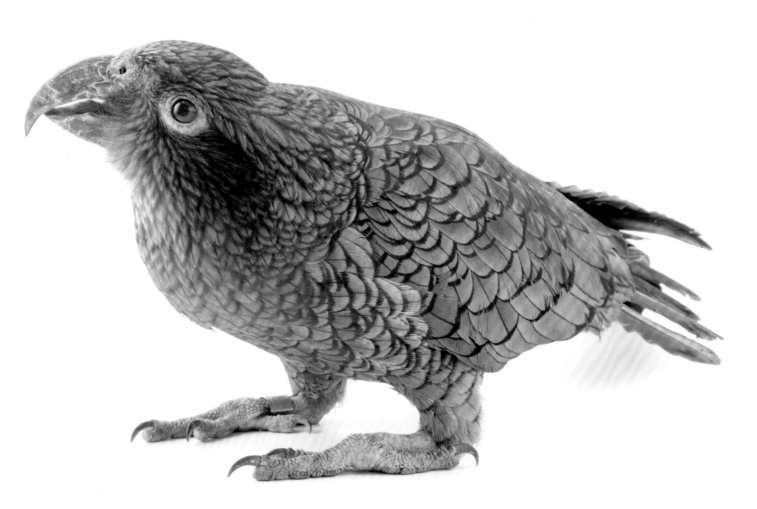

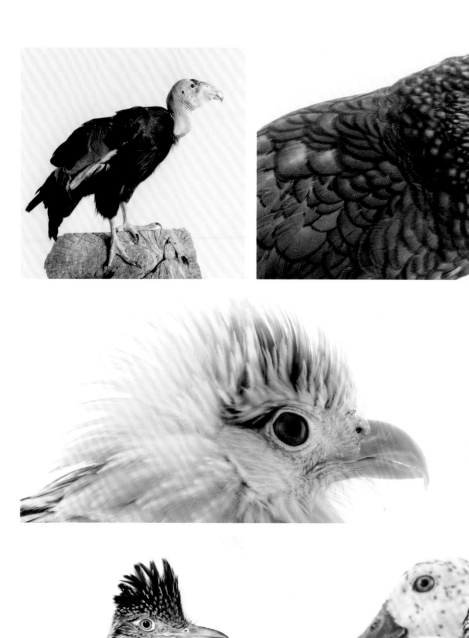

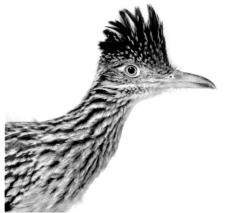

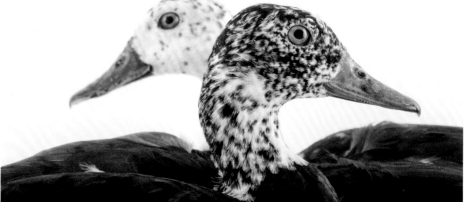

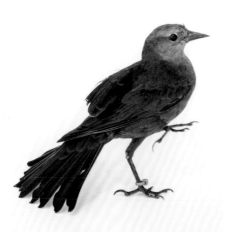
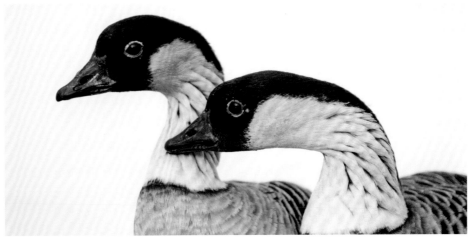

7 / THE FUTURE

CONSERVATION / EXTINCTION / ADAPTABILITY / FREEDOM

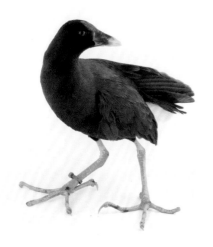
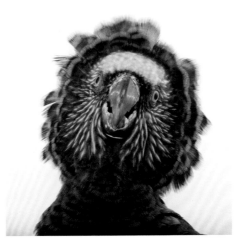
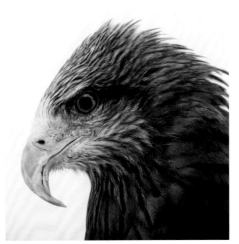

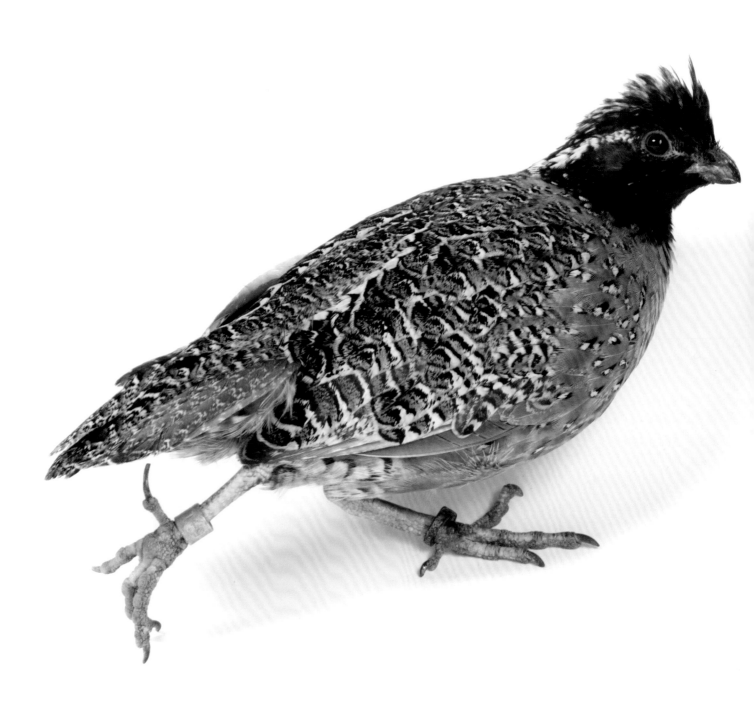

LOOKING AHEAD

Without a crystal ball, any view of the future is largely a guess. Scientific data and computer models might predict how birds will fare in coming years, but their future—and our own—is complicated, and depends in part on choices that we make today.

Many threats face the natural world as human population growth drives industrial and agricultural development, shrinks wild spaces, and leads to species extinctions. Yet there are reasons for hope. In today's increasingly virtual universe, record numbers of people are enjoying the real outdoors. Bird-watching, once a quaint pursuit, has gone mainstream, and more and more people are starting to understand and appreciate how birds fit into our world.

Simply caring is not enough to save birds, but it's a good start. And some bird species are adapting to the changing landscape, stoutly coexisting with people in urban environments. A few have even expanded their ranges to take advantage of new opportunities, more resilient than once thought.

Northern Bobwhite *(Colinus virginianus taylori)* **NT**

The "Masked" subspecies of Northern Bobwhite is endangered, surviving only in Sonora, Mexico, and southern Arizona.

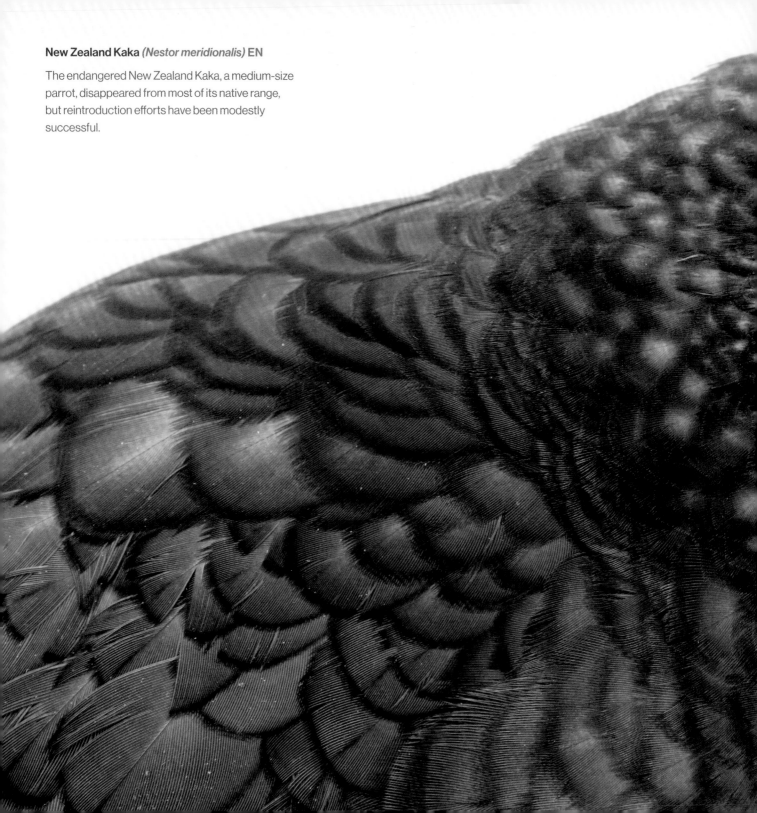

New Zealand Kaka *(Nestor meridionalis)* EN

The endangered New Zealand Kaka, a medium-size parrot, disappeared from most of its native range, but reintroduction efforts have been modestly successful.

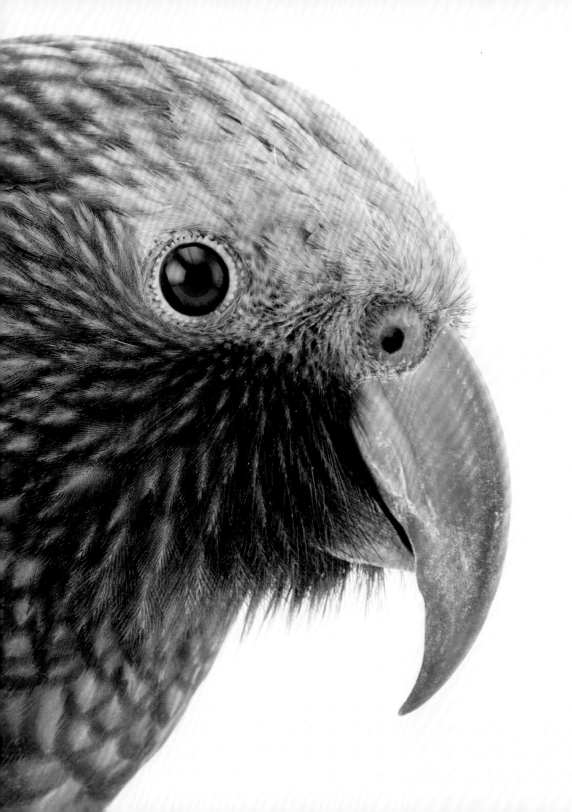

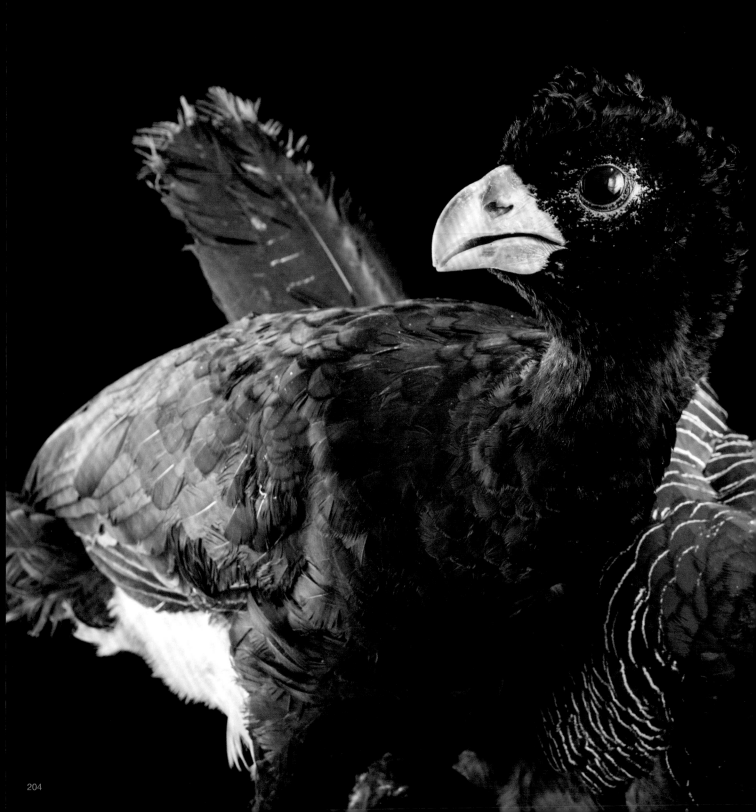

TRENDS **IN** CONSERVATION

An ever growing human race puts pressure on the planet, and most modern environmental worries can be attributed to overpopulation in one way or another. Conserving birds is first and foremost a humanitarian challenge. When people strive for a stable and sustainable lifestyle for their own well-being, they also protect all of nature.

Birds are worth thinking of. They face challenges on many fronts: invasive species, pollution and pesticides, window strikes, feral cats, traffic, depleted food sources, overhunting, bycatch, the illegal pet trade, and electric power lines—not to mention the massive threat of habitat loss through land development. On top of all that, climate change is projected to have huge effects on bird habitats around the world. The IUCN Red List notes that one in eight of the world's birds are in jeopardy, especially those in the tropics, and that many more mammals, amphibians, and plants also will disappear unless urgent action is taken.

Blue-billed Curassow (*Crax alberti*) CR

The critically endangered Blue-billed Curassow, endemic to Colombia, is down to just a couple hundred individuals.

Fewer than 3,000 snow-white Siberian Cranes remain in the wild in their native lands of the Arctic tundra.

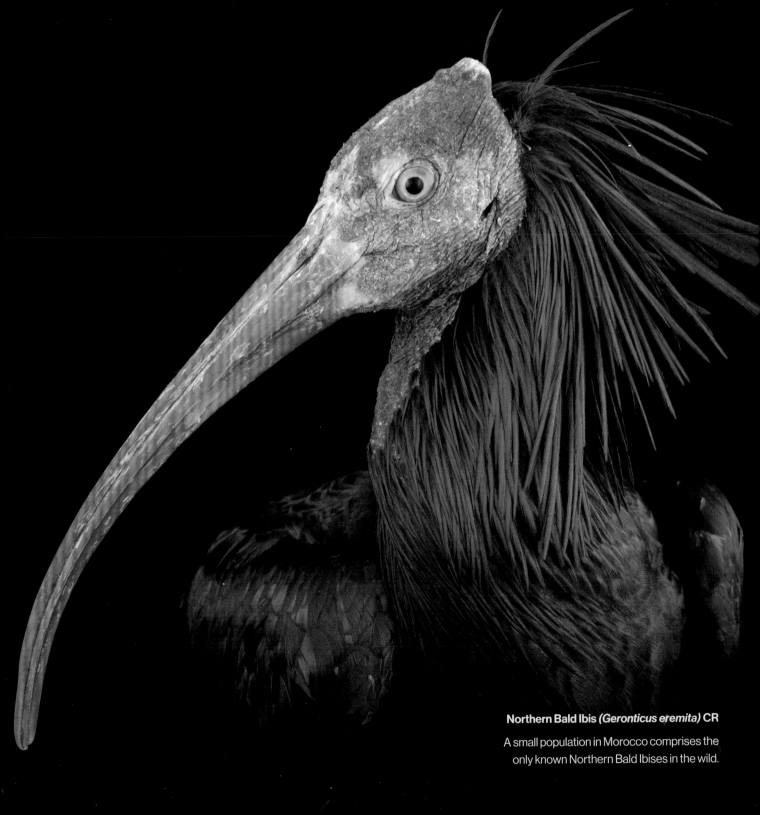

Northern Bald Ibis *(Geronticus eremita)* **CR**

A small population in Morocco comprises the only known Northern Bald Ibises in the wild.

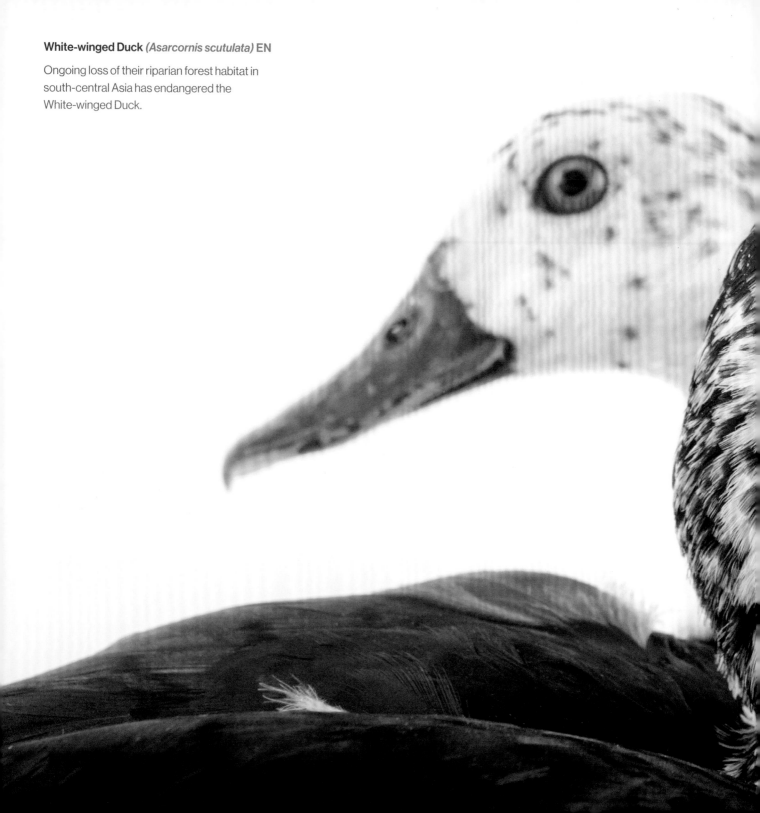

White-winged Duck *(Asarcornis scutulata)* EN

Ongoing loss of their riparian forest habitat in south-central Asia has endangered the White-winged Duck.

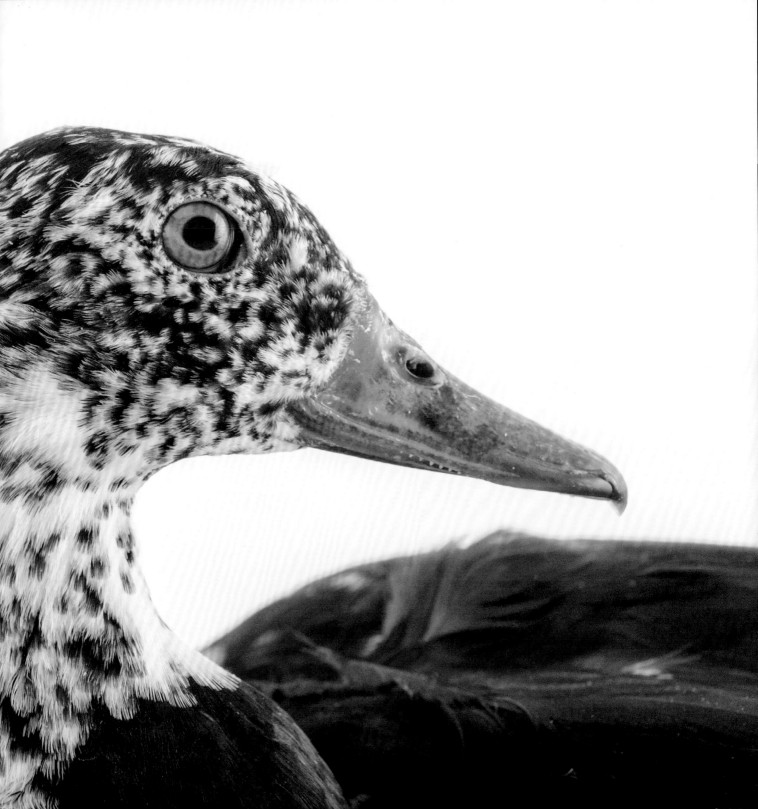

SAVED FROM EXTINCTION

A few birds have been to the brink and back, saved at the eleventh hour by human intervention. When people really set their minds to conservation, the impossible is sometimes possible.

Take the California Condor: Once widespread across the American West, its entire population dwindled to 22 individuals, which were all taken into captivity in the late 1980s. After intense breeding efforts, condors have been reestablished in the wild, and hundreds of these massive birds spread their wings across several states. They need a lot of help, but they are once again flying free.

Similarly, the Laysan Duck, formerly down to 12 individuals, now numbers in the hundreds; the Kirtland's Warbler population has risen from 500 birds to 5,000; and the extinct-in-the-wild Socorro Dove is set to be reintroduced to its native island in Mexico. Saved from extinction, these remarkable birds still share our world.

California Condor *(Gymnogyps californianus)* **CR**

Though they have rebounded from 22 birds to several hundred, California Condors still face challenges.

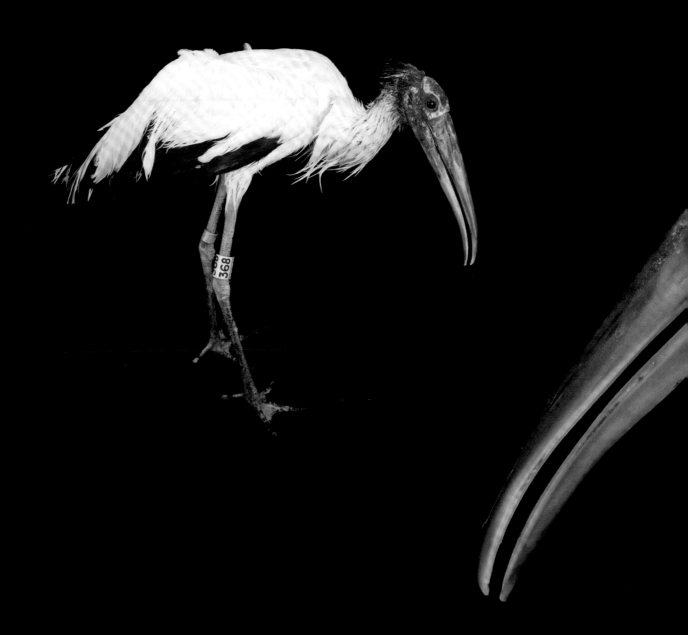

Wood Stork *(Mycteria americana)* **LC**

In the United States, the Wood Stork was listed as
endangered in 1984 but upgraded to "threatened"
in 2014 after a successful recovery effort.

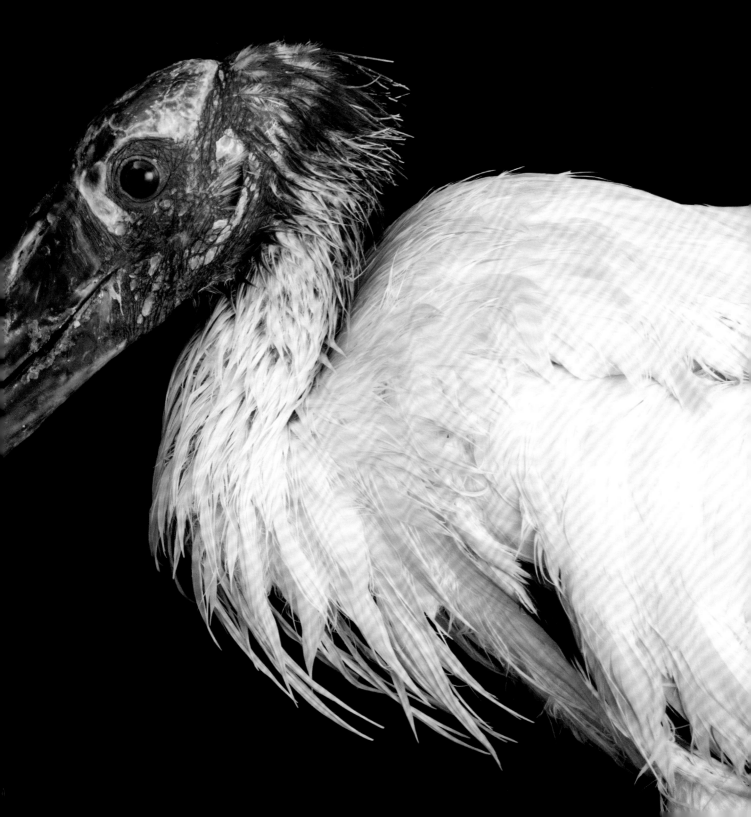

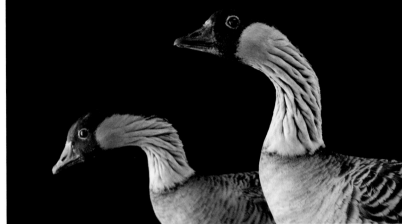

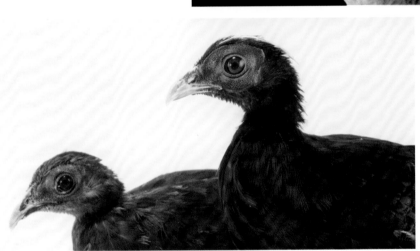

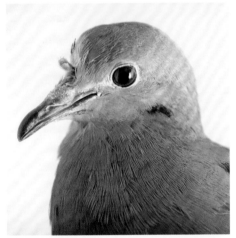

LIFE ON THE BRINK

Birds at risk of extinction can easily slip away, or they can be recovered through intense and focused conservation efforts. Thanks to captive-breeding programs and habitat management, the species on these two pages are still alive.

OPPOSITE, CLOCKWISE FROM TOP LEFT: **Hawaiian Hawk** *(Buteo solitarius)* NT **Laysan Duck** *(Anas laysanensis)* CR **Greater Prairie-Chicken** *(Tympanuchus cupido attwateri)* VU **Madagascar Pochard** *(Aythya innotata)* CR **Kirtland's Warbler** *(Setophaga kirtlandii)* NT **Bali Myna** *(Leucopsar rothschildi)* CR **Red-cockaded Woodpecker** *(Leuconotopicus borealis)* NT THIS PAGE, CLOCKWISE FROM TOP LEFT: **Guam Rail** *(Hypotaenidia owstoni)* EW **Hawaiian Goose** *(Branta sandvicensis)* VU **Socorro Dove** *(Zenaida graysoni)* EW **Pink Pigeon** *(Nesoenas mayeri)* EN **Edwards's Pheasant** *(Lophura edwardsi)* CR

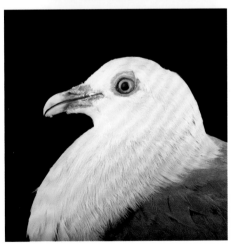

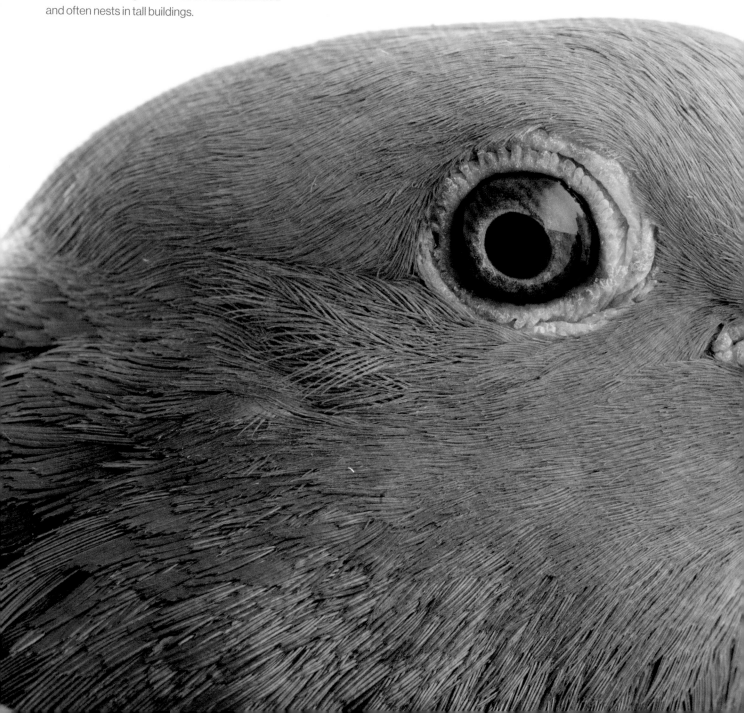

Rock Pigeon *(Columba livia)* LC

A common sight in most urban centers around the world, the Rock Pigeon thrives on discarded food and often nests in tall buildings.

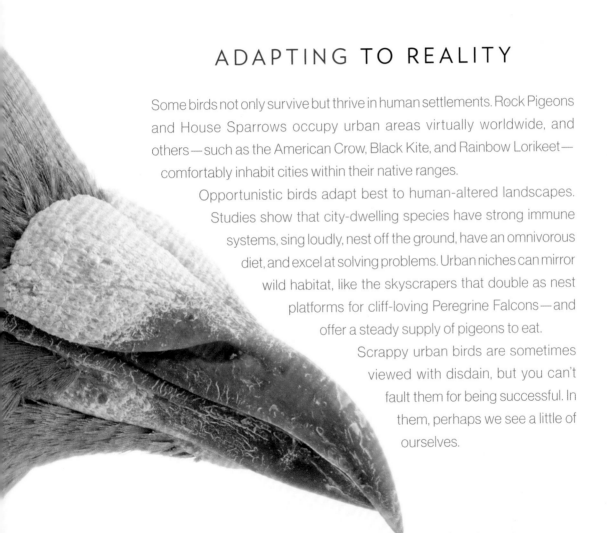

ADAPTING TO REALITY

Some birds not only survive but thrive in human settlements. Rock Pigeons and House Sparrows occupy urban areas virtually worldwide, and others—such as the American Crow, Black Kite, and Rainbow Lorikeet— comfortably inhabit cities within their native ranges.

Opportunistic birds adapt best to human-altered landscapes. Studies show that city-dwelling species have strong immune systems, sing loudly, nest off the ground, have an omnivorous diet, and excel at solving problems. Urban niches can mirror wild habitat, like the skyscrapers that double as nest platforms for cliff-loving Peregrine Falcons—and offer a steady supply of pigeons to eat.

Scrappy urban birds are sometimes viewed with disdain, but you can't fault them for being successful. In them, perhaps we see a little of ourselves.

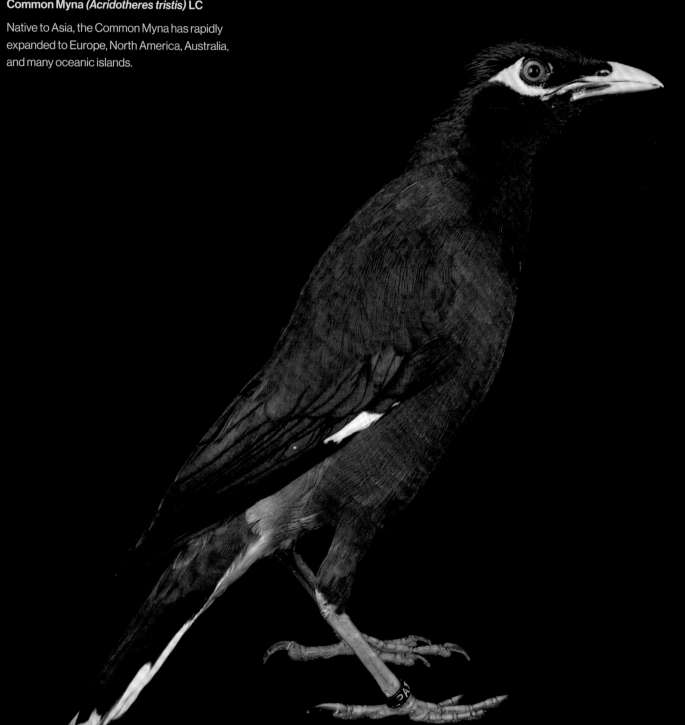

Common Myna *(Acridotheres tristis)* LC

Native to Asia, the Common Myna has rapidly expanded to Europe, North America, Australia, and many oceanic islands.

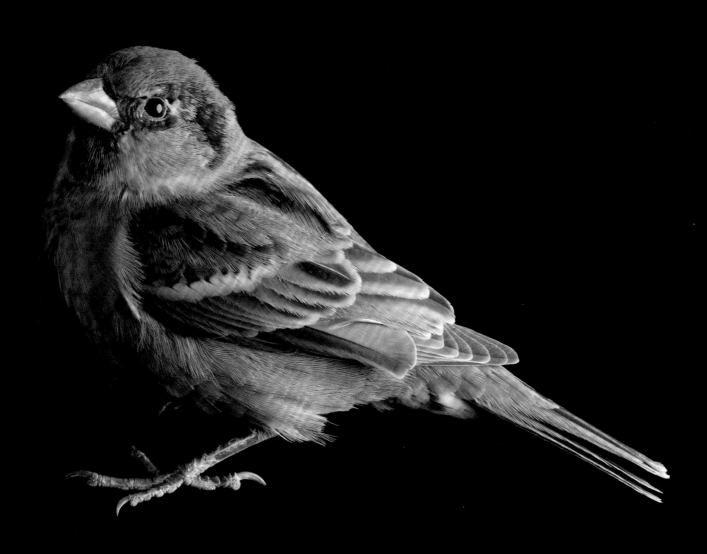

House Sparrow *(Passer domesticus)* LC

By taking up residence in human-altered habitats, the House Sparrow has become one of the most successful birds in the world.

SYMBOLS **OF** FREEDOM

As global citizens, free to fly across borders without visas or passports, birds are natural ambassadors. They are the most universal creatures on Earth. Birds of all shapes, sizes, colors, and habits can be seen and heard by everyone, everywhere.

Symbolically, birds represent peace, prosperity, love, hope, independence, and freedom—as reflected in religious texts and in the national birds adopted by many countries. Birds remind us that we are all connected, and that everything we do has an impact. We marvel at the migrants that fly thousands of miles each year, crossing hemispheres to find a home.

From a bird's-eye view, we might gain a new perspective of our shared world. By paying attention to birds, we can find inspiration.

Bald Eagle *(Haliaeetus leucocephalus)* **LC**

A Bald Eagle represents freedom and strength for many people.

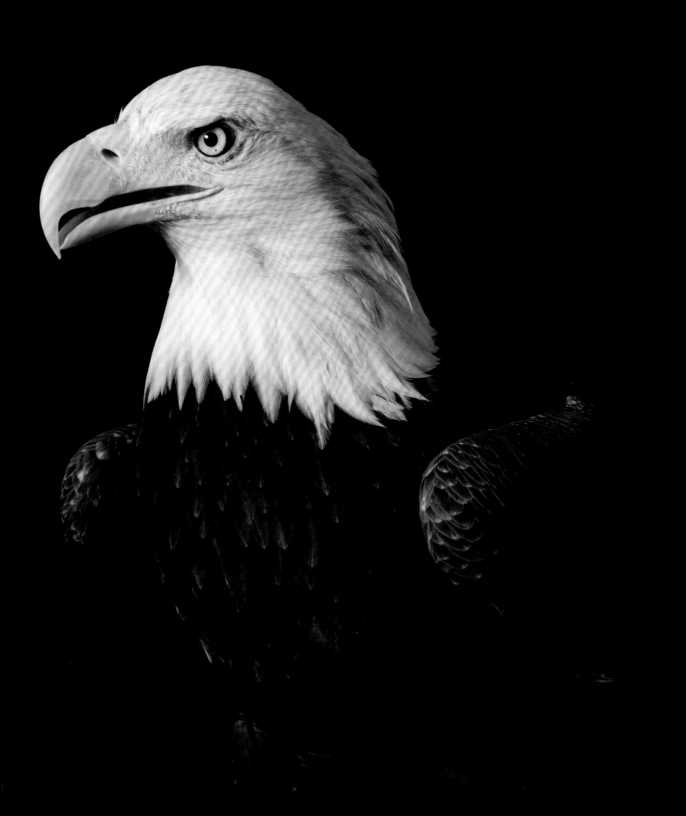

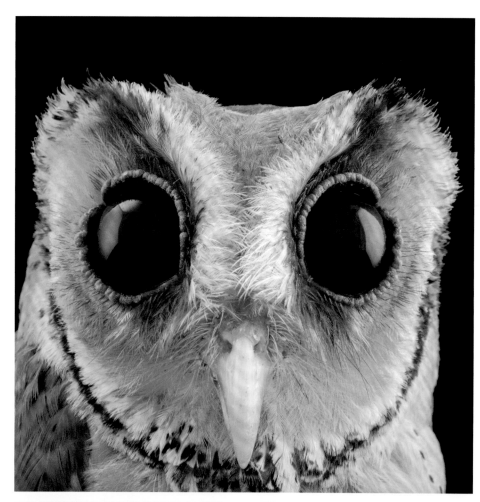

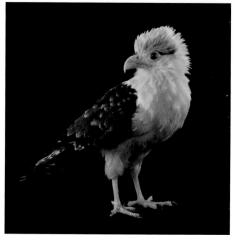
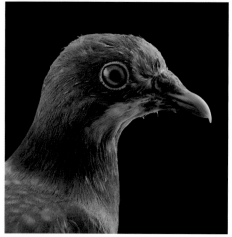
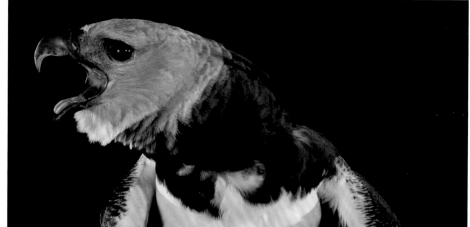

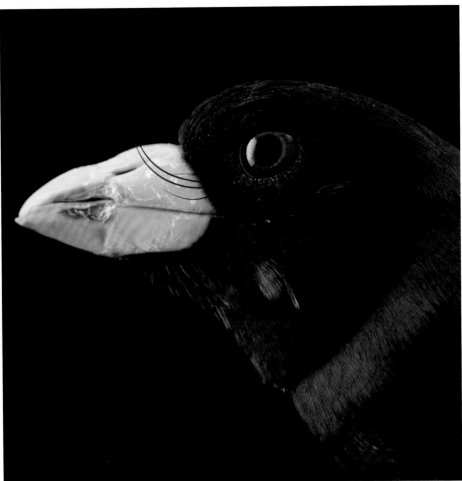

FREE AS A BIRD

Birds are colorful, engaging, and specialized, occupying almost every part of the planet and routinely moving between the different corners of the world. Birds pay no attention to political maps. When we care for and support the birds of the world, we're caring for and supporting the planet, and ourselves. What we have already learned from birds is amazing, and everything we have yet to discover holds endless potential.

OPPOSITE, CLOCKWISE FROM TOP LEFT: **Common Bay Owl** *(Otus lempiji)* LC **Blue-necked Tanager** *(Tangara cyanicollis)* LC **Yellow-headed Caracara** *(Milvago chimachima)* LC **Harpy Eagle** *(Harpia harpyja)* NT **Orange-fronted Fruit-Dove** *(Ptilinopus aurantiifrons)* LC THIS PAGE, CLOCKWISE FROM TOP LEFT: **Superb Parrot** *(Polytelis swainsonii)* LC **Black-and-red Broadbill** *(Cymbirhynchus macrorhynchos malaccensis)* LC **Red-legged Honeycreeper** *(Cyanerpes cyaneus)* LC

Red-fan Parrot
(Deroptyus accipitrinus accipitrinus) **LC**

Red-fan Parrots freely express themselves by
erecting a headdress of colorful feathers.

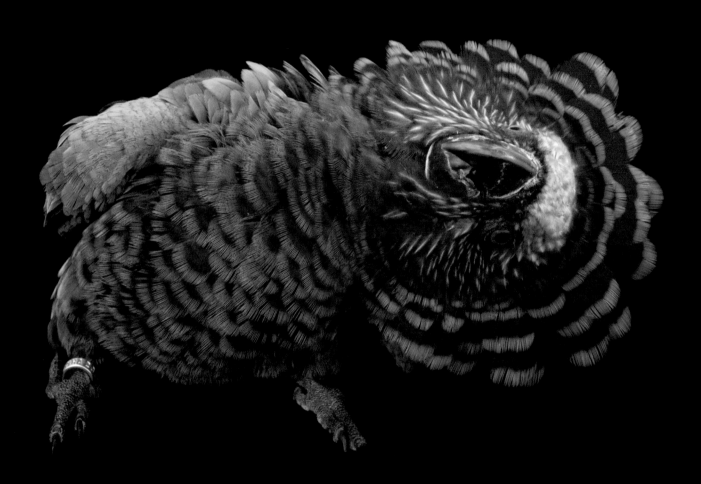

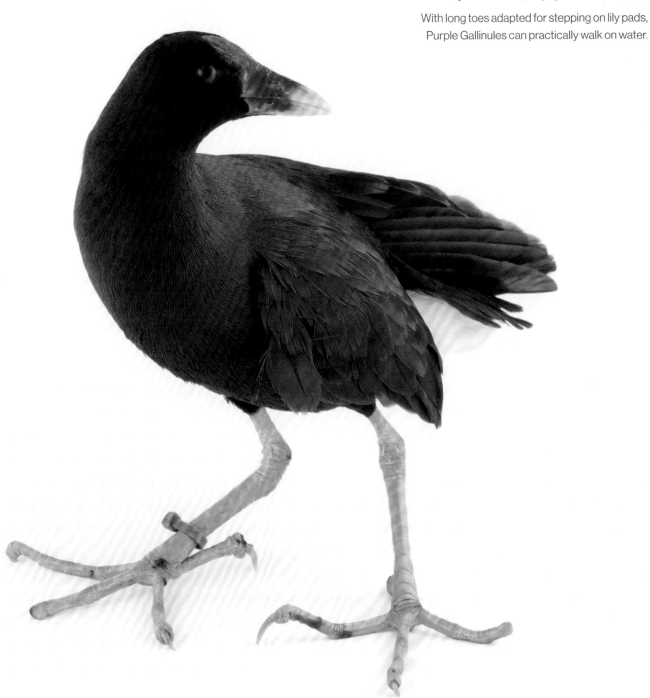

Purple Gallinule *(Porphyrio martinicus)* LC

With long toes adapted for stepping on lily pads,
Purple Gallinules can practically walk on water.

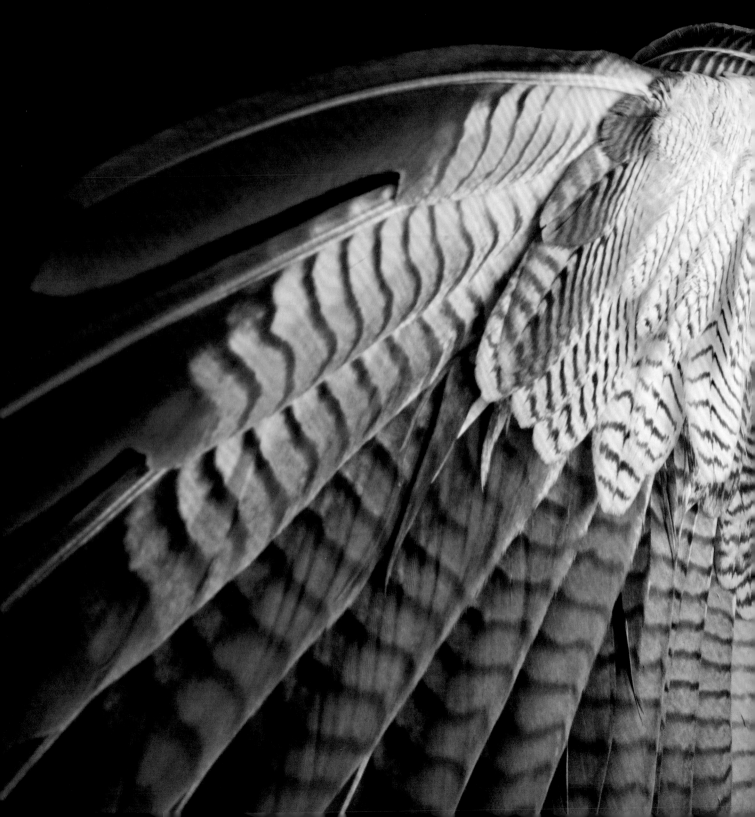

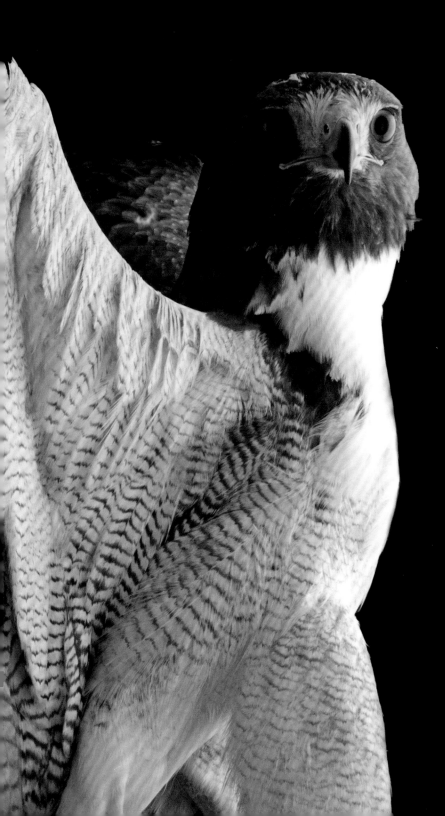

White-tailed Hawk
(Geranoaetus albicaudatus) **LC**

With wings spread, a White-tailed Hawk
can soar almost indefinitely.

ABOUT THE AUTHORS

COLE SARTORE

JOEL SARTORE is a photographer, author, teacher, conservationist, National Geographic Fellow, and a regular contributor to *National Geographic* magazine. His hallmarks are a sense of humor and a Midwestern work ethic. Joel specializes in documenting endangered species and landscapes around the world. He is the founder of the Photo Ark, a 25-year documentary project to save species and habitat. In addition to the work he has done for *National Geographic,* Joel has contributed to *Audubon* magazine, *Sports Illustrated,* the *New York Times, Smithsonian* magazine, and numerous book projects, including *The Photo Ark.* Joel is always happy to return from his travels around the world to his home in Lincoln, Nebraska, where he lives with his wife, Kathy, and their three children.

BOB KEEFER

NOAH STRYCKER is Associate Editor of *Birding* magazine and the author of three previous books about birds: *Birding Without Borders, The Thing With Feathers,* and *Among Penguins.* He contributes to a variety of magazines and other media, has traveled to nearly 50 countries, and works as a guide on expeditions to Antarctica and Svalbard. His backyard in Oregon has hosted 115 bird species.

ACKNOWLEDGMENTS JOEL SARTORE

How to thank a cast of literally thousands in this space? Impossible. So instead, let me just say this: I'm grateful to the staff at zoos, aquariums, private breeders, and wildlife rehab centers for allowing me access to the animals they care for, with quiet dignity and diligence, for years on end. It's important that you support organizations like this in your own hometown; far too often, they are fighting on the very front lines of the extinction crisis. I'm grateful to the many partners who have invested in the Photo Ark, from private donors to the staff at the National Geographic Society, Defenders of Wildlife, Conservation International, the Oceanic Preservation Society, and National Audubon Society, to name just a few. I'm grateful to those who have worked on this project unfailingly for years, from our scientific adviser Pierre de Chabannes to the staff of Joel Sartore Photography, and to my wife, Kathy, daughter, Ellen, and son Spencer, for tolerating my being gone at least half the year for as long as they can remember. And to son Cole, who has been with me on the road more than anyone else.

And finally, I'm grateful to my parents, John and Sharon Sartore, who instilled in me a love for nature and taught me to value hard work. They gave me a flying start.

My deepest thanks to all of you.

ACKNOWLEDGMENTS NOAH STRYCKER

For a bird nerd named Noah, *Birds of the Photo Ark* was a dream. I am grateful to Joel Sartore for capturing the hundreds of striking, extraordinarily detailed images displayed in these pages. A big thank-you to senior editor Susan Tyler Hitchcock, creative director Melissa Farris, senior photo editor Moira Haney, and editorial assistant Michelle C. Cassidy of the National Geographic Books Division for their vision, skill, and creativity in putting the pieces together. My agent, Russell Galen, of the Scovil Galen Ghosh Literary Agency, thoroughly embraced the project from its beginning, and the support of my mom and dad, Lisa Strycker and Bob Keefer, means the world. This book is a beautiful celebration of the 2018 Year of the Bird. I was honored to help bring it to life.

ABOUT THE PHOTO ARK

For many of Earth's creatures, time is running out. Species are disappearing at an alarming rate. That's why National Geographic Society and renowned photographer Joel Sartore are dedicated to finding solutions to save them. The National Geographic Photo Ark is an ambitious project committed to documenting every species living in the world's zoos and wildlife sanctuaries—inspiring people not just to care but also to help protect these animals for future generations. Once completed, the Photo Ark will serve as an important record of these animals' existence and a powerful testament to the importance of saving them. For more information on how you can support this project, visit *natgeophotoark.org*.

Joel Sartore finds a friend in a Rhinoceros Auklet at the Alaska SeaLife Center.

MAKING THE IMAGES

In terms of how we actually photograph the birds, it's a bit of a process. First, I contact the zoo, private breeder, or wildlife rehabber in an area I know I'm going to visit. If they are interested in being part of the Photo Ark, I'll ask to get a list of the species they have in their care.

Next, we determine which of those species have not been photographed already and ask if those particular animals would mind having their pictures taken. Every type of animal poses a different sort of challenge in the way it will respond to being photographed. Most of the birds I work with have been in human care all their lives, and the staff at each facility have a good feeling for which animals will be calm and stress-free enough to be photographed. We go to great lengths to be sure that taking the photo does not harm or disturb the bird in any way.

On the day of the shoot, we work in a wide variety of ways. For larger birds, we might line the back of an enclosure with black or white. For smaller ones, they're often brought in a kennel or transport container to be released into my soft cloth shooting tent. Once inside the tent, they see only the small front of my lens and are generally quite calm. Sometimes we'll feed animals during the photo session so they're rewarded for their appearance. An entire shoot lasts just a few minutes.

As to lighting, we wrap our flashes in soft boxes for camouflage and protection and try to get them close so we can render our subject's true texture and colors with great clarity and depth of field.

The goal is simple: to create photos that finally move the public to care about all creatures great and small while there's still time to save them.

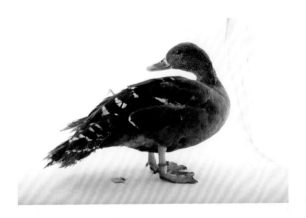

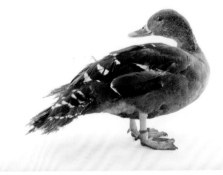

Before: Our main goal is to work quickly to reduce stress. This means cleaning up the images digitally after the shoot.

After: The finished product, after dirt, poop, and a background seam have been removed electronically

CHAPTER OPENER KEYS

TITLE PAGE, ROW 1, L TO R: **Sunbittern** *(Eurypyga helias)* LC **Blue-winged Pitta** *(Pitta moluccensis)* LC **Delacour's Crested Fireback Pheasant** *(Lophura ignita macartneyi)* NT **Paradise Shelduck** *(Tadorna variegata)* LC **Barbary Falcon** *(Falco peregrinus pelegrinoides)* LC **Blue-naped Mousebird** *(Urocolius macrourus)* LC ROW 2, L TO R: **Red Fody** *(Foudia madagascariensis)* LC **Barn Owl** *(Tyto alba)* LC **Eurasian Hoopoe** *(Upupa epops)* LC ROW 3, L TO R: **Goliath Heron** *(Ardea goliath)* LC **Toco Toucan** *(Ramphastos toco)* LC **Long-billed Corella** *(Cacatua tenuirostris)* LC **South Island Takahe** *(Porphyrio hochstetteri)* EN **Sulphur-winged Parakeet** *(Pyrrhura hoffmanni)* LC **Rose-fronted Parakeet** *(Pyrrhura roseifrons roseifrons)* LC **Violet Turaco** *(Musophaga violacea)* LC

CHAPTER 1, ROW 1, L TO R: **Golden Parakeet** *(Guaruba guarouba)* VU **American Kestrel** *(Falco sparverius)* LC **Southern Rockhopper Penguin** *(Eudyptes chrysocome)* VU **Striped Owl** *(Asio clamator)* LC **Red-knobbed Imperial-Pigeon** *(Ducula rubricera)* NT ROW 2, L TO R: **Red Knot** *(Calidris canutus)* NT **Mallard** *(Anas platyrhynchos)* LC ROW 3, L TO R: **Temminck's Tragopan** *(Tragopan temminckii)* LC **Nicobar Pigeon** *(Caloenas nicobarica)* NT **Southern Cassowary** *(Casuarius casuarius)* VU **Kea** *(Nestor notabilis)* VU **Fantail Pigeon** *(Columba livia)* LC

CHAPTER 2, ROW 1, L TO R: **Major Mitchell's Cockatoo** *(Cacatua leadbeateri)* LC **African Spoonbill** *(Platalea alba)* LC **Golden Eagle** *(Aquila chrysaetos)* LC **Florida Grasshopper Sparrow** *(Ammodramus savannarum)* LC **Eurasian Hobby** *(Falco subbuteo)* LC ROW 2, L TO R: **Gentoo Penguin** *(Pygoscelis papua)* LC **Southern Rufous Hornbill** *(Buceros mindanensis mindanensis)* VU ROW 3, L TO R: **Ruby-throated Hummingbird** *(Archilochus colubris)* LC **Indian Peafowl** *(Pavo cristatus)* LC **White-naped Crane** *(Antigone vipio)* VU **Red-cheeked Cordonbleu** *(Uraeginthus bengalus)* LC **North Island Brown Kiwi** *(Apteryx mantelli)* EN **Tufted Puffin** *(Fratercula cirrhata)* LC

CHAPTER 3, ROW 1, L TO R: **Andaman Barn-Owl** *(Tyto alba deroepstorffi)* LC **Demoiselle Crane** *(Anthropoides virgo)* LC **Black Vulture** *(Coragyps atratus)* LC **Common Swift** *(Apus apus)* LC **Red-capped Cardinal** *(Paroaria gularis)* LC ROW 2, L TO R: **Eurasian Kingfisher** *(Alcedo atthis ispida)* LC **Polish Chicken** *(Gallus gallus [domestic])* ROW 3, L TO R: **Gang-gang Cockatoo** *(Callocephalon fimbriatum)* LC **Chinstrap Penguin** *(Pygoscelis antarcticus)* LC **White Cockatoo** *(Cacatua alba)* EN **Raggiana Bird-of-Paradise** *(Paradisaea raggiana)* LC

CHAPTER 4, ROW 1, L TO R: **Eurasian Green Woodpecker** *(Picus viridis)* LC **Southern Caracara** *(Caracara plancus)* LC **Sulawesi Hornbill** *(Rhabdotorrhinus exarhatus)* VU **Great Gray Owl** *(Strix nebulosa)* LC ROW 2, L TO R: **Whimbrel** *(Numenius phaeopus)* LC **Torresian Crow** *(Corvus orru)* LC ROW 3, L TO R: **White-throated Toucan** *(Ramphastos tucanus)* VU **Piping Plover** *(Charadrius melodus)* NT **Acorn Woodpecker** *(Melanerpes formicivorus)* LC **Lesser Flamingo** *(Phoeniconaias minor)* NT **Red-headed Vulture** *(Sarcogyps calvus)* CR

CHAPTER 5, ROW 1, L TO R: **Hawaiian Goose** *(Branta sandvicensis)* VU **Prothonotary Warbler** *(Protonotaria citrea)* LC **Superb Lyrebird** *(Menura novaehollandiae)* LC **White-naped Crane** *(Antigone vipio)* VU ROW 2, L TO R: **Common Murre egg** *(Uria aalge)* LC **Crested Auklet** *(Aethia cristatella)* LC ROW 3, L TO R: **Australian King-Parrot** *(Alisterus scapularis)* LC **Corncrake** *(Crex crex)* LC **Andean Cock-of-the-rock** *(Rupicola peruvianus aequatorialis)* LC **Black Swan** *(Cygnus atratus)* LC **Black-necked Swan** *(Cygnus melancoryphus)* LC **Ural Owl** *(Strix uralensis)* LC

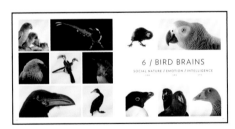

CHAPTER 6, ROW 1, L TO R: **Sun Parakeet** *(Aratinga solstitialis)* EN **Red-billed Blue Magpie** *(Urocissa erythroryncha)* LC **Common Raven** *(Corvus corax)* LC **Gray Parrot** *(Psittacus erithacus)* EN ROW 2, L TO R: **Apostlebird** *(Struthidea cinerea)* LC **Eastern Yellow-billed Hornbill** *(Tockus flavirostris)* LC **Northern Double-collared Sunbird** *(Cinnyris reichenowi)* LC ROW 3, L TO R: **Pied Crow** *(Corvus albus)* LC **Double-crested Cormorant** *(Phalacrocorax auritus)* LC **Adélie Penguin** *(Pygoscelis adeliae)* LC **Eclectus Parrot** *(Eclectus roratus)* LC **Graylag Goose** *(Anser anser)* LC

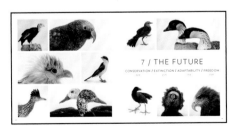

CHAPTER 7, ROW 1, L TO R: **California Condor** *(Gymnogyps californianus)* CR **New Zealand Kaka** *(Nestor meridionalis)* EN **Brewer's Blackbird** *(Euphagus cyanocephalus)* LC **Hawaiian Goose** *(Branta sandvicensis)* VU ROW 2, L TO R: **Yellow-headed Caracara** *(Milvago chimachima)* LC **Blue-winged Mountain-Tanager** *(Anisognathus somptuosus)* LC ROW 3, L TO R: **Greater Roadrunner** *(Geococcyx californianus)* LC **White-winged Duck** *(Asarcornis scutulata)* EN **Purple Gallinule** *(Porphyrio martinicus)* LC **Red-fan Parrot** *(Deroptyus accipitrinus accipitrinus)* LC **Black Kite** *(Milvus migrans)* LC

INDEX OF BIRDS

Here we list, in the order they appear in the book, the common name of each species, the place where the photograph was taken, and, as possible, the website of that location.

78: Black-capped Lory, Indianapolis Zoo, Indianapolis, Indiana | *www.indianapoliszoo.com*

78: Blue-and-yellow Macaw, Parrots in Paradise, Glass House Mountains, Australia | *www.parrotsinparadise.net*

78: Black-legged Parrot, Rare Species Conservatory Foundation, Loxahatchee, Florida | *www.rarespecies.org*

78: Galah, Private Facility

78: Red-lored Amazon, World Bird Sanctuary, Valley Park, Missouri | *www.worldbirdsanctuary.org*

78: Hyacinth Macaw, Fort Worth Zoo, Fort Worth, Texas | *www.fortworthzoo.org*

79: Orange-bellied Parrot, Healesville Sanctuary, Healesville, Australia | *www.zoo.org.au/healesville*

80–81: Scarlet Ibis, Caldwell Zoo, Tyler, Texas | *www.caldwellzoo.org*

IN FLIGHT

82: Andaman Barn-Owl, Kamla Nehru Zoological Garden, Ahmedabad, India | *www.ahmedabadzoo.in*

82: Demoiselle Crane, Sylvan Heights Bird Park, Scotland Neck, North Carolina | *www.shwpark.com*

82: Black Vulture, Wildcare Foundation, Noble, Oklahoma | *www.wildcareoklahoma.org*

82: Common Kingfisher, Alpenzoo, Innsbruck, Austria | *www.alpenzoo.at*

82: Polish Chicken, Soukup Farms, Dover Plains, New York | *www.soukupfarms.com*

82: Gang-gang Cockatoo, Parrots in Paradise, Glass House Mountains, Australia | *www.parrotsinparadise.net*

82: Chinstrap Penguin, Newport Aquarium, Newport, Kentucky | *www.newportaquarium.com*

83: Common Swift, Budapest Zoo, Budapest, Hungary | *www.zoobudapest.com*

83: Red-capped Cardinal, Miller Park Zoo, Bloomington, Illinois | *www.mpzs.org*

83: White Cockatoo, Bramble Park Zoo, Watertown, South Dakota | *www.brambleparkzoo.com*

83: Raggiana Bird-of-Paradise, Cincinnati Zoo, Cincinnati, Ohio | *www.cincinnatizoo.org*

84: Caspian Tern, Tracy Aviary, Salt Lake City, Utah | *www.tracyaviary.org*

86–87: Chinstrap Penguin, Newport Aquarium, Newport, Kentucky | *www.newportaquarium.com*

88–89: Raggiana Bird-of-Paradise, Cincinnati Zoo, Cincinnati, Ohio | *www.cincinnatizoo.org*

90: Andaman Barn-Owl, Kamla Nehru Zoological Garden, Ahmedabad, India | *www.ahmedabadzoo.in*

91: Common Eider, Sylvan Heights Bird Park, Scotland Neck, North Carolina | *www.shwpark.com*

92: Long-billed Corella, Healesville Sanctuary, Healesville, Australia | *www.zoo.org.au/healesville*

93: Sulphur-crested Cockatoo, Minnesota Zoo, Apple Valley, Minnesota | *www.mnzoo.org*

93: Cockatiel, Riverside Discovery Center, Scottsbluff, Nebraska | *www.riversidediscoverycenter.org*

93: Palm Cockatoo, Jurong Bird Park, Singapore | *www.birdpark.com.sg*

93: Gang-gang Cockatoo, Parrots in Paradise, Glass House Mountains, Australia | *www.parrotsinparadise.net*

93: Yellow-crested Cockatoo, Jurong Bird Park, Singapore | *www.birdpark.com.sg*

94–95: Common Swift, Budapest Zoo, Budapest, Hungary | *www.zoobudapest.com*

96: Brown-hooded Kingfisher, Gorongosa National Park, Sofala, Mozambique | *www.gorongosa.org*

97: White-necked Jacobin, Gamboa, Panama

98–99: Bufflehead, Sylvan Heights Bird Park, Scotland Neck, North Carolina | *www.shwpark.com*

100–101: Cut-throat Finch, Tulsa Zoo, Tulsa, Oklahoma | *www.tulsazoo.org*

102–103: Lesser White-fronted Goose, Sylvan Heights Bird Park, Scotland Neck, North Carolina | *www.shwpark.com*

104: Purple Starling, Kansas City Zoo, Kansas City, Missouri | *www.kansascityzoo.org*

104: Superb Starling, Omaha's Henry Doorly Zoo & Aquarium, Omaha, Nebraska | *www.omahazoo.com*

104: Golden-breasted Starling, Zoo Atlanta, Atlanta, Georgia | *www.zooatlanta.org*

104: Long-tailed Glossy Starling, Private Facility

104: Black-collared Starling, Plzeň Zoo, Plzeň, Czech Republic | *www.zooplzen.cz*

105: Emerald Starling, Plzeň Zoo, Plzeň, Czech Republic | *www.zooplzen.cz*

105: Black-winged Starling, Jurong Bird Park, Singapore | *www.birdpark.com.sg*

105: Purple Starling, Topeka Zoo, Topeka, Kansas | *www.topekazoo.org*

106: Arctic Tern, Buttonwood Park Zoo, New Bedford, Massachusetts | *www.bpzoo.org*

108–109: Eurasian Griffon, Cheyenne Mountain Zoo, Colorado Springs, Colorado | *www.cmzoo.org*

110: Demoiselle Crane, Sylvan Heights Bird Park, Scotland Neck, North Carolina | *www.shwpark.com*

111: White Stork, Lincoln Children's Zoo, Lincoln, Nebraska | *www.lincolnzoo.org*

FOOD

112: Eurasian Green Woodpecker, Budapest Zoo, Budapest, Hungary | *www.zoobudapest.com*

112: Southern Caracara, Gladys Porter Zoo, Brownsville, Texas | *www.gpz.org*

112: Whimbrel, National Aviary of Colombia, Barú, Colombia | *www.acopazoa.org*

112: Torresian Crow, Pelican and Seabird Rescue Inc., Thorneside, Australia | *www.pelicanandseabirdrescue.org.au*

112: White-throated Toucan, Alabama Gulf Coast Zoo, Gulf Shores, Alabama | *www.alabamagulfcoastzoo.org*

112: Piping Plover, North Bend, Nebraska

113: Sulawesi Hornbill, Tampa's Lowry Park Zoo, Tampa, Florida | *www.lowryparkzoo.com*

113: Great Gray Owl, New York State Zoo at Thompson Park, Watertown, New York | *www.nyszoo.org*

113: Acorn Woodpecker, Wildlife Images Rehabilitation and Education Center, Grants Pass, Oregon | *www.wildlifeimages.org*

113: Lesser Flamingo, Cleveland Metroparks Zoo, Cleveland, Ohio | *www.clevelandmetroparks.com/zoo*

113: Red-headed Vulture, Palm Beach Zoo, West Palm Beach, Florida | *www.palmbeachzoo.org*

114: Torresian Crow, Pelican and Seabird Rescue Inc., Thorneside, Australia | *www.pelicanandseabirdrescue.org.au*

116–117: Ruddy Turnstone, Conserve Wildlife Foundation of New Jersey, New Jersey | www.conservewildlifenj.org

118–119: Great Gray Owl, New York State Zoo at Thompson Park, Watertown, New York | www.nyszoo.org

120–121: Swainson's Hawk, Raptor Recovery, Elmwood, Nebraska | www.fontenelleforest.org

122: Capuchinbird, Dallas World Aquarium, Dallas, Texas | www.dwazoo.com

123: Chuck-will's-widow, Wichita Mountains National Wildlife Refuge, Indiahoma, Oklahoma

124–125: Whimbrel, National Aviary of Colombia, Barú, Colombia | www.acopazoa.org

126: Northern Ground-Hornbill, Los Angeles Zoo, Los Angeles, California | www.lazoo.org

127: Visayan Hornbill, Plzeň Zoo, Plzeň, Czech Republic | www.zooplzen.cz

127: Wrinkled Hornbill, Penang Bird Park, Perai, Malaysia | www.penangbirdpark.com.my

127: Wreathed Hornbill, Tracy Aviary, Salt Lake City, Utah | www.tracyaviary.org

127: Sulawesi Hornbill, Tampa's Lowry Park Zoo, Tampa, Florida | www.lowryparkzoo.com

127: Red-billed Hornbill, Omaha's Henry Doorly Zoo & Aquarium, Omaha, Nebraska | www.omahazoo.com

128–129: Lesser Flamingo, Cleveland Metroparks Zoo, Cleveland, Ohio | www.clevelandmetroparks.com/zoo

130: Australian Pelican, Plzeň Zoo, Plzeň, Czech Republic | www.zooplzen.cz

131: Brown Booby, International Bird Rescue, San Pedro, California | www.bird-rescue.org

132: Semipalmated Plover, Monterey Bay Aquarium, Monterey, California | www.montereybayaquarium.org

132: Killdeer, Columbus Zoo and Aquarium, Powell, Ohio | www.columbuszoo.org

132: Southern Lapwing, Palm Beach Zoo, West Palm Beach, Florida | www.palmbeachzoo.org

132: Spur-winged Lapwing, Houston Zoo, Houston, Texas | www.houstonzoo.org

132: Masked Lapwing, Sylvan Heights Bird Park, Scotland Neck, North Carolina | www.shwpark.com

132: Grey Plover, Marathon Wild Bird Center, Marathon, Florida | www.marathonbirdcenter.org

133: Masked Lapwing, Private Facility

133: Snowy Plover, Monterey Bay Aquarium, Monterey, California | www.montereybayaquarium.org

133: Piping Plover, Fremont, Nebraska

134–135: King Penguin, Indianapolis Zoo, Indianapolis, Indiana | www.indianapoliszoo.com

136–137: Cape Griffon, Cheyenne Mountain Zoo, Colorado Springs, Colorado | www.cmzoo.org

138: Himalayan Griffon, Assam State Zoo and Botanical Garden, Assam, India | www.assamforest.in

138: Egyptian Vulture, Parco Natura Viva, Bussolengo, Italy | www.parconaturaviva.it

138: Greater Yellow-headed Vulture, Sedgwick County Zoo, Wichita, Kansas | www.scz.org

138: White-rumped Vulture, Kamla Nehru Zoological Garden, Ahmedabad, India | www.ahmedabadzoo.in

138: Cinereous Vulture, The Living Desert, Palm Desert, California | www.livingdesert.org

139: Red-headed Vulture, Palm Beach Zoo, West Palm Beach, Florida | www.palmbeachzoo.org

139: American Black Vulture, Sylvan Heights Bird Park, Scotland Neck, North Carolina | www.shwpark.com

139: Palm-nut Vulture, Jurong Bird Park, Singapore | www.birdpark.com.sg

140–141: King Vulture, Gladys Porter Zoo, Brownsville, Texas | www.gpz.org

NEXT GENERATION

142: Hawaiian Goose, Sylvan Heights Bird Park, Scotland Neck, North Carolina | www.shwpark.com

142: Prothonotary Warbler, Virginia Aquarium & Marine Science Center, Virginia Beach, Virginia | www.virginiaaquarium.com

142: Australian King-Parrot, Parrots in Paradise, Glass House Mountains, Australia | www.parrotsinparadise.net

142: Common Murre egg, University of Nebraska State Museum, Lincoln, Nebraska | www.museum.unl.edu

142: Crested Auklet, Cincinnati Zoo, Cincinnati, Ohio | www.cincinnatizoo.org

142: Corncrake, Plzeň Zoo, Plzeň, Czech Republic | www.zooplzen.cz

142: Andean Cock-of-the-rock, National Aviary of Colombia, Barú, Colombia | www.acopazoa.org

143: Superb Lyrebird, Healesville Sanctuary, Healesville, Australia | www.zoo.org.au/healesville

143: White-naped Crane, Columbus Zoo and Aquarium, Powell, Ohio | www.columbuszoo.org

143: Black Swan, Kansas City Zoo, Kansas City, Missouri | www.kansascityzoo.org

143: Black-necked Swan, Sylvan Heights Bird Park, Scotland Neck, North Carolina | www.shwpark.com

143: Ural Owl, Plzeň Zoo, Plzeň, Czech Republic | www.zooplzen.cz

144: Australian King-Parrot, Parrots in Paradise, Glass House Mountains, Australia | www.parrotsinparadise.net

146–147: Superb Lyrebird, Healesville Sanctuary, Healesville, Australia | www.zoo.org.au/healesville

148–149: Ringed Teal, Sylvan Heights Bird Park, Scotland Neck, North Carolina | www.shwpark.com

150: Rosy-Faced Lovebird, Tampa's Lowry Park Zoo, Tampa, Florida | www.lowryparkzoo.com

151: Crested Auklet, Cincinnati Zoo, Cincinnati, Ohio | www.cincinnatizoo.org

152–153: Malayan Peacock-Pheasant, Pheasant Heaven, Clinton, North Carolina

154–155: Corncrake, Plzeň Zoo, Plzeň, Czech Republic | www.zooplzen.cz

156: Wood Thrush, St. Francis Wildlife Association, Quincy, Florida | www.stfranciswildlife.org

157: Oriole Warbler, Oklahoma City Zoo, Oklahoma City, Oklahoma | www.okczoo.org

157: Jungle Babbler, Kamla Nehru Zoological Garden, Ahmedabad, India | www.ahmedabadzoo.in

157: Yellow-headed Blackbird, New Mexico Wildlife Center, Espanola, New Mexico | www.thewildlifecenter.org

157: Red-billed Leiothrix, Houston Zoo, Houston, Texas | www.houstonzoo.org

157: Prothonotary Warbler, Virginia Aquarium & Marine Science Center, Virginia Beach, Virginia | www.virginiaaquarium.com

159: **Sandhill Crane,** Great Plains Zoo, Sioux Falls, South Dakota |
www.greatzoo.org

160: **Superb Bird-of-Paradise,** Houston Zoo, Houston, Texas |
www.houstonzoo.org

161: **Red Bird-of-Paradise,** Houston Zoo, Houston, Texas | *www.houstonzoo.org*

162–163: **Andean Cock-of-the-rock,** National Aviary of Colombia, Barú, Colombia |
www.acopazoa.org

164–165: **Blue-winged Kookaburra,** Houston Zoo, Houston, Texas |
www.houstonzoo.org

166: **Black Swan,** Kansas City Zoo, Kansas City, Missouri |
www.kansascityzoo.org

166: **Tundra Swan,** Sylvan Heights Bird Park, Scotland Neck, North Carolina |
www.shwpark.com

166: **Black-necked Swan,** Omaha's Henry Doorly Zoo & Aquarium, Omaha,
Nebraska | *www.omahazoo.org*

166: **Black Swan,** Sylvan Heights Bird Park, Scotland Neck, North Carolina |
www.shwpark.com

167: **Trumpeter Swan,** Houston Zoo, Houston, Texas | *www.houstonzoo.org*

167: **Whooper Swan,** Sylvan Heights Bird Park, Scotland Neck,
North Carolina | *www.shwpark.com*

167: **Black-necked Swan,** Sylvan Heights Bird Park, Scotland Neck,
North Carolina | *www.shwpark.com*

168: **Eurasian Eagle-Owl,** Zoo Atlanta, Atlanta, Georgia | *www.zooatlanta.org*

169: **Spotted Eagle-Owl,** Plzeň Zoo, Plzeň, Czech Republic |
www.zooplzen.cz

170–171: **Golden-headed Quetzal,** Houston Zoo, Houston, Texas |
www.houstonzoo.org

172: **Verreaux's Eagle-Owl,** Zoo Atlanta, Atlanta, Georgia |
www.zooatlanta.org

172: **Common Murre egg,** University of Nebraska State Museum, Lincoln, Nebraska |
www.museum.unl.edu

172: **Common Grackle,** Private Facility

172: **Western Kingbird,** Private Facility

172: **Little Penguin,** Cincinnati Zoo, Cincinnati, Ohio | *www.cincinnatizoo.org*

172: **Hawaiian Goose,** Sylvan Heights Bird Park, Scotland Neck, North Carolina |
www.shwpark.com

173: **Chilean Flamingo,** Houston Zoo, Houston, Texas | *www.houstonzoo.org*

173: **Ural Owl,** Plzeň Zoo, Plzeň, Czech Republic | *www.zooplzen.cz*

173: **Bufflehead,** National Mississippi River Museum & Aquarium, Dubuque, Iowa |
www.rivermuseum.com

174: **Whooping Motmot,** National Aviary of Colombia, Barú, Colombia |
www.acopazoa.org

175: **European Bee-eater,** Budapest Zoo, Budapest, Hungary |
www.zoobudapest.com

BIRD BRAINS

176: **Sun Parakeet,** Bramble Park Zoo, Watertown, South Dakota |
www.brambleparkzoo.com

176: **Red-billed Blue Magpie,** Houston Zoo, Houston, Texas | *www.houstonzoo.org*

176: **Apostlebird,** Healesville Sanctuary, Healesville, Australia |
www.zoo.org.au/healesville

176: **Eastern Yellow-billed Hornbill,** Indianapolis Zoo, Indianapolis, Indiana |
www.indianapoliszoo.com

176: **Northern Double-collared Sunbird,** Bioko Island, Equatorial Guinea

176: **Pied Crow,** Ocean Park, Hong Kong | *www.oceanpark.com.hk*

176: **Double-crested Cormorant,** Cincinnati Zoo, Cincinnati, Ohio |
www.cincinnatizoo.org

177: **Common Raven,** Los Angeles Zoo, Los Angeles, California | *www.lazoo.org*

177: **Gray Parrot,** Dallas Zoo, Dallas, Texas | *www.dallaszoo.com*

177: **Adélie Penguin,** Faunia, Madrid, Spain | *www.faunia.es*

177: **Eclectus Parrot,** Parrots in Paradise, Glass House Mountains, Australia |
www.parrotsinparadise.net

177: **Graylag Goose,** Sylvan Heights Bird Park, Scotland Neck,
North Carolina | *www.shwpark.com*

178: **Adélie Penguin,** Faunia, Madrid, Spain | *www.faunia.es*

180–181: **Star Finch,** Melbourne Zoo, Parkville, Australia | *www.zoo.org.au/melbourne*

182–183: **Red-billed Blue Magpie,** Houston Zoo, Houston, Texas |
www.houstonzoo.org

184–185: **Sun Parakeet,** Bramble Park Zoo, Watertown, South Dakota |
www.brambleparkzoo.com

186: **Common Moorhen,** Private Facility

187: **Superb Fairywren,** Healesville Sanctuary, Healesville, Australia |
www.zoo.org.au/healesville

188: **Military Macaw,** Denver Zoo, Denver, Colorado | *www.denverzoo.org*

188–189: **Blue-and-yellow Macaw,** Denver Zoo, Denver, Colorado |
www.denverzoo.org

190: **Apostlebird,** Healesville Sanctuary, Healesville, Australia |
www.zoo.org.au/healesville

191: **Common Murre,** Omaha's Henry Doorly Zoo & Aquarium, Omaha, Nebraska |
www.omahazoo.org

192–193: **Pied Crow,** Ocean Park, Hong Kong | *www.oceanpark.com.hk*

194: **Red-throated Bee-eater,** Oklahoma City Zoo, Oklahoma City, Oklahoma |
www.okczoo.org

194: **Clark's Nutcracker,** University of Nebraska-Lincoln, Lincoln, Nebraska |
www.unl.edu

194: **House Crow,** Kamla Nehru Zoological Garden, Ahmedabad, India |
www.ahmedabadzoo.in

194: **Eclectus Parrot,** Parrots in Paradise, Glass House Mountains, Australia |
www.parrotsinparadise.net

194: **Black-throated Magpie-Jay,** Houston Zoo, Houston, Texas |
www.houstonzoo.org

194: **American Crow,** George M. Sutton Avian Research Center, Bartlesville,
Oklahoma | *www.suttoncenter.org*

195: **Asian Azure-winged Magpie,** University of Nebraska-Lincoln, Lincoln,
Nebraska | *www.unl.edu*

195: **Plush-crested Jay,** Houston Zoo, Houston, Texas | *www.houstonzoo.org*

195: **Florida Scrub-Jay,** Cape Canaveral, Florida

195: **Hooded Crow,** Budapest Zoo, Budapest, Hungary | *www.zoobudapest.com*

195: **Gray Parrot,** Dallas Zoo, Dallas, Texas | *www.dallaszoo.com*

196: **Common Raven,** Los Angeles Zoo, Los Angeles, California | *www.lazoo.org*

197: **Kea,** Wellington Zoo, Wellington, New Zealand | *www.wellingtonzoo.com*

THE FUTURE

198: **California Condor,** Phoenix Zoo, Phoenix, Arizona | *www.phoenixzoo.org*

198: **New Zealand Kaka,** Wellington Zoo, Wellington, New Zealand |
www.wellingtonzoo.com

198: **Yellow-headed Caracara,** Summit Municipal Park, Gamboa, Panama

Since 1888, the National Geographic Society has funded more than 12,000 research, exploration, and preservation projects around the world. National Geographic Partners distributes a portion of the funds it receives from your purchase to National Geographic Society to support programs including the conservation of animals and their habitats.

National Geographic Partners
1145 17th Street NW
Washington, DC 20036-4688 USA

Get closer to National Geographic explorers and photographers, and connect with our global community. Join us today at nationalgeographic.com/join

For information about special discounts for bulk purchases, please contact National Geographic Books Special Sales: specialsales@natgeo.com

For rights or permissions inquiries, please contact National Geographic Books Subsidiary Rights: bookrights@natgeo.com

ISBN: 978-1-4262-1898-9

ISBN: 978-1-4262-1982-5 (deluxe)

Printed in China

17/RRDS/1

"I WANT PEOPLE TO CARE, TO FALL IN LOVE, AND TO TAKE ACTION."

—JOEL SARTORE

The Photo Ark
ONE MAN'S QUEST TO DOCUMENT THE WORLD'S ANIMALS

JOEL SARTORE
With a foreword by HARRISON FORD

Includes a foreword by **HARRISON FORD**, Vice Chair of Conservation International

FOR KIDS

Animal Ark
Celebrating our WILD WORLD in poetry and pictures

Photographs by JOEL SARTORE, Photo Ark Creator
Words by KWAME ALEXANDER, Winner of the Newbery Medal

Written by Newbery Medalist and Poet **KWAME ALEXANDER**

FOR MANY OF EARTH'S CREATURES, TIME IS RUNNING OUT.

Joel Sartore, founder of Photo Ark, pledged to photograph every animal species in captivity and inspire people to care and take action. Filled with stunning and exquisite photographs, these books gloriously showcase the infinite variety of the animal kingdom and convey a powerful message with humor, poetry, compassion, and art.

AVAILABLE WHEREVER BOOKS ARE SOLD
AND AT NATIONALGEOGRAPHIC.COM/BOOKS

 NATGEOBOOKS @NATGEOBOOKS

© 2018 National Geographic Partners, LLC